IMAGES
of America

DANBURY

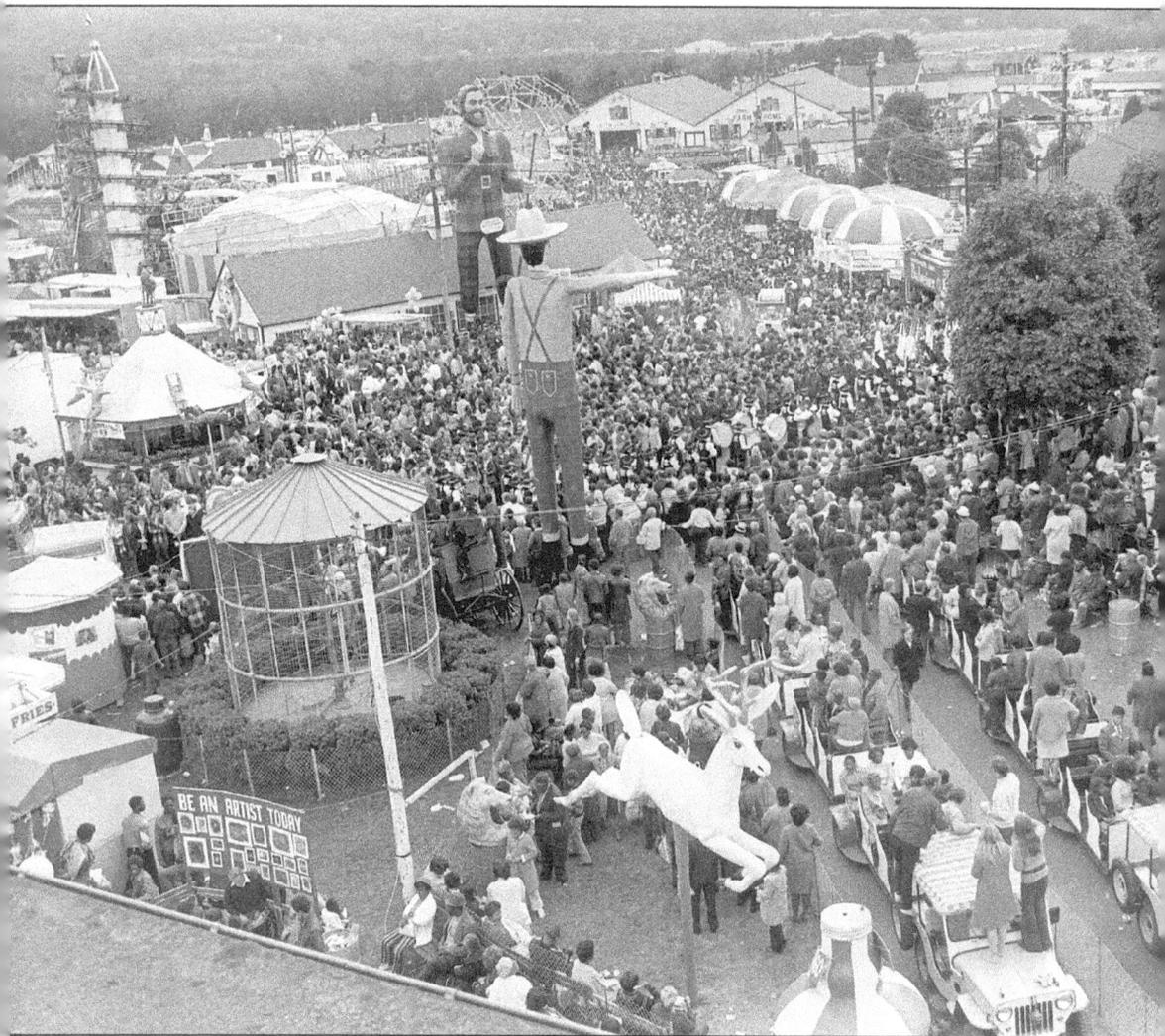

THE MIDWAY AT THE DANBURY FAIR. Two pieces of John Leahy's statuary look out over the crowd at the Great Danbury State Fair (1869–1981). One of the two farmer statues at the fair looks southwest toward the Danbury Airport, while Paul Bunyan smiles at the northeast. The fairgrounds were located in southwestern Danbury; the site is now occupied by the Danbury Fair Mall.

IMAGES
of America

DANBURY

Danbury Museum & Historical Society

ARCADIA
PUBLISHING

Published by Arcadia Publishing
Charleston, South Carolina

Library of Congress Catalog Card Number: 2001089285

For all general information contact Arcadia Publishing at:
Telephone 843-853-2070
Fax 843-853-0044
E-mail sales@arcadiapublishing.com
For customer service and orders:
Toll-Free 1-888-313-2665

Visit us on the Internet at www.arcadiapublishing.com

On the cover: THE TRIMMING DEPARTMENT, MALLORY HAT FACTORY. In 1883, the November 7 edition of the *Danbury News* reported on ". . . the romantic experience of Miss Beach, the young Bethel lady who wrote her name on the band of a hat and finally married the New Orleans gentleman into whose hands it fell." Some 20 percent of the hatters in Danbury were females, usually employed in the trimming departments, where the sweatbands, satin linings, decorative ribbons, and feathers were attached to the finished product.

CONTENTS

Acknowledgments

We would like to take this opportunity to thank those individuals who have donated photographs to the Danbury Museum & Historical Society since its establishment in 1947. This publication would not have been possible without the generosity and foresight of those benefactors.

We would also like to thank the society's board of trustees for providing the society with the time and materials necessary for this most worthwhile project: Sally Anyan, James Arconti, Ellen Blom, Fil Cerminara, Scott Cooney, Evelyn Durgy, Deborah Grover, Pat Konov, Joan Lubus, Michael McLachlan, Clarice Osiecki, James Ogden, Martin Ogden, Debra Pires, Elizabeth Scott, and Robert Young. More importantly we want to acknowledge the board advisory committee, JoAnn Brown, Brenda Grover, and Levi Newsome, who dedicated their time and expertise, and staff members Brigid Durkin, curatorial specialist, and Kathleen Zuris, research specialist, who prepared this publication.

Lastly, composition of this work was greatly aided by the efforts of those whose words have been previously published: James Montgomery Bailey, Stephen Collins, Jerrold Davis, William Devlin, Evelyn Durgy, William Francis, Herb Janick, Imogene (Heireth) Karabeinikoff, Dorothy Schling, Truman Warner, and Donald Wood. We salute all who have gone before us—those writers whose legacy of chronicling Danbury's history has enlightened, informed, and entertained.

INTRODUCTION

"John Bur, Thomas Benedict, and Thomas Fitch, by this court [May session of the General Assembly, 1684] were appointed and empowered a committee for to order the planting of a towne above Norwalke or Fayrefield, and to receive in inhabitants to plant there, and what they or any three of them shall doe in the premises shall be good to all intents and purposes for the planting of Paquioqe."

Paquioqe or Pahquioque was how the Indians referred to the open plain on which the eight founding families settled in 1684. Danbury was constituted a town in 1687 and was granted a patent in 1702.

The need for an established turnpike arose early in Danbury's history due to local farmers not being able to supply all the goods for Danbury's inhabitants. A network of paths was created to trade Danbury's surplus crops, and those paths established the town as a center for commerce. They resulted in Danbury's role in the American Revolution as a military store, and it became a well-known stopover for military and civilian leaders passing between New England and areas west.

On August 9, 1784, the Connecticut General Assembly voted that the Superior and County Courts be held in Fairfield and Danbury. The following year a courthouse and jail were built.

In 1822, the borough district was established and the center of the town was taxed to pay for services for district residents and businesses. The revenue also paid for some of the amenities for people on the outskirts of town until the town and city merged in 1965. Danbury's first bank, the Danbury National Bank, opened in 1824, and the first fire company was organized in 1829.

The 1830s and 1840s saw changes in public utilities and services. A hook and ladder company was organized, and residents were introduced to piped water. In 1846, Town Street became Main Street, where the Danbury Savings and Pahquioque banks were soon established.

The hatting industry saw substantial growth in Danbury in the 1850s, despite the loss of Bethel's hat shops when that part of town seceded from Danbury in 1855. The introduction of the cash system replaced the barter method of exchange at the beginning of the decade. Forming machines were able to produce 30 hat bodies in the same amount of time it took to prepare one manually. By 1852, hats and hat supplies were being transported by rail to and from Danbury and coal was the energy used to power trains and machines and to heat homes. However, during the following decade, those trains were out of reach for the southern retail hat shops, established at the beginning of the 19th century by Danbury hatters, due to the Civil War.

7

By 1860, Danbury had 12 street gas lamps, 11 on Main Street and one at the corner of West Street and Deer Hill Avenue. This decade ended in disaster, when the Kohanza Dam burst in 1869 and 10 lives were lost. The last three decades of the 19th century brought about new machinery for the hatting industry, and the population grew from 11,666 in 1880 to well over 20,000 by 1900.

Paving of Main Street began in the 1880s, as did electrification of that thoroughfare. This decade also saw the establishment of Danbury Hospital, a fire alarm system, and a weekly newspaper. A new city hall was completed by 1886, three years before Danbury obtained a city charter.

By the start of the last decade of the 19th century, Danbury was producing five million hats a year. Horse-drawn streetcars gave way to an electrified railway. However, the next popular mode of transportation, the automobile, was the catalyst for the decline of the hatting industry.

Danbury was producing six million hats a year at the beginning of the 20th century, but it was also the beginning of the end of hat making in Danbury. The automobile, for the most part, was styled for the bare head, and protection from the elements was unnecessary in a covered car. The convertible required snug-fitting head wear classified as caps, still in wide use today.

At the conclusion of World War I, in 1918, diversification was imminent and the Danbury Industrial Corporation was formed. Success was slow but due to an existing supply of laborers who could adjust their hatting skills where needed, new enterprises arrived in Danbury. In 1946, more Danburians were employed in non-hatting industries for the first time since 1832.

Danbury's location midway between Hartford and New York City made it an attractive place for incoming industries in the 1950s and 1960s. Aided by the completion of Interstate 84, Danbury saw the influx of companies involved in the space program (Perkin-Elmer), publishing (Grolier), surgical instruments (Davis & Geck), and Union Carbide (chemicals and other products), which moved its headquarters here in 1980.

In 1986, the Danbury Fair Mall opened on the former Danbury fairgrounds. Western Connecticut State University, which began the 20th century as the Danbury Normal School, ended the century with an extensive renovation of its downtown campus that included a new library.

Downtown Danbury saw several changes from the 1960s through the end of the 2000, mostly due to redevelopment after the 1955 floods. A new train station was built in the 1990s and a historical, dining, and entertainment district was established nearby.

One

THIS IS THE TOWN . . .

*Danbury is a good-natured town, a hard-working town,
an honest town, a town free from tensions.*
—Columbia University School of Engineering study, 1953

Pahquioque, Swampfield, Beantown, Hat City, Gateway to New England—all are nicknames for Danbury, Connecticut. Yet "survivor" may be the best word to describe the town. In spite of the loss of several buildings and records (put to the torch by the British in 1777), the blight of a one-industry town, the floods of 1955, a downtown bombing, high school riots, a mall that failed, lawsuits, and the closing of the Danbury Fair, Danbury has always managed to rebound from disaster to prosperity.

Danbury's location has been the key to its success. It was selected as a supply center during the American Revolution because it had been a trading center since shortly after it was settled. The eight families who moved here from Norwalk exchanged with their former neighbors on a regular basis; thus, the route to the coastline became a much traveled byway. Also, Danbury's farms provided New York with produce. Equidistant between New York and Hartford and surrounded by smaller towns, it became a hub for business and travel.

Corporate headquarters, one of the largest malls in New England, a hospital, a university, an airport, a train station, Candlewood Lake, and the construction of Interstate 84 contributed to Danbury's progress.

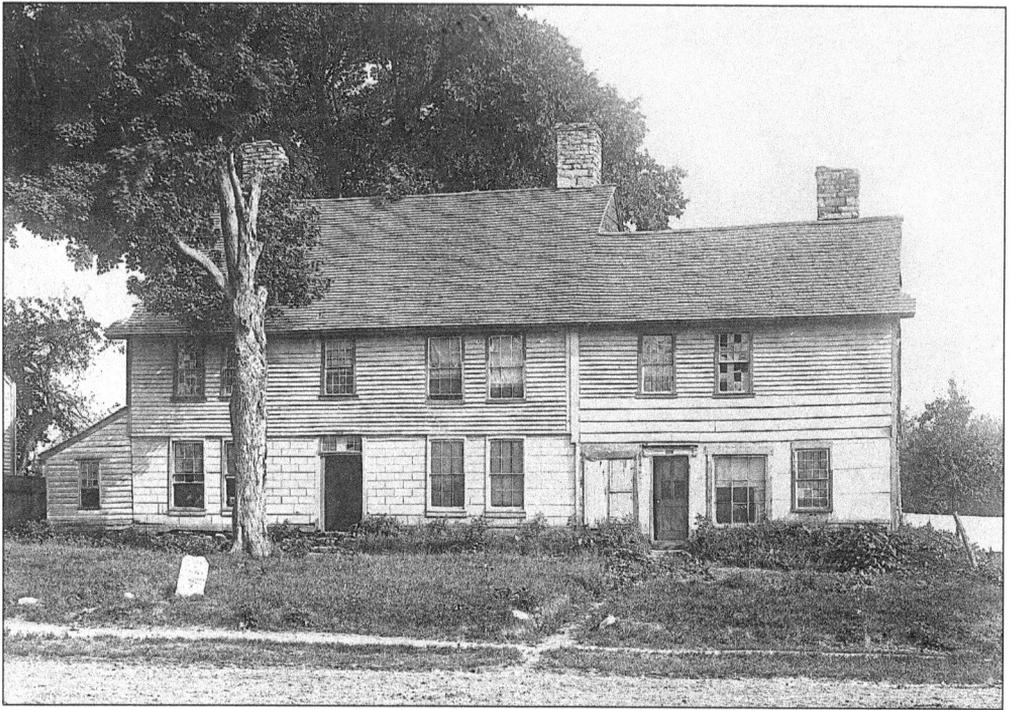

TAYLOR'S TAVERN. This structure was built on the site of the last home burned by the British during their raid on Danbury on April 26, 1777. When the tavern was rebuilt by Major Taylor, it housed a taproom, dining room, and ballroom. (Note the white stone mileage marker in the foreground.)

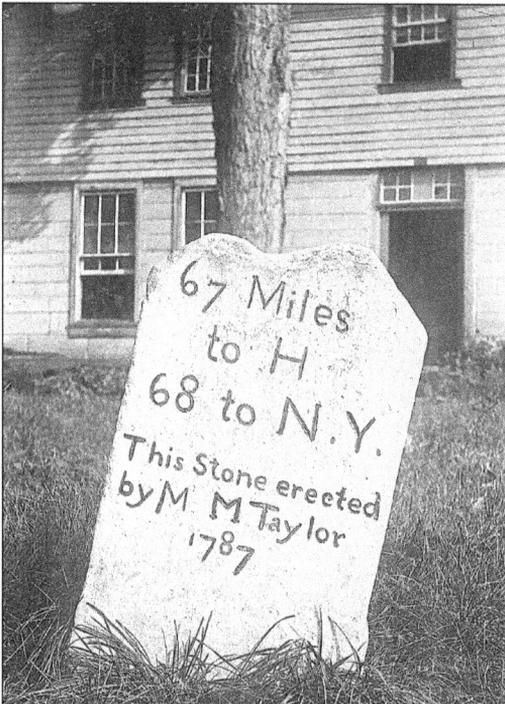

A MILEAGE MARKER. Erected by Major Taylor in 1787, this tablet informs passersby of the distance to Hartford and New York City. Although the house is gone, the mileage marker still remains; it sits at the entrance to Rogers Park at the corner of Main Street and Memorial Drive.

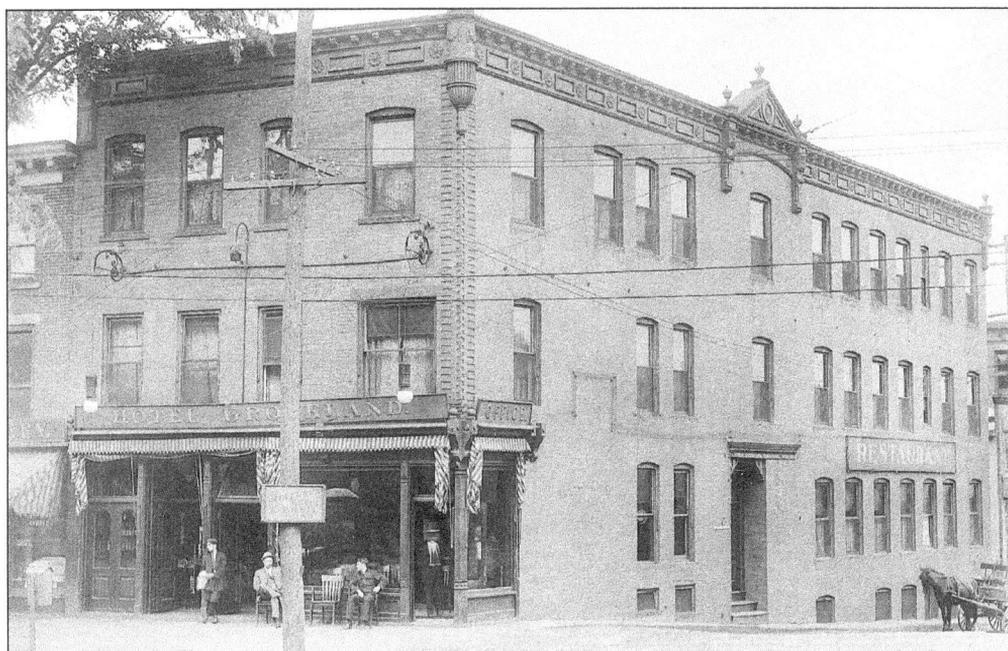

THE HOTEL GROVELAND. Built in 1891, the Groveland was opened as an elegant gentlemen's hotel, complete with an impressive restaurant and accommodations with carved-oak furniture, marble washbasins, and brass beds. Located at 275 Main Street, it is currently the site of Mimi's Restaurant.

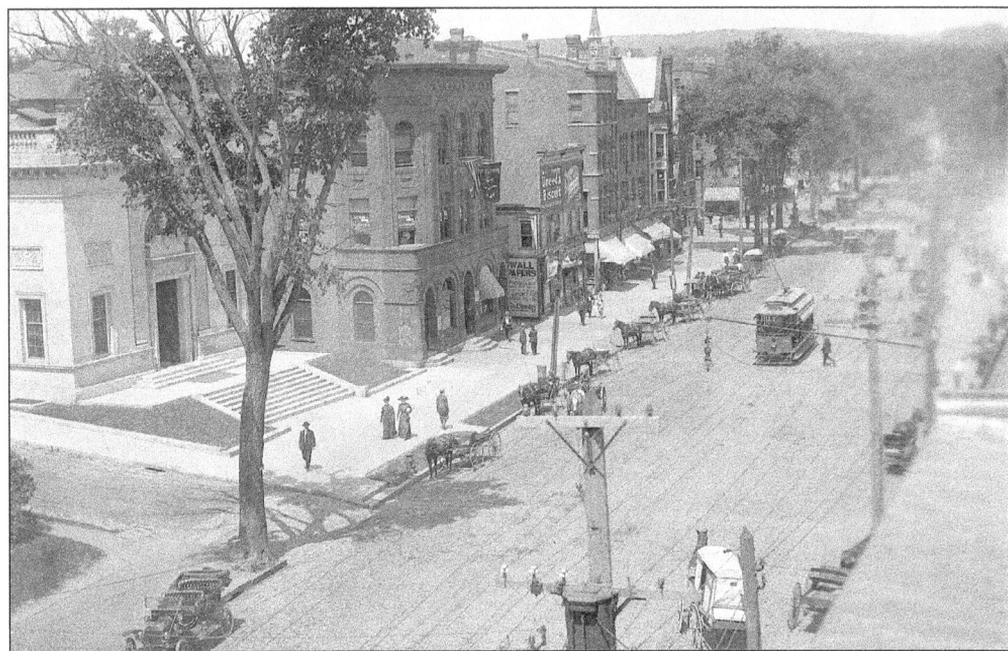

MAIN STREET AT BANKER'S ROW, C. 1914. This photograph was taken looking north on Main Street. Note the Belgian blocks (instead of a paved Main Street), a trolley car, an early automobile, and many horse-drawn carriages. This period marks Danbury's transportation transition, which continued for at least a decade.

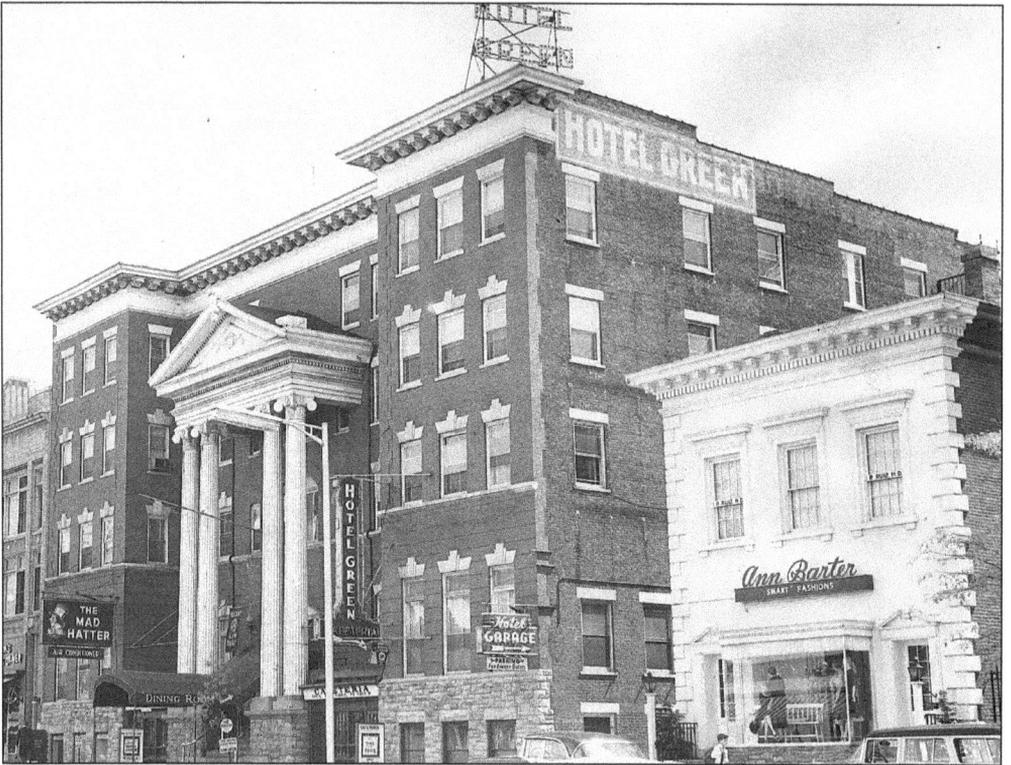

THE HOTEL GREEN. One of Danbury's best-known landmarks, the Hotel Green offered dining and lodging. "Tell your friends to meet you at the Green" drew area residents to the hotel's Peacock Ballroom, Mad Hatter Tap Room, cafeteria, grill, and main dining room. The year 1959 saw the end of this hotel's operation. It was replaced by the New Englander Hotel, which evolved into Ives Manor.

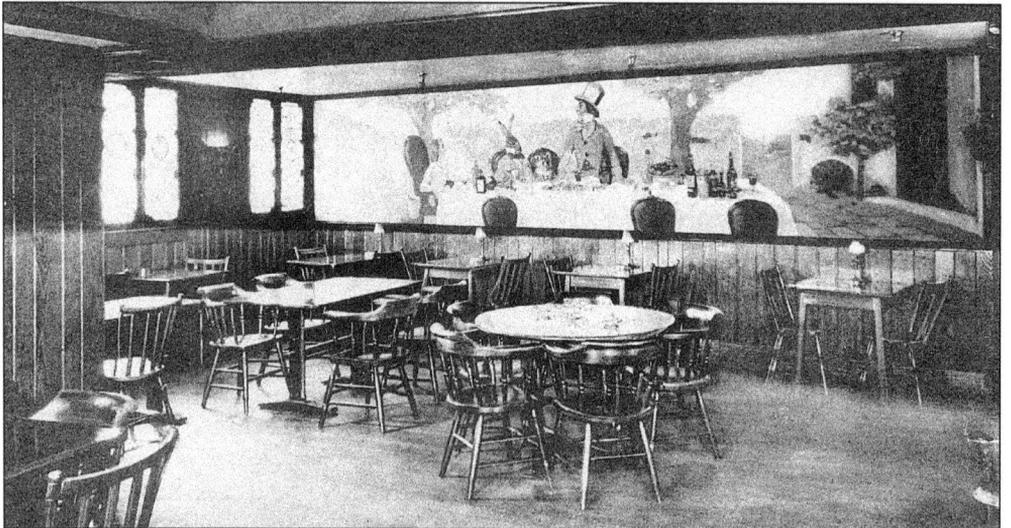

THE MAD HATTER TAP ROOM. This popular taproom offered air-conditioning, hospitality, and good cheer. It featured a large mural of the Mad Hatter's Tea Party from *Alice in Wonderland*.

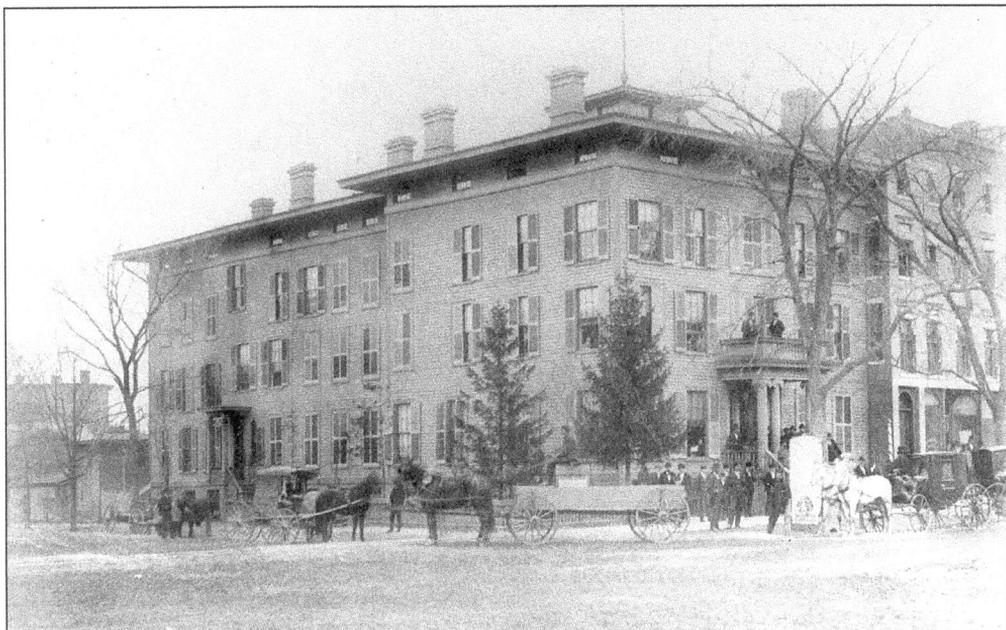

THE WOOSTER HOUSE. Built in 1851 by a stock company named for Gen. David Wooster, this hotel was located at the corner of White and Main Streets. In 1870, when the photograph was taken, the hotel was convenient to the train station, the post office, and the soon-to-be-built Danbury Library on Main Street.

WOOSTER SQUARE. In the 1890s, the Wooster House was torn down and this larger building was erected on the site. The first floor was home to the Globe Dry Goods Store, which operated for several years. Eventually that store was replaced by a series of drugstores and, in 1939, by Feinson & Sons.

THE TURNER HOUSE, 1890. This hotel at 73 Main Street was on the present site of Walgreen's Drugstore. It was constructed for circus man Aaron Turner in 1850 on the site of previous hotels and taverns. Illegitimate and illiterate, Turner was a successful businessman who introduced P.T. Barnum to the circus. Son-in-law George F. Bailey inherited Aaron Turner's business, which evolved into the Barnum & Bailey Circus.

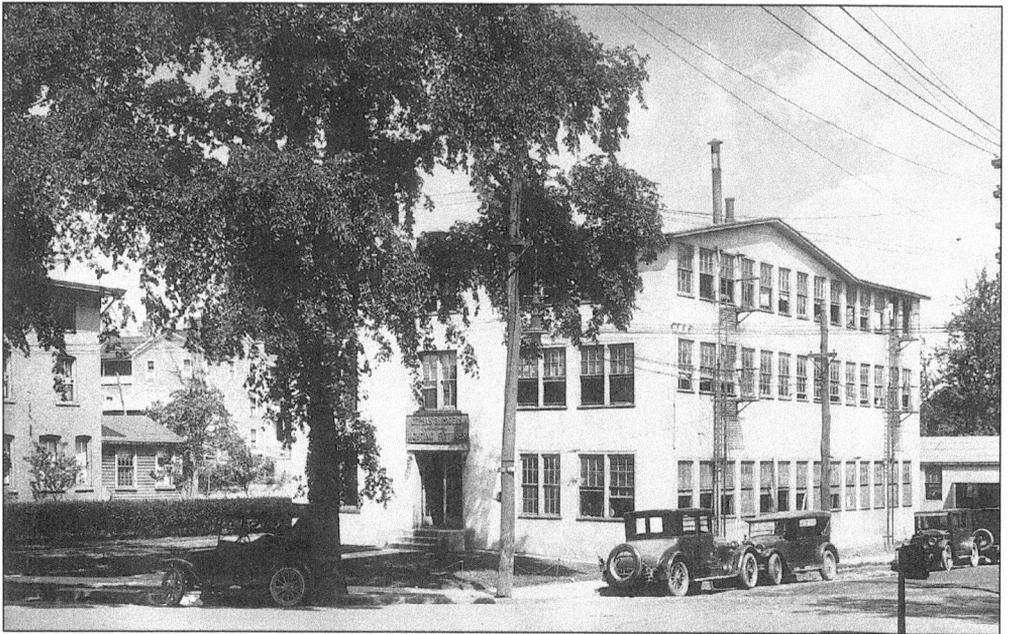

CEPHAS P. ROGERS LIGHTING FIXTURES, 85 LIBERTY STREET, C. 1920S. Cephas Rogers received a design award from the Home Owners Institute for a model home demonstration. Rogers donated 25 acres to the city of Danbury and in his honor, the city named that site Rogers Park. With the help of the Works Progress Administration, the city drained the swampy land and created ball fields, an ice rink, a pool, and tennis courts.

14

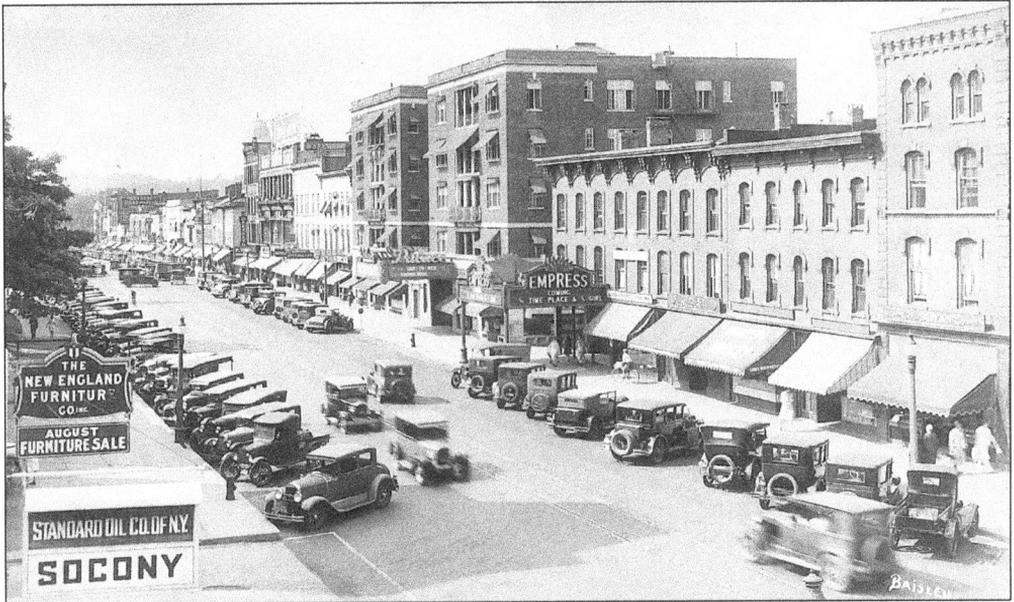

LOOKING NORTH ON MAIN FROM KEELER STREET, 1929. Taken by one of Danbury's most prolific photographers, Frank Baisley, this photograph highlights two popular movie theaters in town, the Palace and the Empress (center). Side by side, they offered their customers competitive prices and many movie choices. The Palace managed to outlive the other downtown movie theaters but was finally forced to close in 1995.

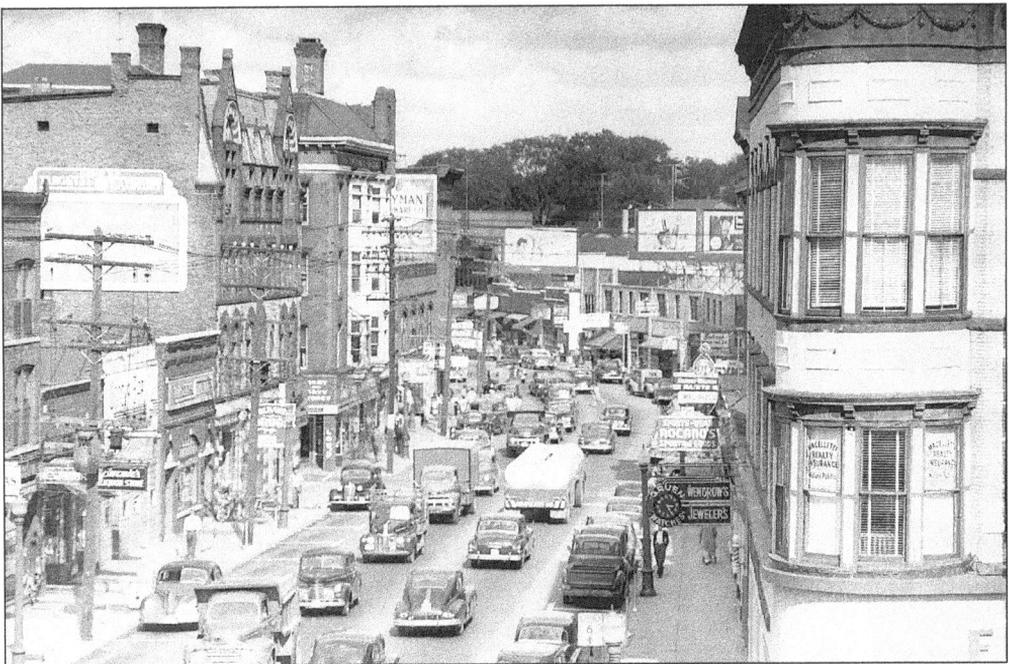

WHITE STREET, LOOKING EAST, C. 1940S. This photograph showcases a bustling downtown Danbury prior to the great flood of 1955, which severely altered the downtown streetscape. From insurance to jewelers to restaurants to fashion accessories, downtown Danbury had something to offer everyone.

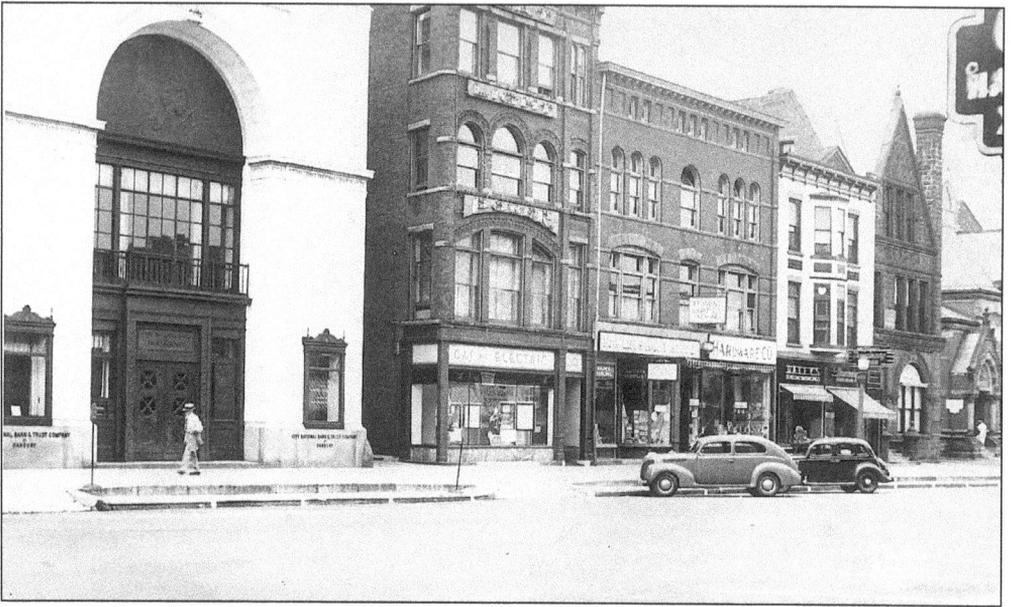

THE WEST SIDE OF MAIN STREET, C. 1940s. This photograph offers a view of the City National Bank & Trust Company (far left, now Chase Manhattan Bank), the Danbury & Bethel Gas & Electric Light Company (center), and the old Danbury Public Library (far right). Although the occupants of these buildings have changed over the last several decades, the sight line has remained and still offers a glimpse of the downtown of yesteryear.

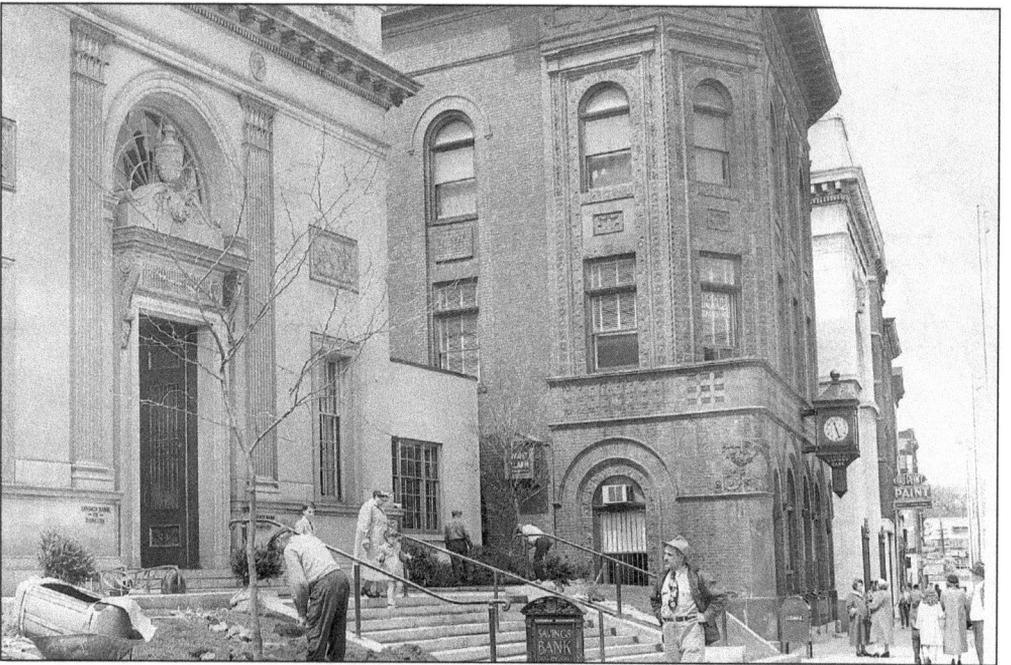

THE SAVINGS BANK OF DANBURY. Established in 1849 as the first mutual bank in Danbury, the Savings Bank of Danbury (left) originally operated from the Main Street home of its first treasury secretary, George White Ives. In 1909, the building shown above was built on Main Street; it still serves as the main branch of the Savings Bank of Danbury.

16

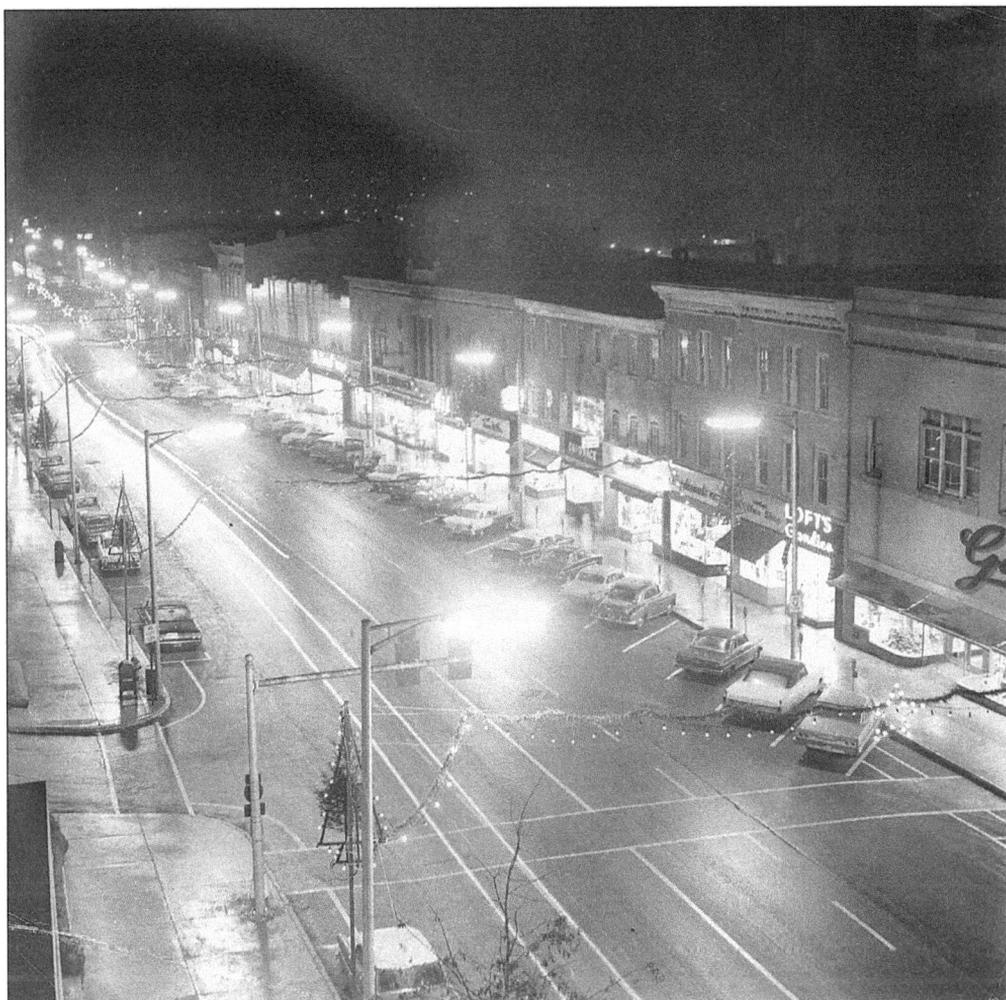

MAIN STREET AT NIGHT, C. 1963. This photograph of Main Street dressed up in holiday lights serves to underscore the pride local citizens have always felt in Danbury. Decorating downtown during the holiday season was yet another way Danburians celebrated their town.

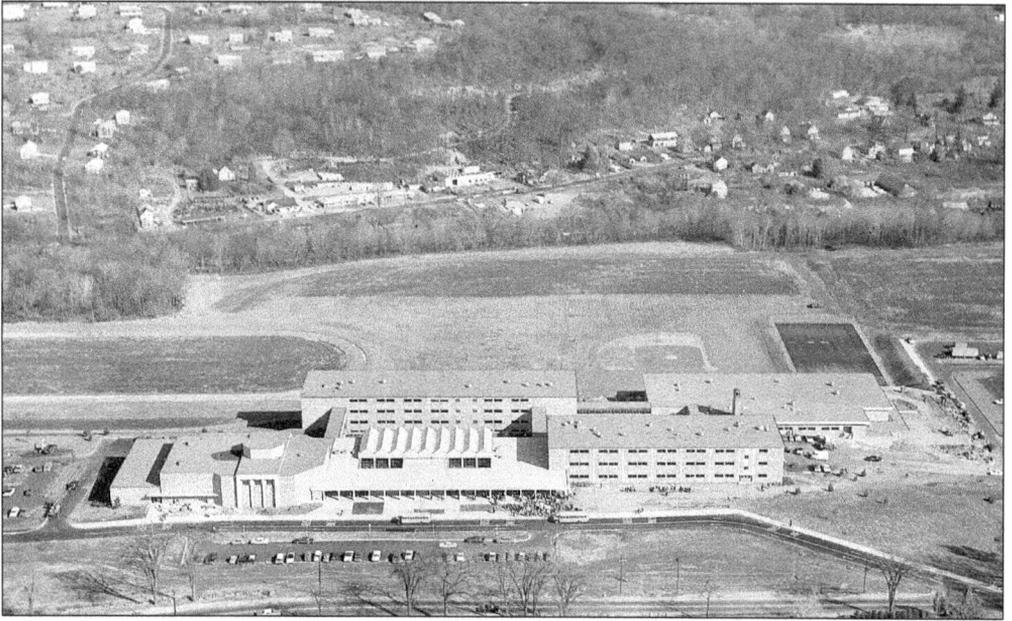

DANBURY HIGH SCHOOL, 1964. The third edifice built for a high school in Danbury was the outcome of immense overcrowding, double sessions, and the efforts of June Goodman and a committee of 10, which grew to a group of over 1,000. Great Plain, King Street, and Shelter Rock Elementary Schools and Danbury High all were dedicated on May 16, 1965.

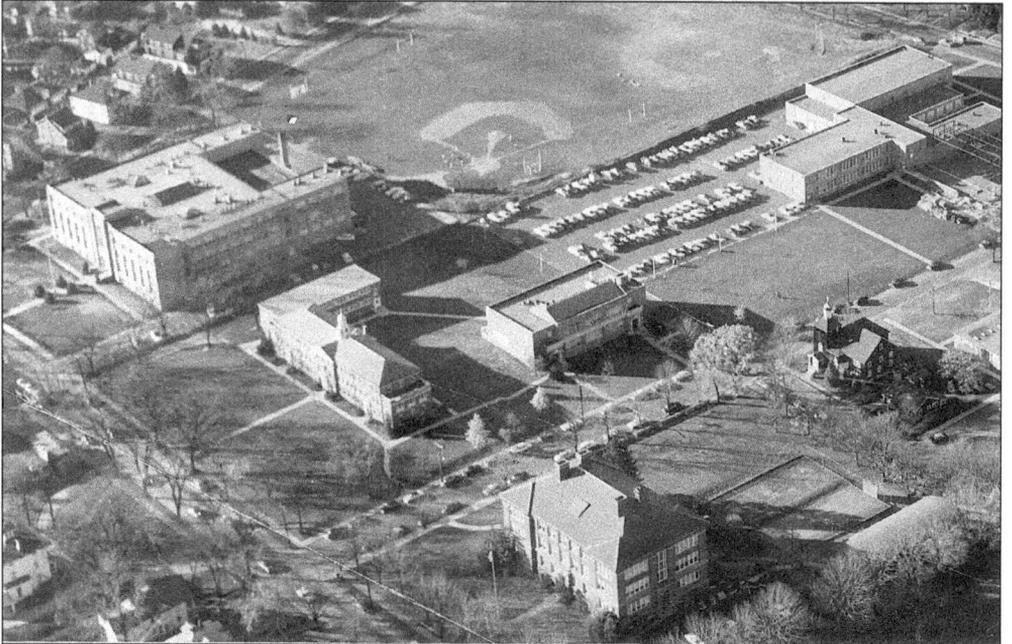

WESTERN CONNECTICUT STATE UNIVERSITY, DOWNTOWN CAMPUS, C. 1955. When the first structure built for a high school was erected in 1903, the first Danbury Normal School students attended classes on the top floor of that building at Main and Boughton Streets. In 1905, these 42 women (future teachers) moved into the new building at White Street and Seventh Avenue (center foreground) on property donated by the Alexander White family.

MIRY BROOK. An early agricultural settlement, Miry Brook's western route to New York was utilized by the British when they retreated from Danbury. The brook collects water from the Sugar Hollow area, which flows into the Still River near the Danbury airport. The second Baptist church in Danbury was founded in the Miry Brook section in 1788. In the late 1920s, Tucker's Field became the location of the Danbury Airport.

THE BEAVER BROOK PAPER MILL DAM. Another tributary of the Still River, Beaver Brook, now mostly covered by a shopping center, had a paper mill as early as 1790. The Sturdevant hat factory was also located in this section of Danbury. Paper quality had been compromised by Still River pollutants, and George Morgan, who owned a gristmill in Beaver Brook, sued the city. Danbury was then ordered to build a filtration plant in 1895.

5312 Boat Landing, Lake Kenosha, Danbury, Conn.

LAKE KENOSIA. Originally named Mill Plain Pond, this body of water is a part of the Still River, which begins near the New York State border and flows north, ending at the confluence of the Housatonic River in New Milford. Near the turn of the 20th century, Kenosia Park could be accessed by trolley and provided such diversions as a hotel, boat rides, swimming, a merry-go-round, and a roller coaster.

TOWN PARK. Most people consider Lake Candlewood as a source for recreational activities, not as a man-made reservoir created for the generation of electricity. When Kenosia Park was destroyed by a fire in 1926, Danbury residents and their guests soon flocked to the newly created lake. In 1948, a small section became a town park for the enjoyment of all citizens of Danbury.

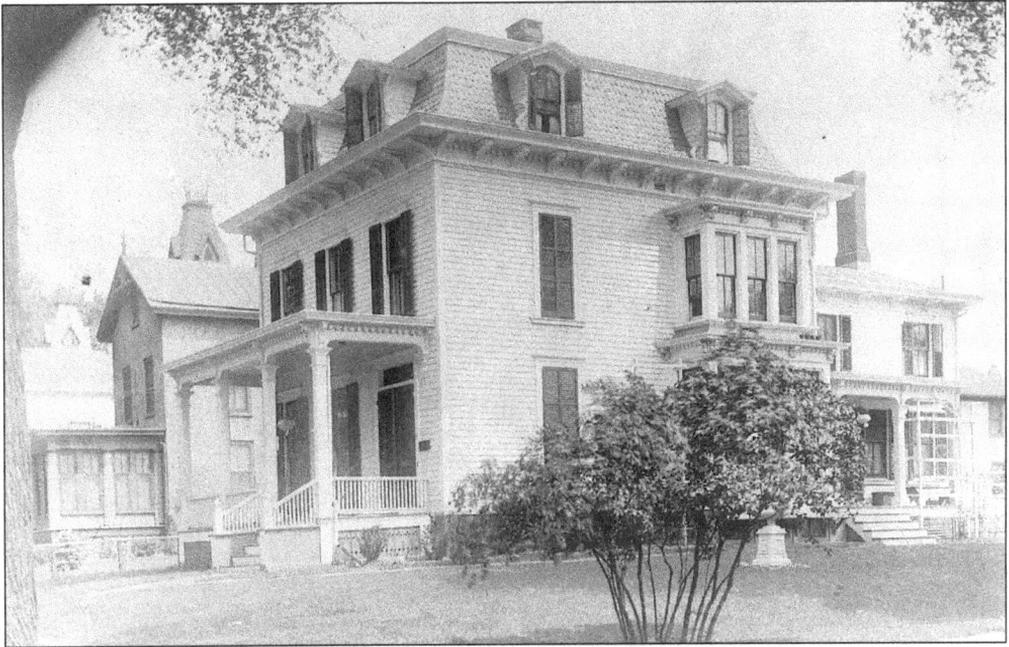

17 BALMFORTH AVENUE. The Rawlins House was purchased for the widow of Brig. Gen. John A. Rawlins (Mary Emma Hurlburt) with money contributed to a fund in honor of Gen. Ulysses S. Grant's chief of staff, who died of consumption. When Grant became president in 1869, Rawlins, who had fought at Appomattox, Shiloh, and Vicksburg, was selected to be secretary of war, but he died shortly after being appointed.

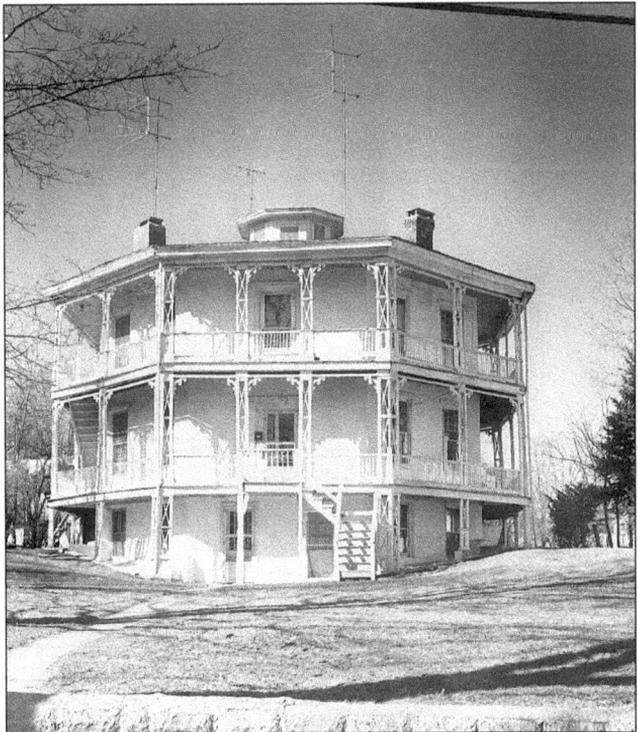

THE OCTAGON HOUSE. One of the few homes in Danbury on the National Registry of Historic Places, 21 Spring Street was built in 1853 in a style suggested by phrenologist Orson Fowler. It has served as a landmark to many generations of Danbury residents. When the house was constructed, Spring Street did not yet exist and Elm Street was the original access point and address.

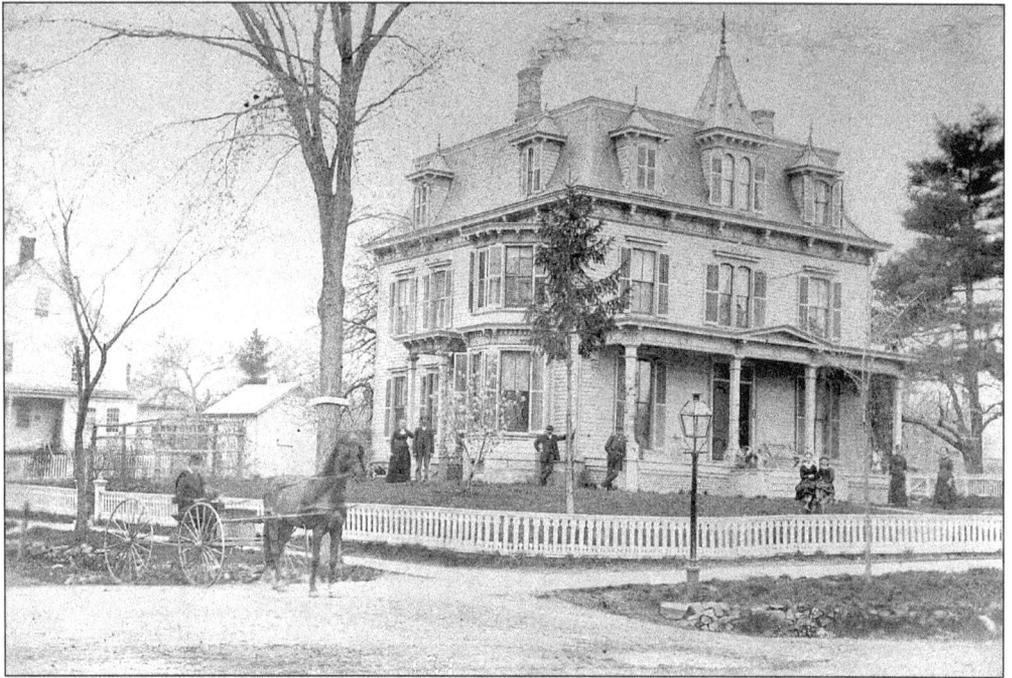

THE BARNUM HOUSE, C. 1870. This house stood on the corner of West and William Streets. Like several older buildings in Danbury, it had many uses over its life span. It began as a family home and was later used as a club by the local members of the American Legion. Later, the site became the home of the Connecticut State Employment Agency.

THE OLD RED HOUSE. Located at 80 West Street (currently a Rite Aid drugstore), this home burned to the ground on October 31, 1905. The Halloween fire was started when a candle-lighted search for a costume turned into a disaster.

MEEKER'S TAVERN. Originally built by Major Whiting, this building later became a home for the aged, known as the Amelia Brewster Home (named for its founder, the aunt of composer Charles Ives). Taverns and, later, hotels abounded in Danbury, especially in the well-traveled Town Street (Main Street) area of Danbury. The building was torn down in the 1970s. The lot was vacant for decades until 2000, when construction began on a low-income and senior housing complex.

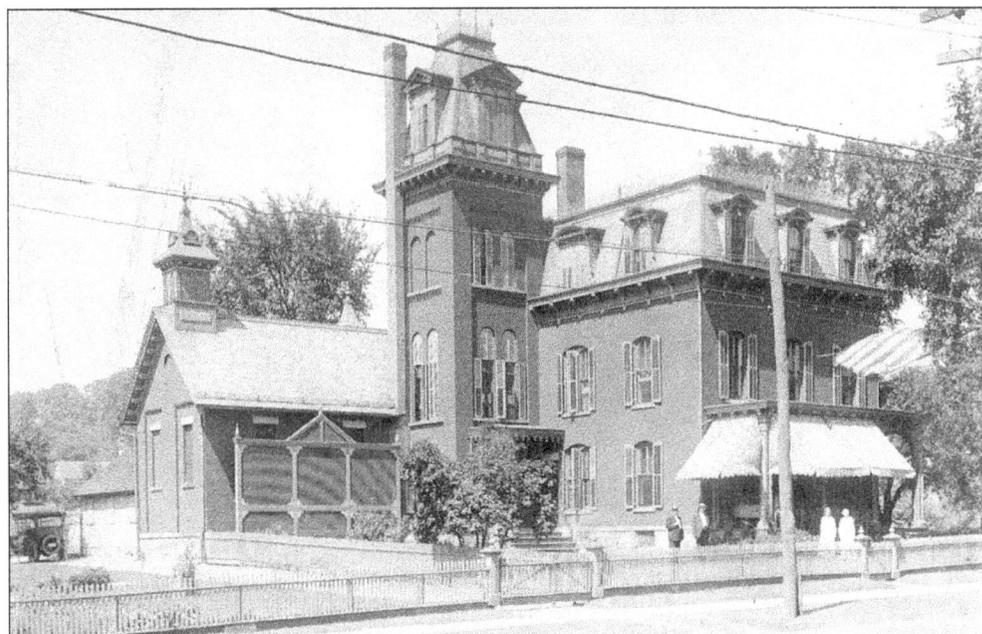

THE OLD JAIL AT 80 MAIN STREET. Danbury was made a half-shire (it shared judicial matters with Fairfield) for Fairfield County in 1784. This building was used as a jail until 1959, when county government ended. Built in 1872 and restored in 1980, it now houses the Danbury Senior Center. Its predecessor, erected in 1830, housed P.T. Barnum and his newspaper operation during his 60-day incarceration for libel in 1832.

23

ST. JAMES EPISCOPAL CHURCH ON WEST STREET. This third building for St. James's parish was built in the 1840s. The first structure for the Anglican faith in Danbury was built in the 1760s on the site of today's South Street School. Although it stored military supplies during the American Revolution, the Church of England was spared the torch when the British raided Danbury in 1777.

THE SANDEMANIAN CHURCH. "Their rules prohibit games of chance, prayers at funerals, college training, as well as most nineteenth-century innovations, while in food they are forbidden to use fleshmeat and 'all things strangled.'" This religious sect began in Scotland, when Robert Sandeman broke away from the Presbyterian Church. The New Sandemanian Church, which began in Danbury in 1774 with former Congregationalists, was one of the largest in the country.

24

THE UNITED JEWISH CENTER, 30 WEST STREET. Before the United Jewish Center bought its site on Deer Hill Avenue, the congregation used the Concordia Hall on Crosby Street, the Elks Hall, and this location, Henry Dick's house at 30 West Street.

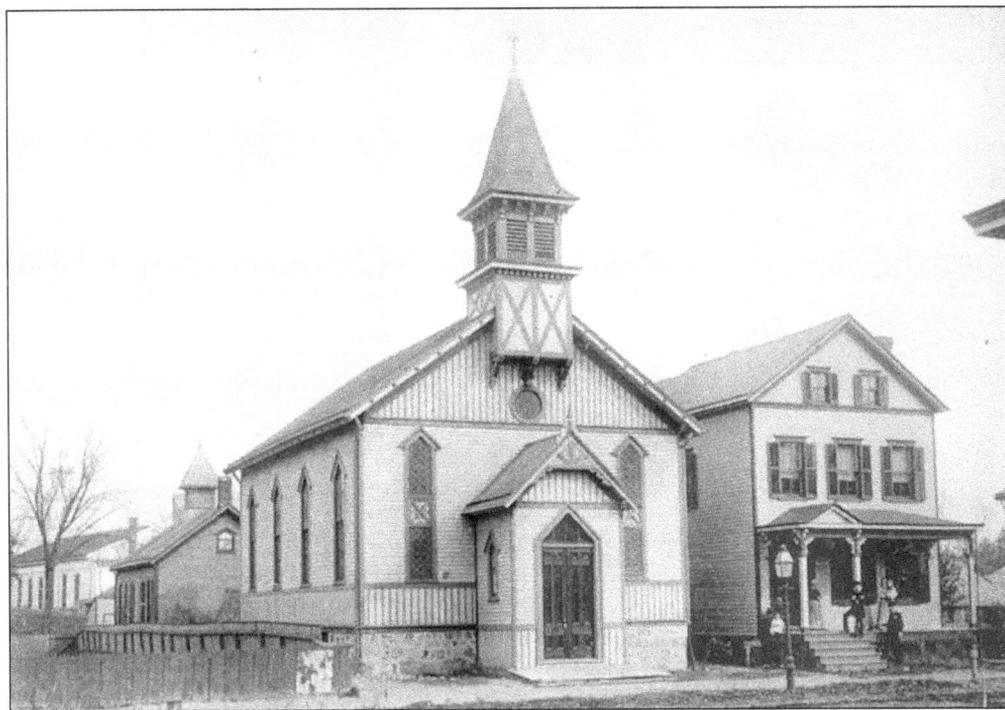

THE IMMANUEL LUTHERAN CHURCH ON FOSTER STREET. The church, parsonage, and school were built in the 1880s by Prussian immigrants. In 1927, St. Paul's Slovak Lutheran congregation marched from the Immanuel Lutheran Church (the former Second Congregational Church) on West Street to its own building on Spring Street. The Immanuel Lutheran School was the first parochial school in Danbury.

THE UNITED METHODIST CHURCH, 162 MAIN STREET, 1960. Like its towered neighbor, the old Danbury City Hall, this building was torn down to make room for the new Danbury Library that was built in 1970. Circuit rider Jesse Lee visited Danbury in 1789 and the Methodist Society built a church on Franklin Street in 1809. In 1970, the Methodists moved from their temporary home in a synagogue on Main Street to Clapboard Ridge.

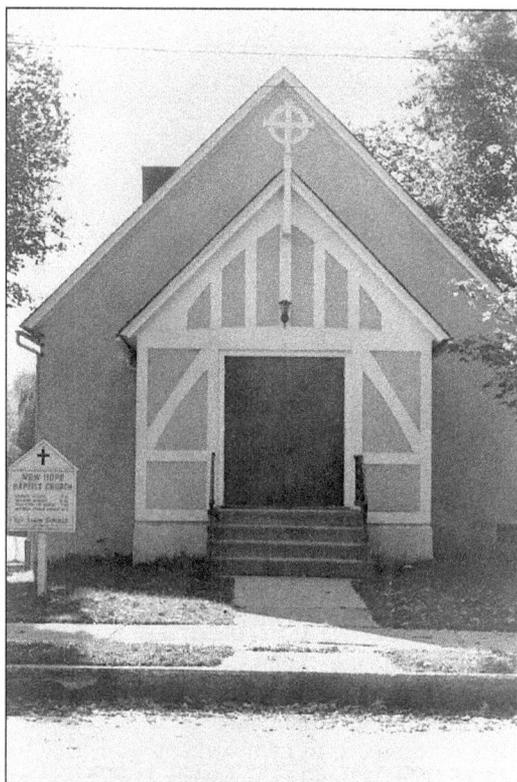

THE NEW HOPE BAPTIST CHURCH, CHERRY STREET. Organized in 1895, the New Hope Baptist Church was built on Cherry Street in 1924. The second church built by blacks in Danbury, it was convenient to the small African American community living in the William Street area. In 1908, the Mount Pleasant African Methodist Episcopal Zion Church was built on Rowan Street.

THE UNIVERSALIST CHURCH ON LIBERTY STREET, C. 1870. The Universalists worshiped on Liberty Street from the 1850s until 1893, when they dedicated a church at 347 Main Street. The Main Street church was torn down in 1975. The society, formed in 1822, moved to Redding in the 1960s.

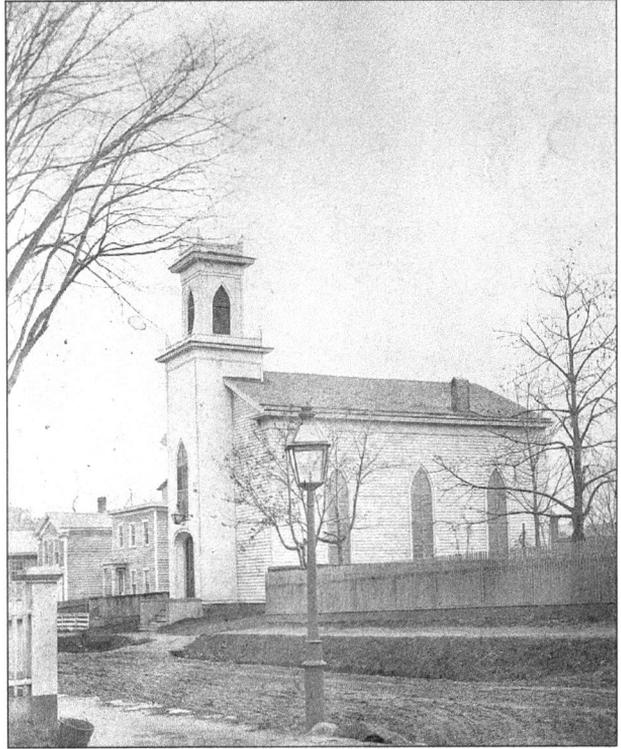

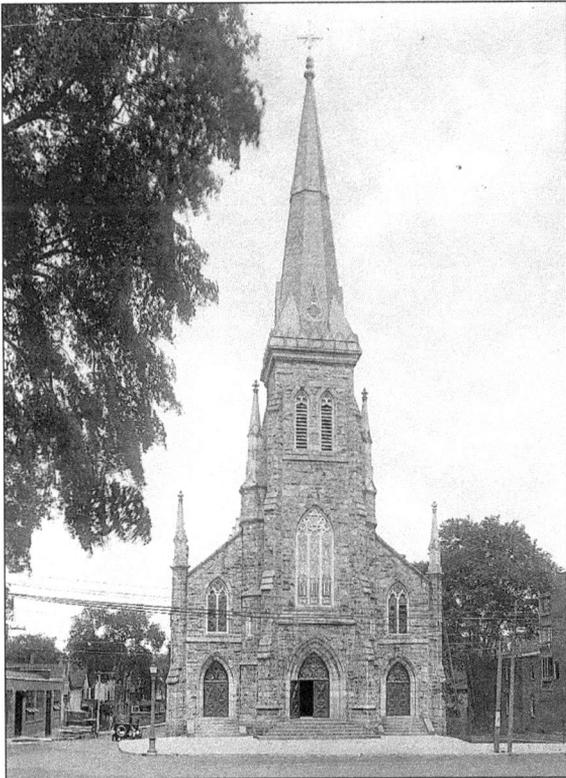

ST. PETER'S CHURCH, 115 MAIN STREET, C. 1925. The parish of St. Peter bought the former Universalist Church at Main and Wooster Streets in 1851. The Catholic Church's beginnings in Danbury go back to the early 19th century, when the first Mass was said in the Grassy Plain area. The first Catholic church in the area, the building at Main and Center Streets, was dedicated in 1875, and the school opened in 1885. Masses in Portuguese were offered at the church from 1969 until 1982 and again in the 1990s for the Brazilian community.

27

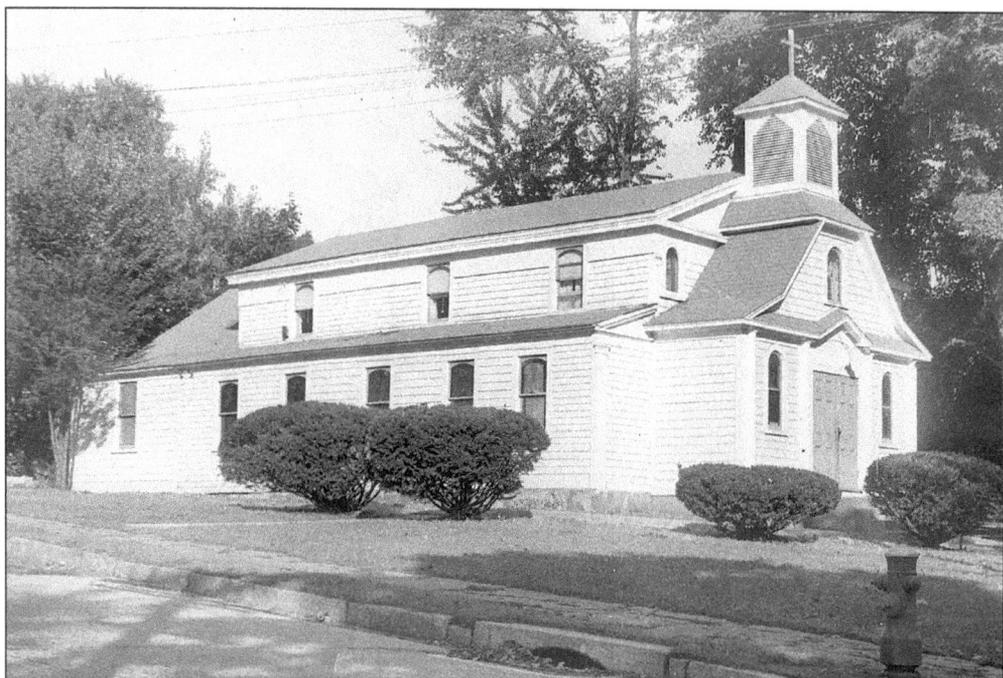

ST. ANTHONY'S MARONITE CHURCH, GRANVILLE AVENUE. St. Anthony's Church originated in 1932 on New Street, a short distance from Oil Mill Road, where William Buzaid opened the first Lebanese-owned fur shop in 1910. Syrians and Lebanese also worked in the hat shops in the Beaver Street area. The largest of the Arabic churches in Danbury, St. Anthony's moved into this new, larger building in 1958.

THE CENTRAL CHRISTIAN CHURCH, 71 WEST STREET (DEDICATED 1936). The first meetinghouse for the Disciples of Christ was on the site now occupied by the train station built in 1903 on White Street. The fifth Protestant denomination in the United States, the Danbury flock was an offshoot of the New Danbury Church, a group who separated from the Congregational Church in 1770. They were called Osbornites after newspaperman Levi Osborne.

Two

. . . And These Are the People

*Hard workers as were the men and women there, sharp, too at a bargain as they were,
and eager to get gain, no one with much knowledge of them but would soon discover that
in their thoughts and questions the next world has no less prominence than this.*
—Julius Seeley of Bethel commenting on Danbury residents

Danbury's population increased by 1,000 between the first census in 1756 and the second in 1774. When the count was taken in 1790, the town had increased by only 500. (This number included 20 "free" blacks. Danbury's black population was quite small until after World War II.) More than 100 people had died during an epidemic in 1775, and some Tory residents who fled Danbury were not welcomed back home after the American Revolution. In the early part of the 19th century, several inhabitants migrated to the Sandusky area of Ohio after being awarded land for property lost during the war.

Danbury's reputation as "Hat City" was developing, and its hat shops soon became filled with the increasing numbers of immigrants from Ireland and Germany in the 1850s. As Italians, Swedes, and Poles were added to the mix in the late 19th century, the population—18 percent of which was foreign born—boomed in the 1880s, adding almost 1,000 people to the count every year for nine years.

By 1910, almost one quarter of Danbury was foreign born, with the addition of Slavs, Syrians, and Lebanese. The Liberty Street area is home to the oldest Portuguese club in Connecticut, founded in 1924, shortly after several Portuguese workers came to Danbury from Massachusetts. Greeks and Chinese came to Danbury in the first half of the 20th century, and the 1970s saw an influx of Asian and Hispanic immigrants. Brazilians arriving near the close of the 20th century have increased the number of dialects spoken at Danbury High School to more than 40.

CHARLES RIDER. Charles Rider was the great-grandson of John Rider, who built the 1785 Rider House on Main Street. Charles Rider married Estelle Pulling, raised a family, and operated Rider Dairy in Danbury. By the time of his death, his business was thriving and had become a family affair, with several members of the Rider family holding key positions.

THE JOHN AND MARY RIDER HOUSE, 43 MAIN STREET, C. 1950. The signature building for the Danbury Museum & Historical Society was built on property apportioned to the Benedict family in 1685. John Rider built a house here in 1785 for his family, who at the time consisted of his wife, Mary Jarvis, and son, John Rider Jr. The Riders had eight more children, among them William Rider, who also choose the carpentry profession.

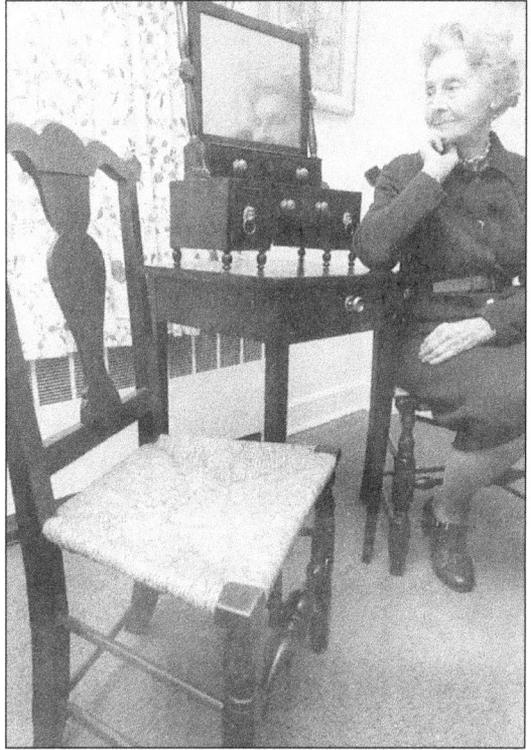

HELEN RIDER, C. 1975. The daughter of Charles Rider gazes at the 19th-century mahogany shaving stand made by her great-great-grandfather John Rider. Her ancestor's home at 43 Main Street remained in the family until the 1920s and, in 1942, it became a museum. The shaving stand and other Rider furnishings are now a part of the museum's collection.

ALBERT WADSWORTH MESERVE. The Danbury Museum & Historical Society has benefited substantially from the Meserve Memorial Fund. Since its establishment in 1983, the organization has awarded grants to nonprofit agencies that service the Danbury area. Albert Wadsworth Meserve, an arborist, was president of the Danbury (Scott-Fanton) Museum & Historical Society in the late 1950s. Students interested in furthering their careers in forestry and horticulture have taken advantage of the Albert Wadsworth and Helen Clark Meserve Memorial Trust Fund Scholarship.

31

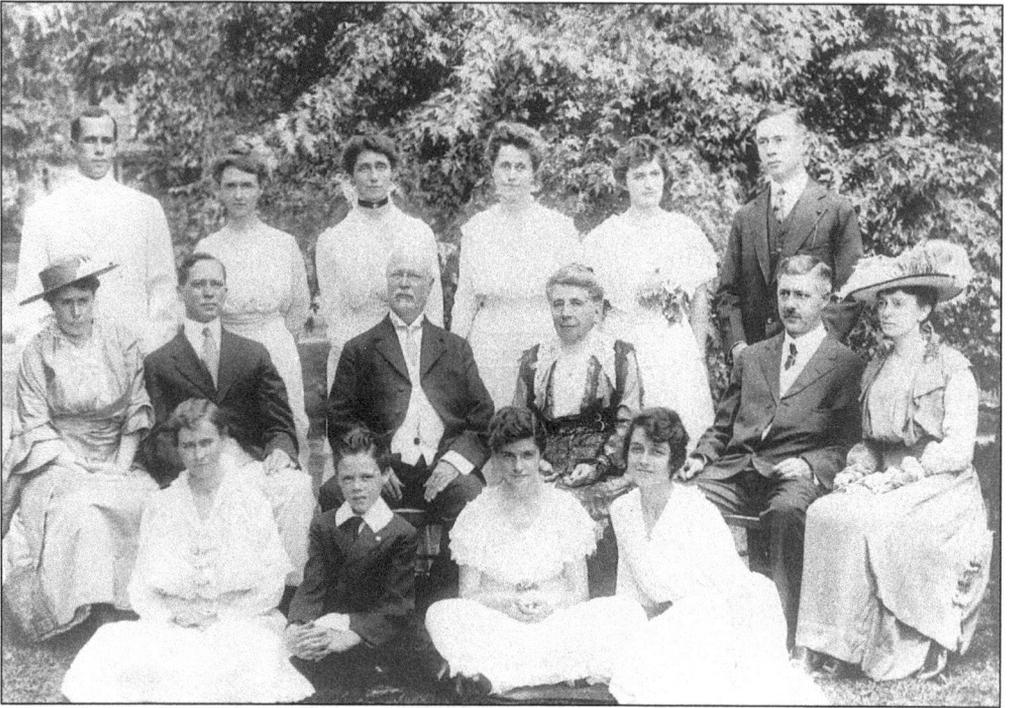

CHARLES HART MERRITT FAMILY PORTRAIT. At the family homestead at 350 Main Street are, from left to right, the following: (front row) Miss Merritt, Charles Merritt III, Luana Hooper, and Elizabeth Hooper; (middle row) Mrs. Charles Merritt Jr., Charles Merritt Jr., Charles Hart Merritt, Mrs. Charles Hart Merritt, George Merritt, and Mrs. George Merritt; (back row) Walter Gordon Merritt, Isabel Merritt, Mary Merritt, Ann Merritt, Mrs. Nelson Merritt, and Nelson Merritt. Charles Merritt was a hat manufacturer and an organizer of the American Anti-Boycott Association.

BEN LYNES ,1895, 43 YEARS OLD. The Lynes real estate holdings in Danbury were substantial. Ben's Lynes's father, Benjamin Lynes, owned the land where the Danbury Fair Mall is located and was a founder of Pleasure Park and the Danbury Agricultural Society. Barden's, Lee Farms Corporate Park, Pleasant Street, Southern Boulevard, and Wooster Heights in southern Danbury were also a part of the Lynes acreage.

Elizabeth Lynes Stevens, c. 1902. In 1902, Elizabeth Lynes, daughter of Ben Lynes of 75 Park Avenue, married Charles Stevens, an insurance agent and president of the Danbury Industrial Corporation. She was a member of the Daughters of Cincinnati, and part of her property was sold for the B'nai Israel Synagogue and Linron Apartments.

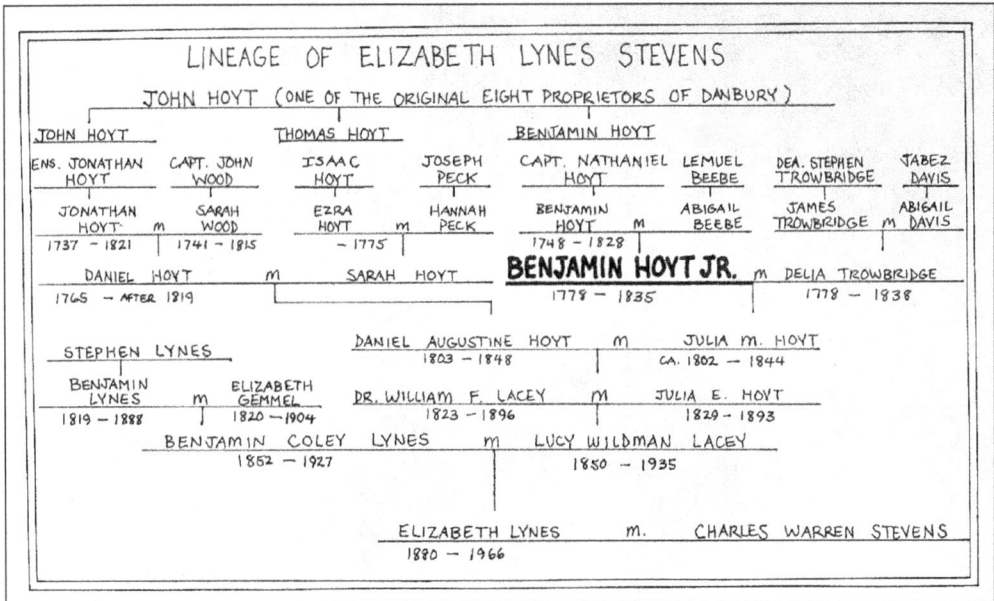

LINEAGE OF ELIZABETH LYNES STEVENS

JOHN HOYT (ONE OF THE ORIGINAL EIGHT PROPRIETORS OF DANBURY)

JOHN HOYT		THOMAS HOYT		BENJAMIN HOYT				
ENS. JONATHAN HOYT	CAPT. JOHN WOOD	ISAAC HOYT	JOSEPH PECK	CAPT. NATHANIEL HOYT	LEMUEL BEEBE	DEA. STEPHEN TROWBRIDGE	JABEZ DAVIS	
JONATHAN HOYT	SARAH WOOD	EZRA HOYT	HANNAH PECK	BENJAMIN HOYT	ABIGAIL BEEBE	JAMES TROWBRIDGE	ABIGAIL DAVIS	
1737 – 1821	m 1741 – 1815	– 1775	m	1748 – 1828	m		m	

DANIEL HOYT m SARAH HOYT **BENJAMIN HOYT JR.** m DELIA TROWBRIDGE
1765 – AFTER 1819 1778 – 1835 1778 – 1838

DANIEL AUGUSTINE HOYT m JULIA M. HOYT
1803 – 1848 CA. 1802 – 1844

STEPHEN LYNES

BENJAMIN LYNES	m	ELIZABETH GEMMEL	DR. WILLIAM F. LACEY	m	JULIA E. HOYT
1819 – 1888		1820 – 1904	1823 – 1896		1829 – 1893

BENJAMIN COLEY LYNES m LUCY WILDMAN LACEY
1852 – 1927 1850 – 1935

ELIZABETH LYNES m. CHARLES WARREN STEVENS
1880 – 1966

Elizabeth Lynes Stevens's Family Tree. This genealogical chart was prepared for the publication of *Benj. Hoyt's Book: An Original 1830 Manuscript*, issued by the Danbury Scott-Fanton Museum and Historical Society in 1977. Benjamin Hoyt was born in 1778 and wrote his memoirs when he was 50. The diary was found under floorboards in the attic just prior to the demolition of the Lynes-Stevens family home.

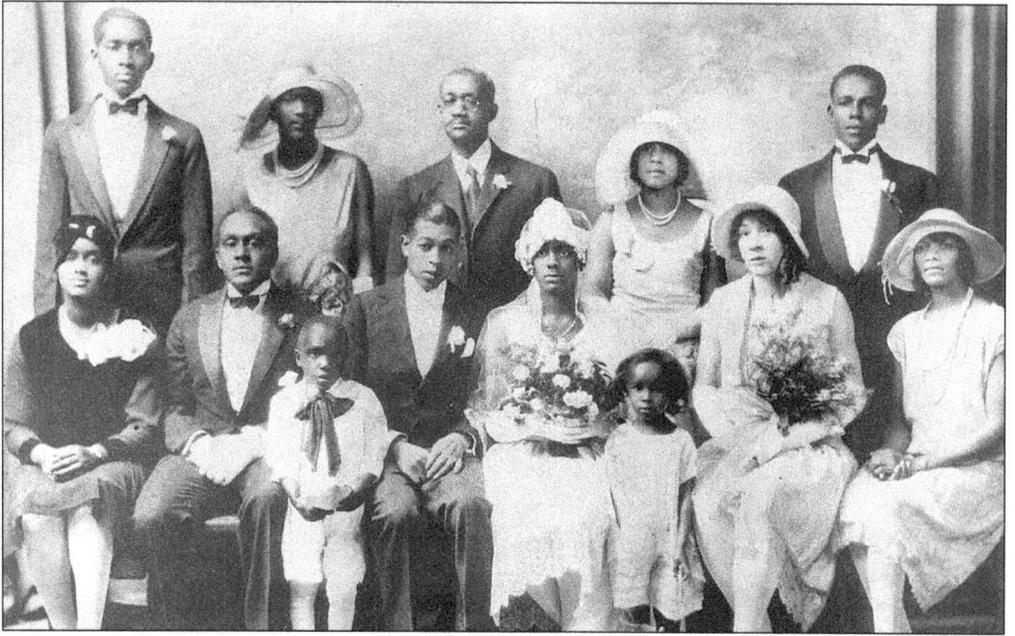

THE WEDDING OF PAUL BENSON TALLMAN SR. TO PAULINE ELIZABETH KEARNEY, SEPTEMBER 28, 1928. Pauline Kearney and Paul Tallman were married on a Friday, not unusual at the time; since most guests did not have to travel far, weddings were common every day of the week. The Kearney family purchased land near West Wooster and Division Streets, providing affordable housing for the black community.

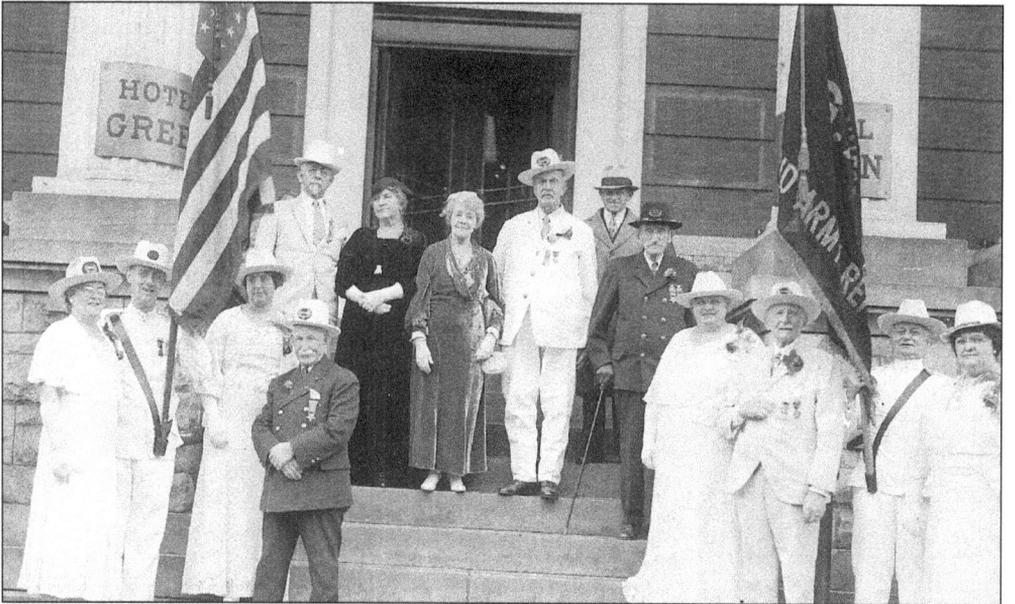

THE WEDDING OF COL. IRA WILDMAN. When 85-year-old Ira Wildman married Ella C. Bond of Oshkosh, Wisconsin, on February 15, 1935, the wedding ceremony made national news. Danbury's last surviving member of the Grand Army of the Republic, Wildman was assigned to the Fifth Michigan Cavalry just a month shy of his 15th birthday. He played a vital part in achieving a reconciliation with Confederate veterans.

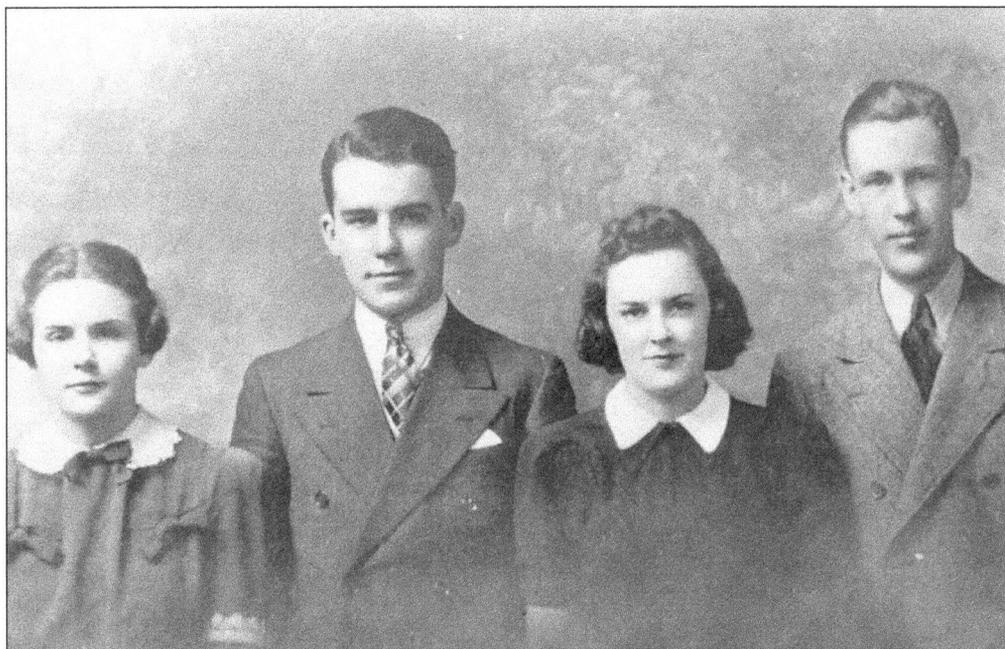

THE DANBURY HIGH SCHOOL CLASS OFFICERS, 1938. Class officers in 1938 are, from left to right, Mary Keating, John Durkin, Peg Cleary (McLeod), and Bob Costello.

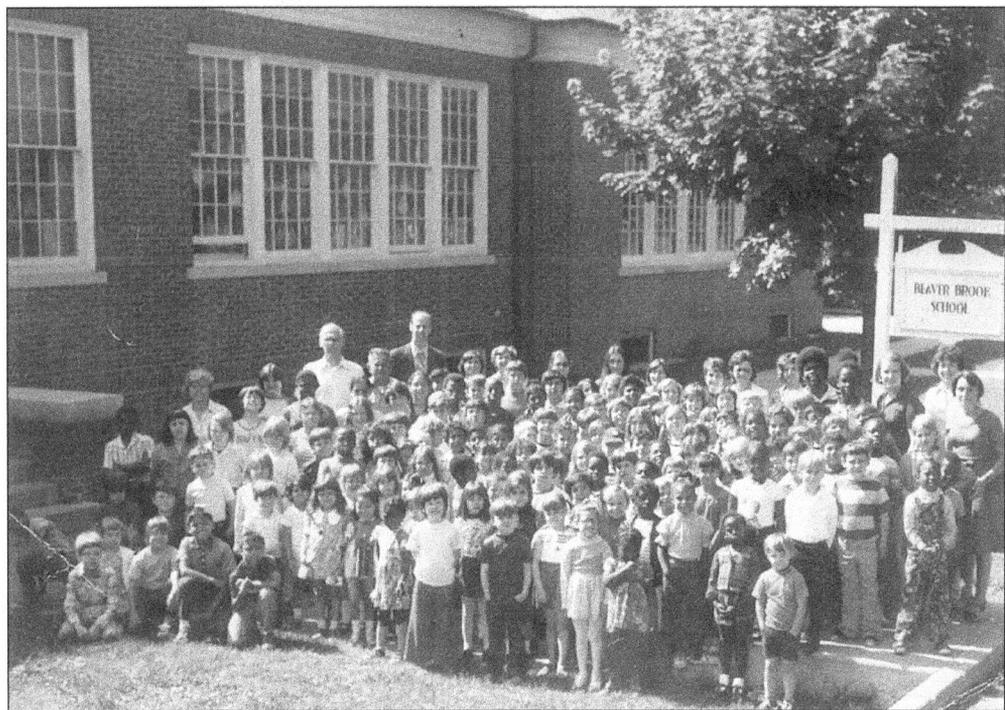

SCHOOL'S OUT—FOREVER. On June 14, 1977, Beaver Brook School, a Works Progress Administration project, held its last session of classes. The entire student body and staff pose next to the school that was built in the 1930s. The building currently houses administrative offices for the Danbury public school system.

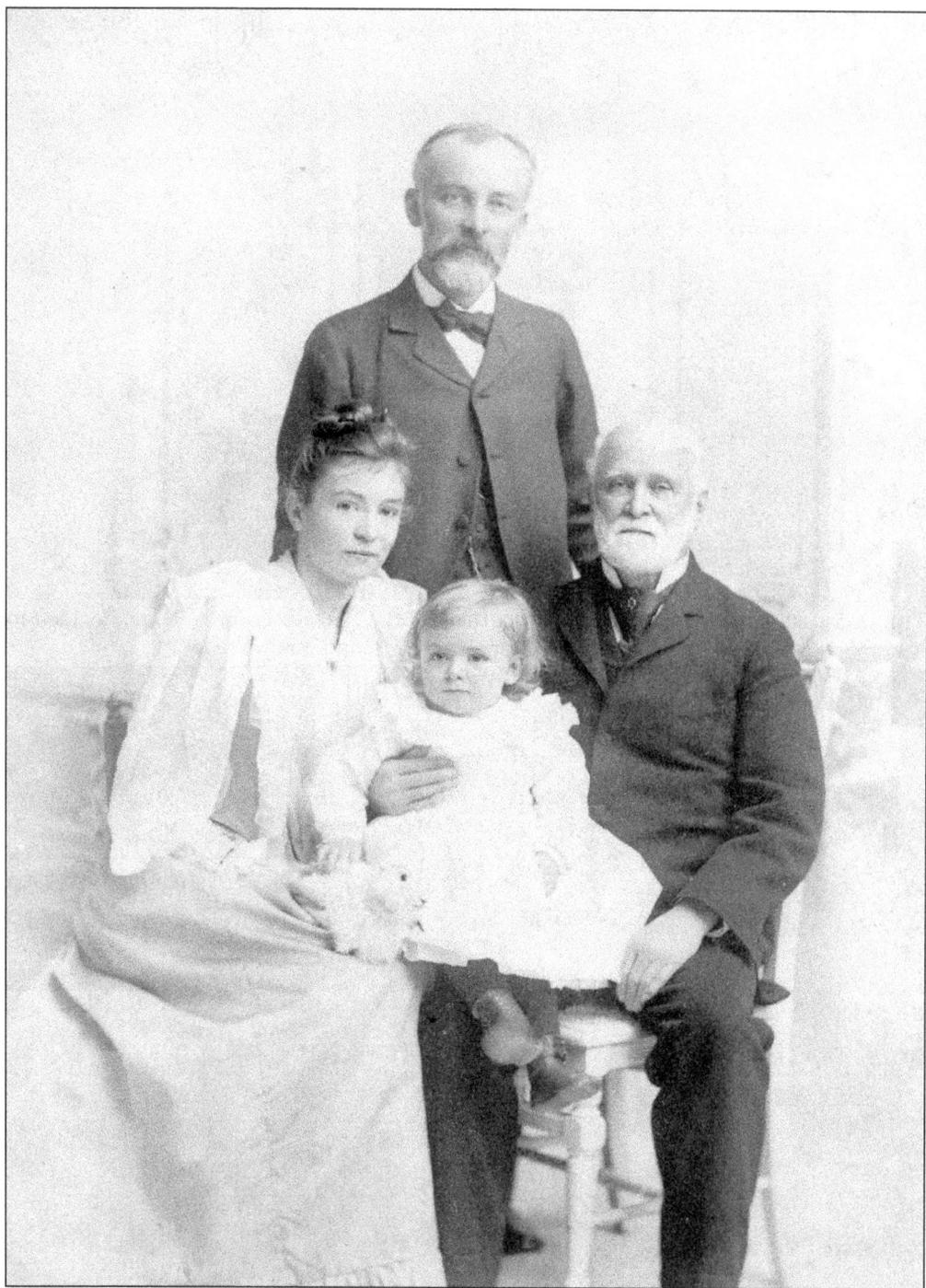

THE ALEXANDER WHITE FAMILY. Alexander Moss White (seated) and William August White (standing), sons of Ephraim Moss White, donated land and money and the family home for a library in Danbury. The home was used as the library until a new building was constructed in 1879. E. Moss White started a fur-cutting business on Beaver Street in 1825. The business was handed down to his sons, and it grew to be the largest of its kind in the country.

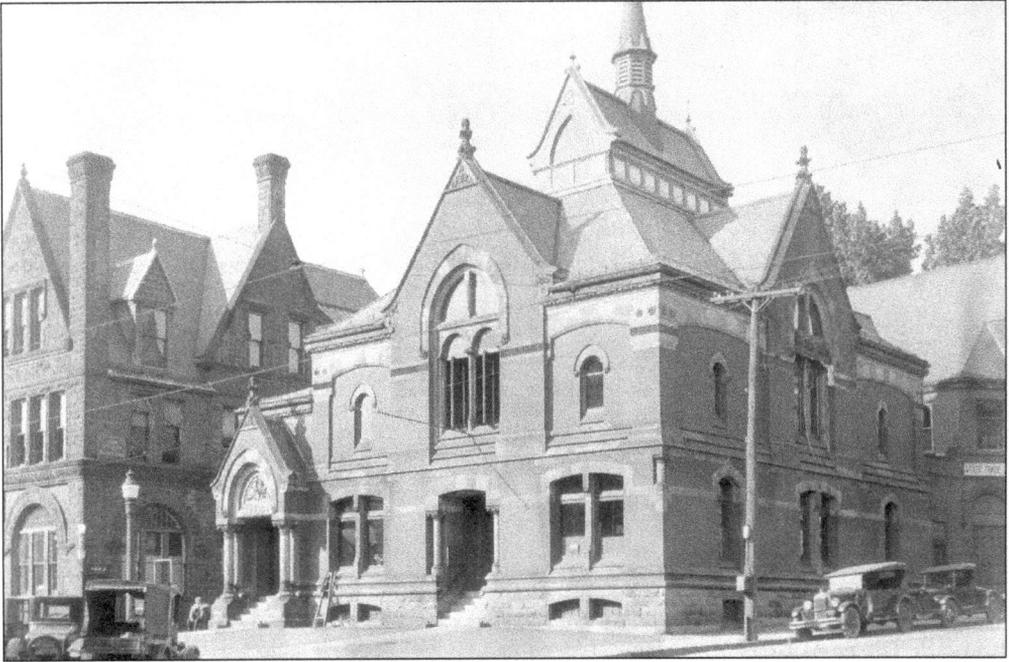

THE OLD DANBURY LIBRARY, 254 MAIN STREET, C. 1934. The first librarian for this building was Mary Elizabeth (Dickens) Taylor, a cousin of Charles Dickens. When it opened in 1879, the library occupied the second floor and businesses were located on the ground floor. In the 1930s, the children's department moved to the first floor and Bethel resident Charles Federer donated his talents by painting storybook murals that covered all four walls.

THE DANBURY MUSIC CENTRE. In 1935, Donald Tweedy founded the Danbury Music Centre. In 1970, after a new library was built at the corner of Main and West Streets, 254–256 Main Street housed several nonprofit agencies and municipal offices. In 1988, the Danbury Music Centre, after occupying several other Main Street addresses, moved into the high Victorian building where it resides today.

DANBURY MUSIC CENTRE

SEASON MARCH - SEPTEMBER 1935

SIXTH CONCERT

CONCORDIA HALL, WEDNESDAY, JUNE 5, 1935
AT 8:30 P. M.

ALPHA GLEE CLUB OF DANBURY

SHERMAN J. KREUZBERG, DIRECTOR

assisted by

DONALD TWEEDY, Pianist

PROGRAM

I

Mariner's Hymn - - - -	*Robson*
Ave Maris Stella - - - -	*Grieg*
Fool that I am - - - -	*Thomas*
Song of the Jolly Roger - -	*Candish*

ALPHA GLEE CLUB

II

Suite, "From Holberg's Time" (17th Century) *Grieg*
Prelude
Sarabande
Gavotte and Musette
Air
Gigue

MR. TWEEDY

III

Sea Fever - - - - -	*Andrews*
So Softly Sleeps My Love - -	*Hidalgo*
Passing By - - - -	*Purcell*
Song to Bohemia - - -	*Taylor*

THE GLEE CLUB

INTERMISSION

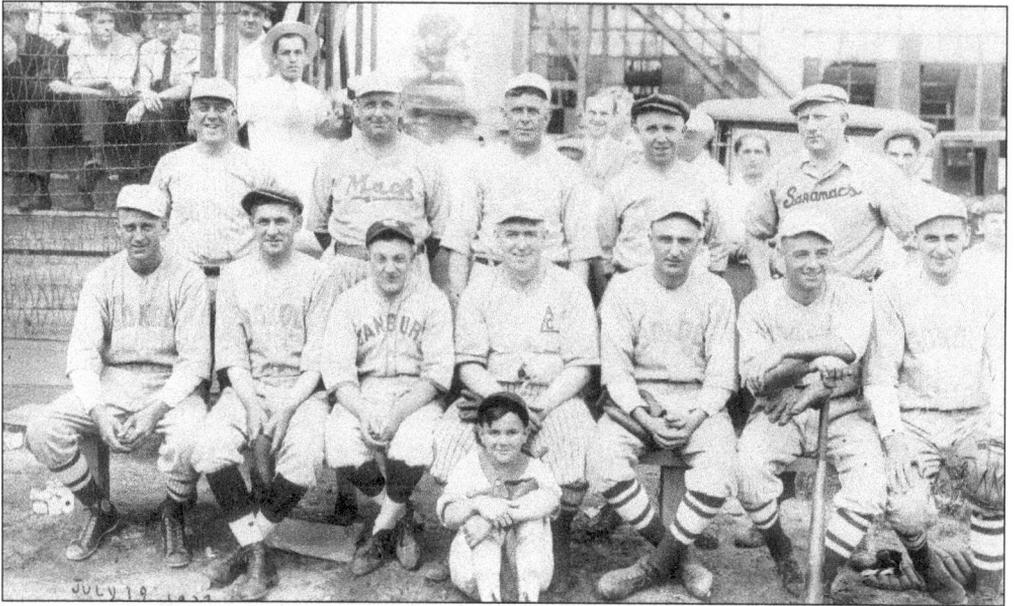

THE DANBURY PAID FIRE DEPARTMENT VS. THE DANBURY POLICE DEPARTMENT, JULY 19, 1927. At this benefit game played at Lee Field on Triangle Street are, from left to right, the following: (front row) John Torielli, Gus Mock, Fred Ellis, Danny Green, Charlie Koch, Emil Gantert, Tony Falvo, and bat boy Jim Feely; (back row) Mark McCarthy, Harry Anderson, Bill Fisher, John Ireland, and Frank Braunies.

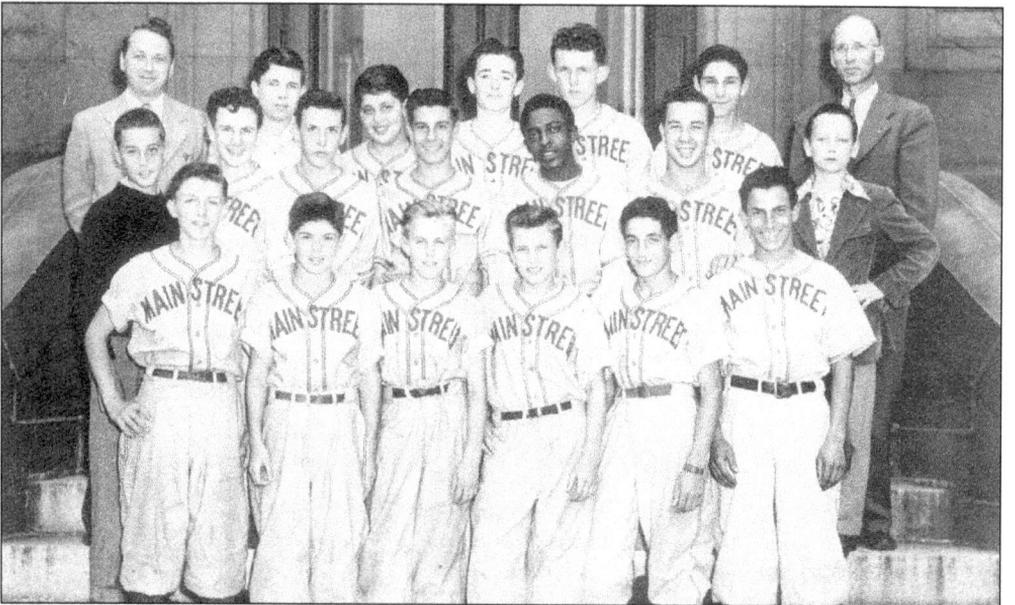

THE 1948 BASEBALL TEAM OF DANBURY'S MAIN STREET SCHOOL. Team members, from left to right, are as follows: (front row) David Wells, Jimmy Robinson, Clayton Haviland, Fred Janesky, Eddie Mitchell, and Benny De Fazio; (middle row) Clifford Russell, Gary Emerson, Jerry Smith, Neil Rudenstine, Joe Morton, "Pee Wee" Chauvin, and Mike Middleton; (back row) Mr. Haitch, Anthony Schirmer, Teddy Haddad, Clifford Mead, Donald Torcaso, Frank Ferrauiolo, and Claire Maginley, principal and coach.

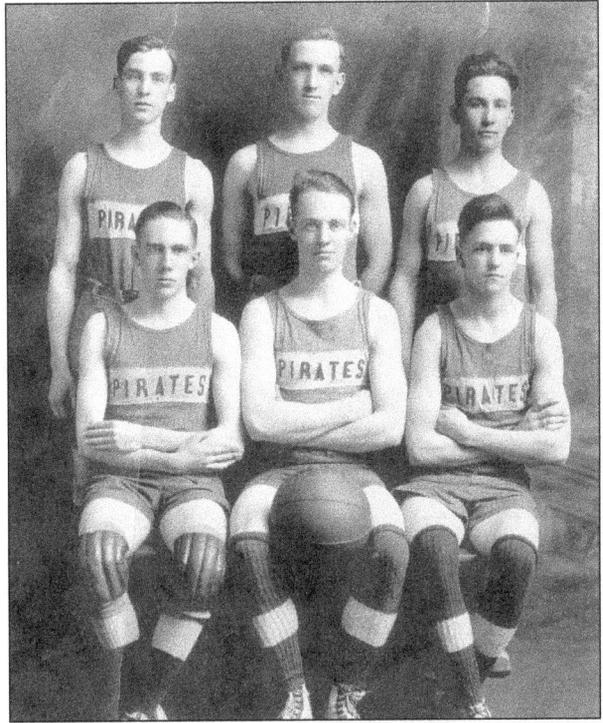

THE DANBURY PIRATES. This studio portrait of the Danbury Pirates basketball club was taken in 1921. Seated in the middle of the front row is C. LeGrand Benedict, grandson of Danbury Mayor L.L. Hopkins (1889–1891). Basketball continues to be a very popular sport in Danbury with many youth groups, parochial schools, and public schools competing at all age and skill levels across town.

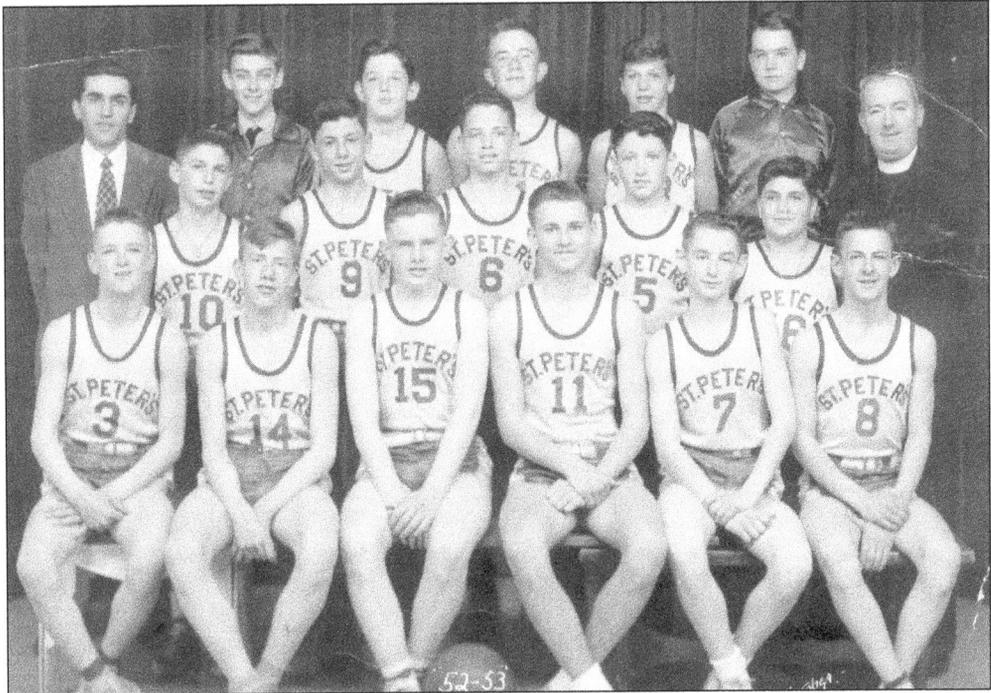

ST. PETER'S BASKETBALL TEAM. Members of the 1952–1953 basketball team from St. Peter's Grammar School smile proudly for this team photo. St. Peter's is the oldest Catholic parish in Danbury. The school, at 98 Main Street, was opened on September 6, 1886, and was filled to capacity with the 620 students who enrolled that first year.

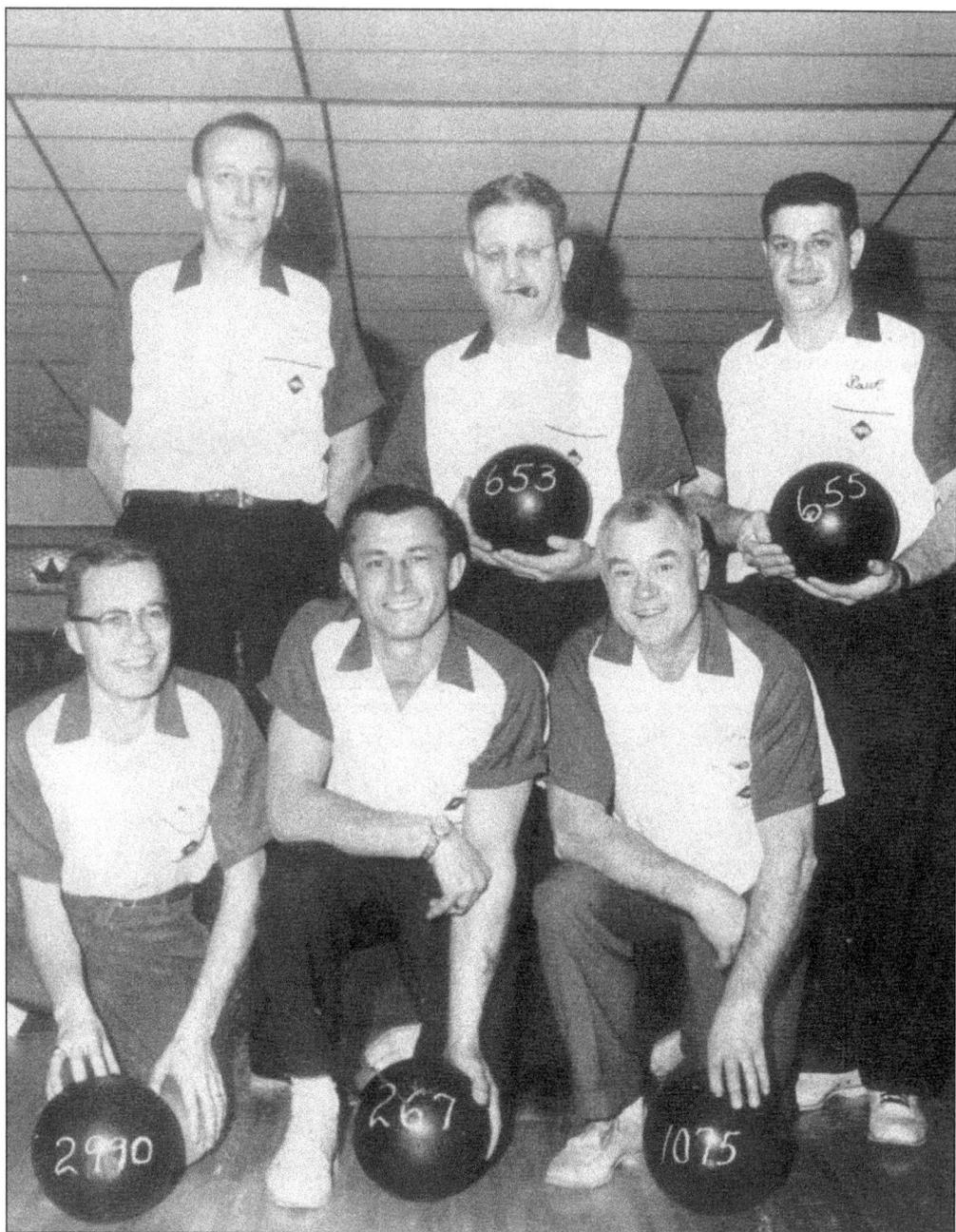

THE 1962–1963 DANBURY CITY TENPIN CHAMPIONS. Bowling champions, from left to right, are as follows: (front row) Jerrold Davis, Frank Eriquez, and Charles Smalley; (back row) Larry Heslin, Ben Doto, and Paul Doto Sr. Like the three B's in music (Bach, Brahms, and Beethoven), Danbury residents in the early part of the 20th century participated in and patronized three B's in sports: baseball, basketball, and boxing. After World War II, bowling was added to the list of the most popular sports in the area.

Three

WE BUILT THIS CITY

To-day the city of Danbury, thriving and growing, with its many thousand inhabitants,
its numerous streets, fine buildings and busy hum of industry, lies under the same blue sky that
smiled, two centuries ago, upon the eight new homes at the foot of the "open plain."
—James Montgomery Bailey, c. 1890

If the eight families from Norwalk who settled Danbury in 1684 had intended to build their homes in the center of town, they were not too far off. The oldest part of town is the section of Main Street between South and Wooster Streets. The geographical center is approximately where the old Danbury and Bethel Gas and Electric Company stood on Main Street. Main Street is situated between two ridges, making it a natural site for a village.

Main Street, Danbury's soul, has played a significant role in establishing the city's history of municipal government, commerce, culture, institutions, places of worship, and residences for its most prominent people. The focal point on Main Street, however, has not always been the same. Over the years, the following places have vied separately and simultaneously to be the center of attention: Main and Wooster Streets; Main, Liberty, and West Streets; and the intersection of Main, White, and Elm Streets.

Who owned what or what was where usually dictated which part of town received major improvements. Since most of the affairs of the town were run by the Congregational Church, established in 1696, the church building located near the old cemetery on Wooster Street was the town's first public meeting place.

Directly after the Revolutionary War, a new Congregational church was built at Main and West Streets and major activities gravitated north. The first train station, built in 1852, was constructed near the present-day post office, close to the residences of the railroad's major stockholders.

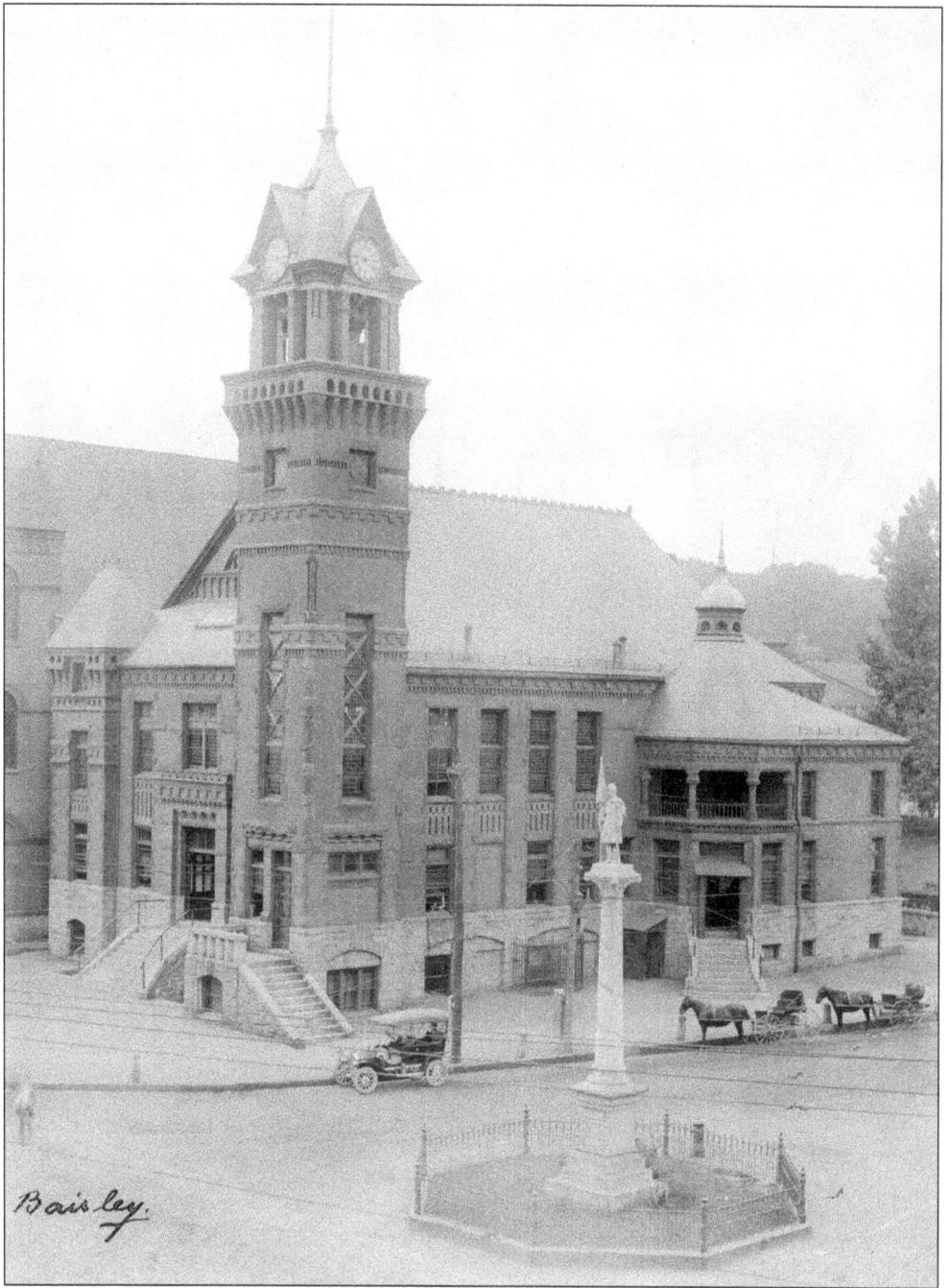

CITY HALL, MAIN AND WEST STREETS, C. 1905. After this building was erected in 1885, it was thought that it would not be long before the borough and town governments would be combined, due to Danbury's designation as a city. A self-governing municipality was a progressive trend near the end of the 19th century. Nevertheless, more than half a century passed before the consolidation of town and city in 1965. Five years after the merger, this building was torn down and the current Danbury City Hall was erected at the corner of Deer Hill Avenue and West Street.

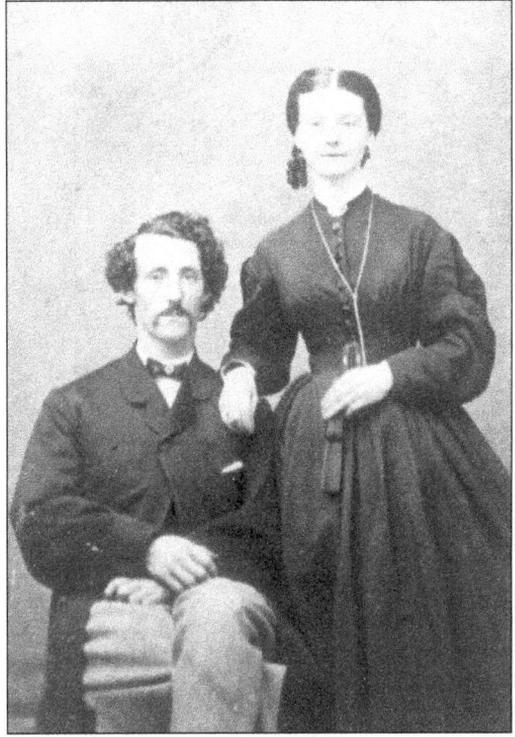

LOUIS LEGRAND HOPKINS AND GRACE CROAL HOPKINS, C. 1865. Danbury's first mayor was elected warden of the borough of Danbury in 1888, just prior to being voted the town's first highest ranking official. Only seven years earlier, he had lost everything in a fire at his property in New Fairfield. He moved to Danbury and was employed by the Danbury and Norwalk Railroad as a freight agent.

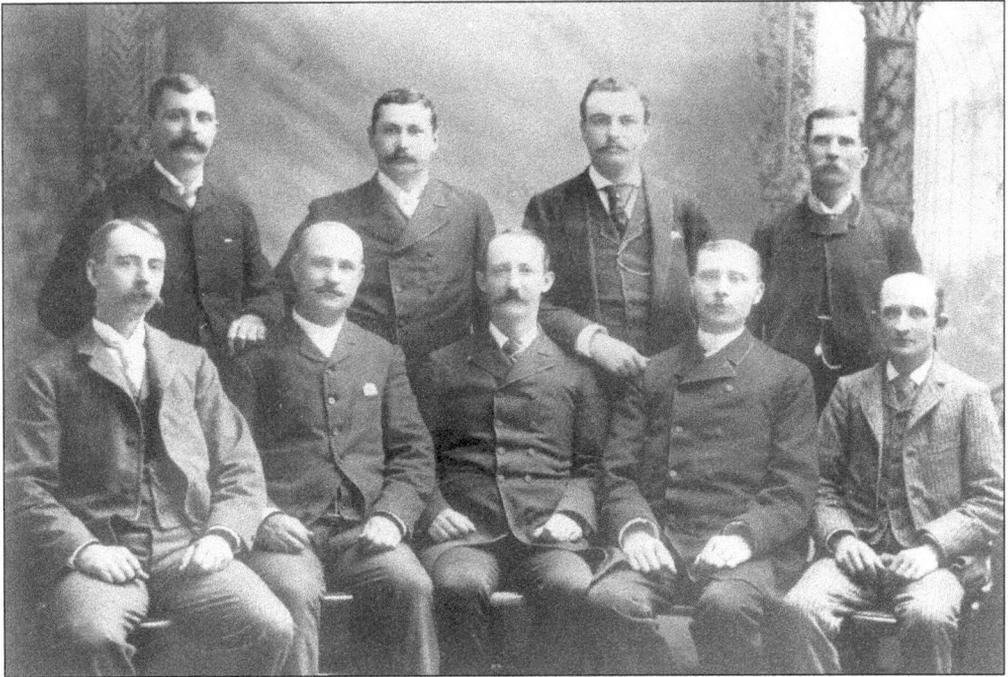

THE FIRST MAYOR OF DANBURY AND THE BOARD OF COUNCILMEN, 1889. The mayor and councilmen, from left to right, are as follows: (front row) Oscar H. Meeker, Charles L. Halstead, Mayor LeGrand Hopkins, Dietrich E. Loewe, and Caleb Purdy; (back row) Matthew W. Scott, Henry W. Hoyt, William McPhelemy, and George W. Taylor.

MARTIN J. CUNNINGHAM. A president of the Danbury Chamber of Commerce and an original director of the Danbury Industrial Corporation, Martin Cunningham was probate judge when elected mayor in 1937. As early as 1874, the Irish held political offices in Danbury or represented Danbury in the Connecticut Legislature. By the end of the 19th century, the Fourth Ward, which encompassed the parish of St. Peter, was synonymous with the Irish.

"GIVE 'EM HULL!" MEETS "THE FATHER OF CONSOLIDATION." J. Thayer Bowman (right) is sworn in as the first mayor of the consolidated city and town of Danbury on April 5, 1965, by state Sen. T. Clark Hull. Up until this time, the city borough's taxpayers had been supporting the growth that occurred on the outskirts of the town. Bowman, elected in 1961, was the last mayor of the old bicameral government.

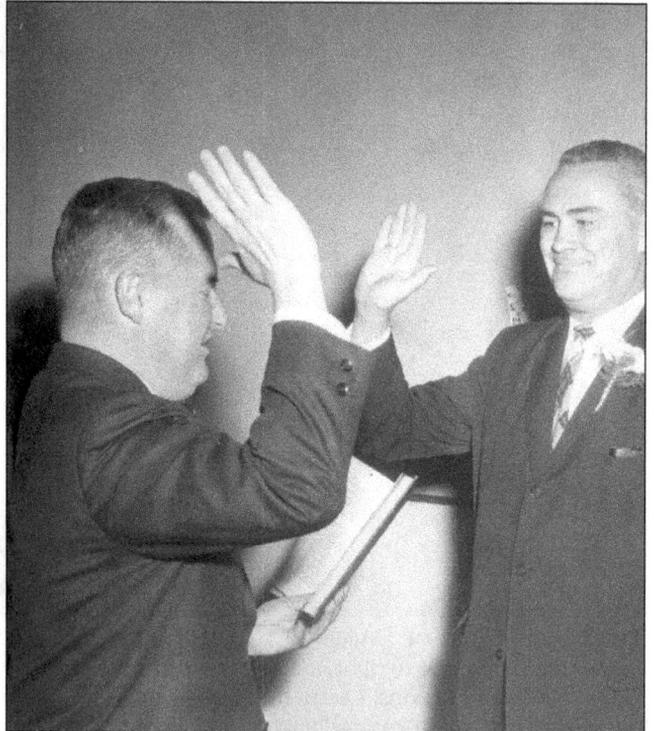

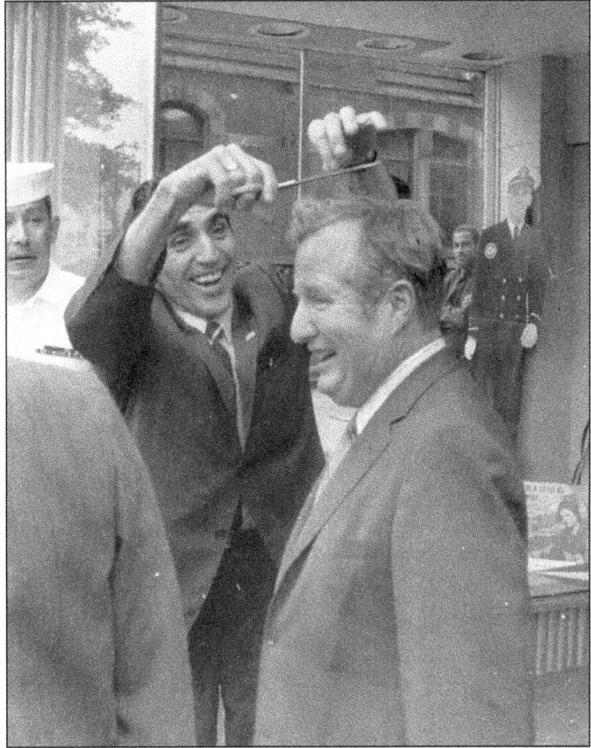

GINO ARCONTI AND T. CLARK HULL, JULY 3, 1970. Mayor Gino Arconti (left) grooms state Sen. T. Clark Hull for service in front of the U.S. Air Force Recruiting Office. The fourth Danbury mayor of Italian descent, Arconti was elected in 1967 and served three terms. Hull went on to become lieutenant governor under Thomas Meskill. He later served as superior court judge and state supreme court associate justice and on the state appellate court.

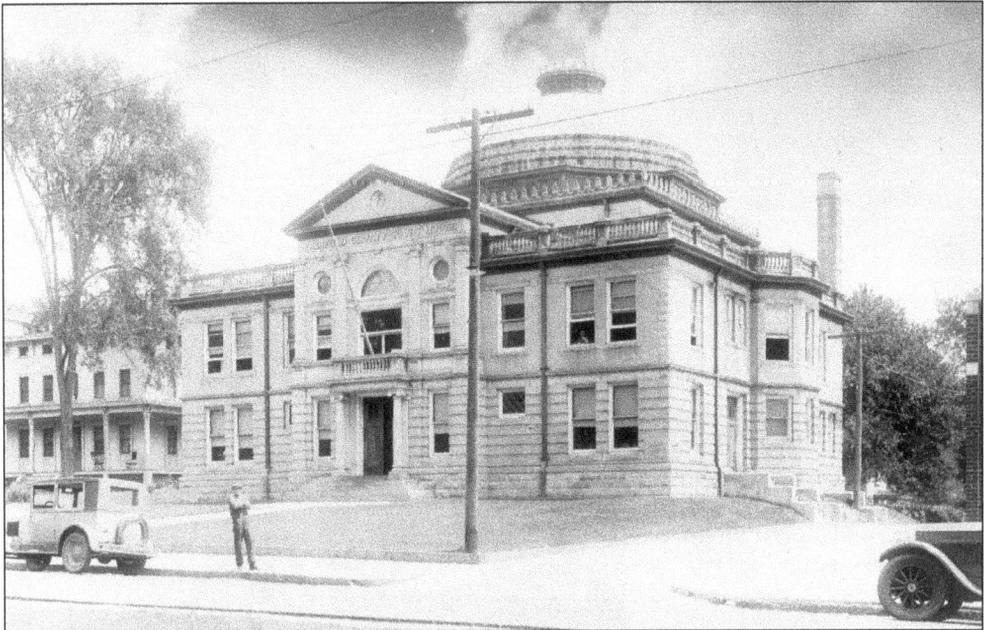

THE FAIRFIELD COUNTY COURT HOUSE, BUILT IN 1899. Situated across the street from the Old Jail (page 23), this Greco-Roman style edifice was the third courthouse built in Danbury. The first was built in 1785 and the second, built in 1823, was moved to Elmwood Place on land owned by Mayor Charles Kerr. Juvenile court sessions are now held inside this copper-domed, buff brick and sandstone exterior.

A PROMINENT BUILDER AND A FUTURE MAYOR, C. 1899. Philip Sunderland (right) and his father, William Webb Sunderland, constructed "Stormfield" in Redding for Mark Twain. The renowned author was a good friend of the Rev. Joseph Twichell, whose daughter Harmony married composer Charles Ives. Anthony "Tone" Sunderland (left), Philip Sunderland's brother, was Danbury's youngest mayor when he was elected in 1913 and was the first to serve five full terms. He was vice president of the Settle Agency for more than 40 years.

THE DANBURY NEWS BUILDING, C. 1930. In 1873, Anthony and Philip Sunderland's father, William Webb Sunderland, built the first structure for a Danbury newspaper, at 288 Main Street. He and his son Philip remodeled and expanded the building in 1893—the son designing its distinctive tower. Philip Sunderland's son, named William Webb Sunderland for his grandfather, designed the current News-Times building at 333 Main Street.

46

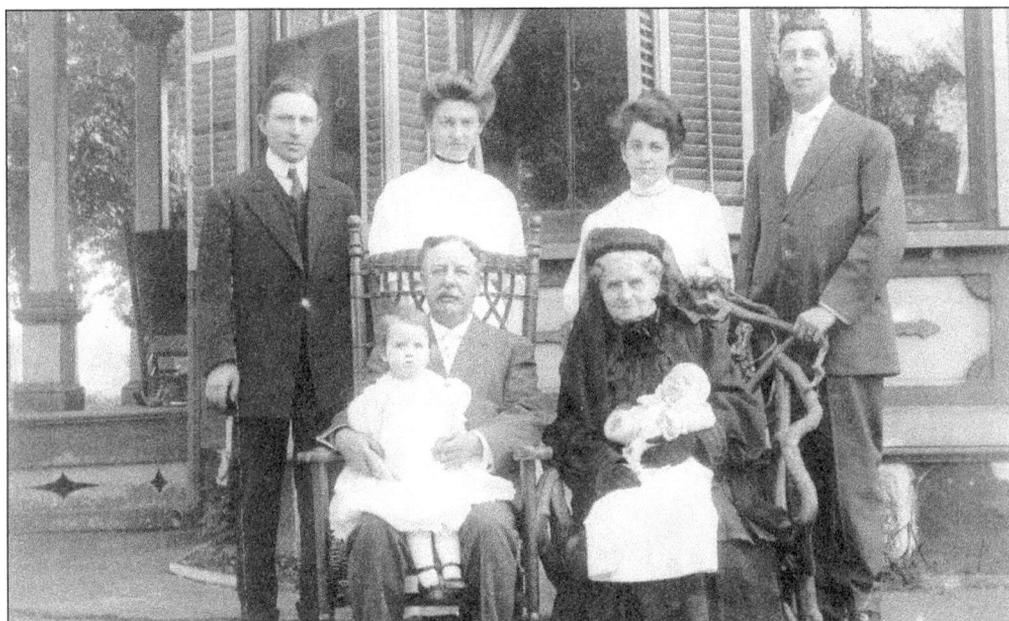

HATTERS AND A FUTURE PHOTOGRAPHER, 1908. Pictured, from left to right, are the following: (front row) Ella C. Loewe (Hooper), Charles Arthur Mallory, (Mrs. Ezra) Hannah Mallory, and Ruth Hart Mallory (Sunderland); back row: Harry B. Mallory, Mary Mallory, Clara Mallory Loewe, and Mathias Loewe. The future photographer is the youngest Mallory in this photograph (Ruth); the oldest member, Charles, was the grandson of Ezra Mallory, the founder of the Mallory Hat Company.

PARK AVENUE SCHOOL, PHOTOGRAPH BY RUTH MALLORY. Ruth Hart Mallory and William W. Sunderland were married on June 6, 1941. He designed Park Avenue School and 31 other area school buildings. She photographed several of her husband's buildings, as well as those of her father-in-law, Philip Sunderland. Although never listed in the city directories under photographers, she received an honorable mention in an *American Photography* magazine competition.

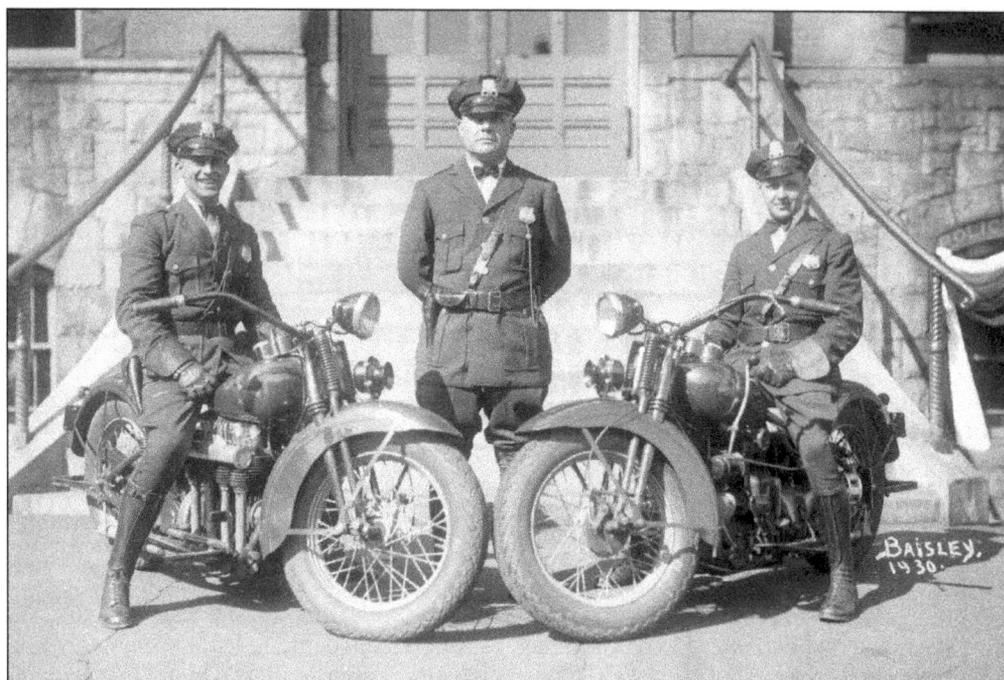

THE FIRST DANBURY POLICE MOTORCYCLE PATROL, 1930. Shown in front of Danbury City Hall at the corner of Main and West Streets, from left to right, are Frank Testa, Arthur Cahill, and Arnold Schulze. Ralph Gulliver was the first policeman to ride a motorcycle in the 1920s.

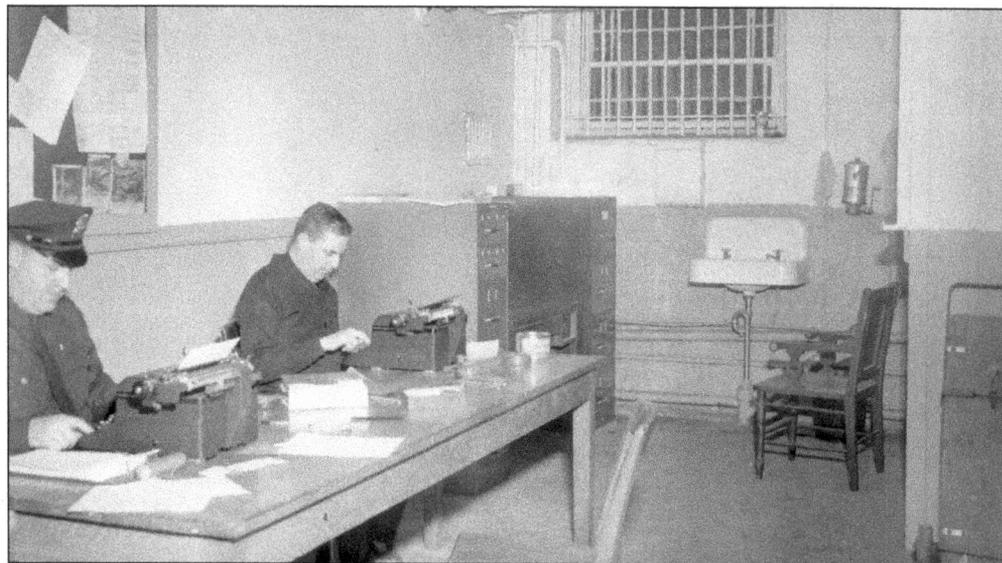

THE REPORT ROOM AT CITY HALL, MAIN AND WEST STREETS. In 1957, the *Danbury News-Times* reported on the overcrowded conditions at Danbury City Hall. However, the police department, organized since the 1880s, did not occupy a building of its own until the 1960s. The old high school at Main and Boughton Streets became available due to the construction of the new and current high school on Clapboard Ridge. Junior high school students who had occupied that first high school (on Main Street) moved to the second high school on White Street.

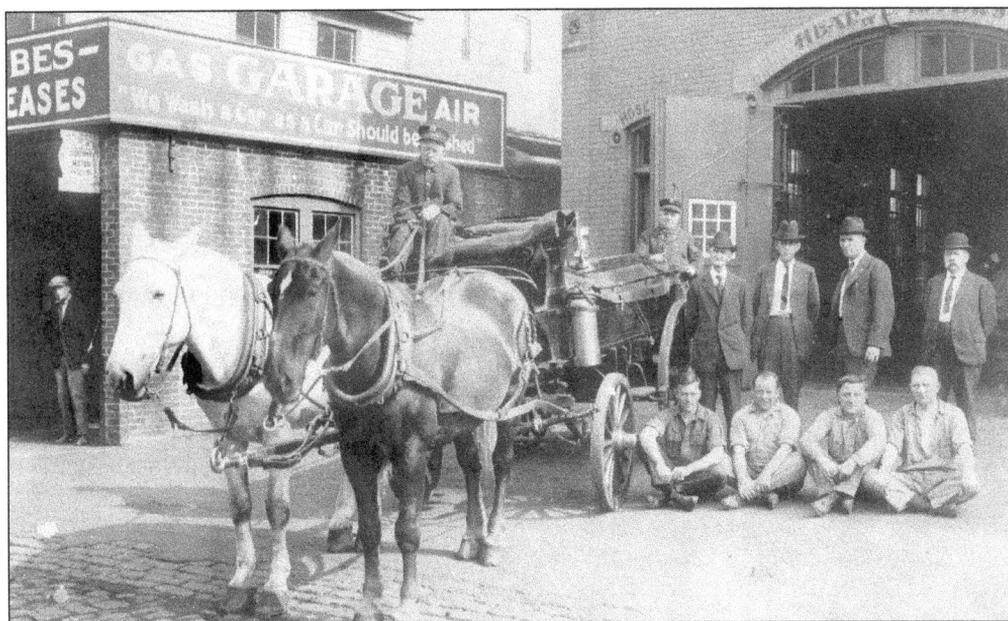

HOSE COMPANY NO. 2, IVES STREET HEADQUARTERS, 1920. Pictured, from left to right, are the following: driver Jim Hyatt; (sitting) John Torielli, Charles "Chubby" Ray, Henry Ireland, and Frank Braunies; (standing) Chief Peter Beckerle, Mayor William C. Gilbert, Leroy Jackson Sr., Thayer Bowman Sr., and Assistant Chief Richard Fitzsimmons. The last year horses were used by the fire department was 1920. The building was designed by William Webb Sunderland in 1883.

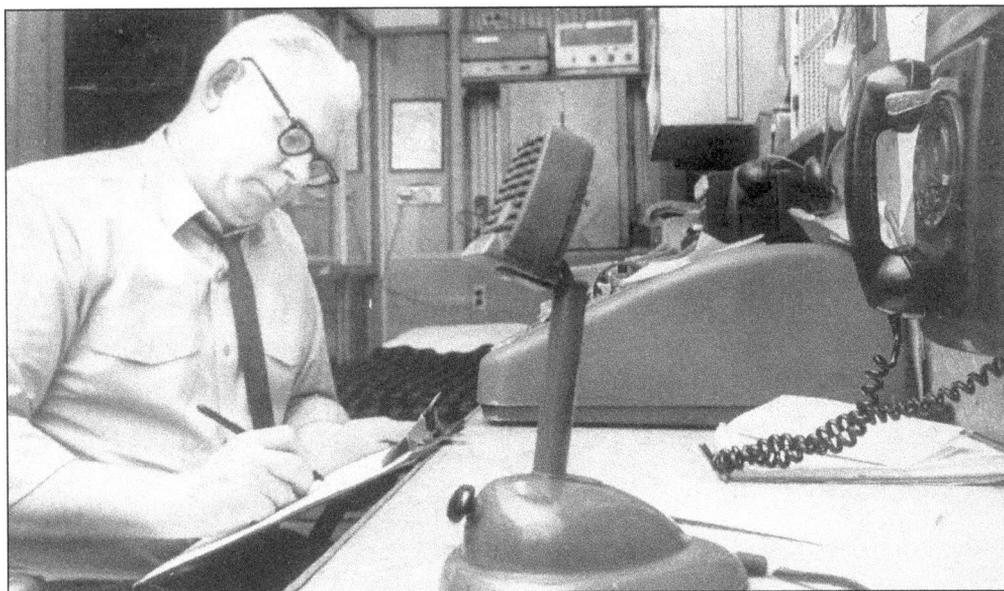

DONALD C. WOOD, FIRE DEPARTMENT DISPATCHER, IVES STREET HEADQUARTERS, 1968. The first reference to a fire department in Danbury was in the *Republican Journal* on November 11, 1783. In 1829, the first fire companies were organized. In 1969, the headquarters moved from Ives Street to the site of the New Street School. Donald Wood wrote a history of the department in 1970. He retired from the department in 1984 after 30 years of service.

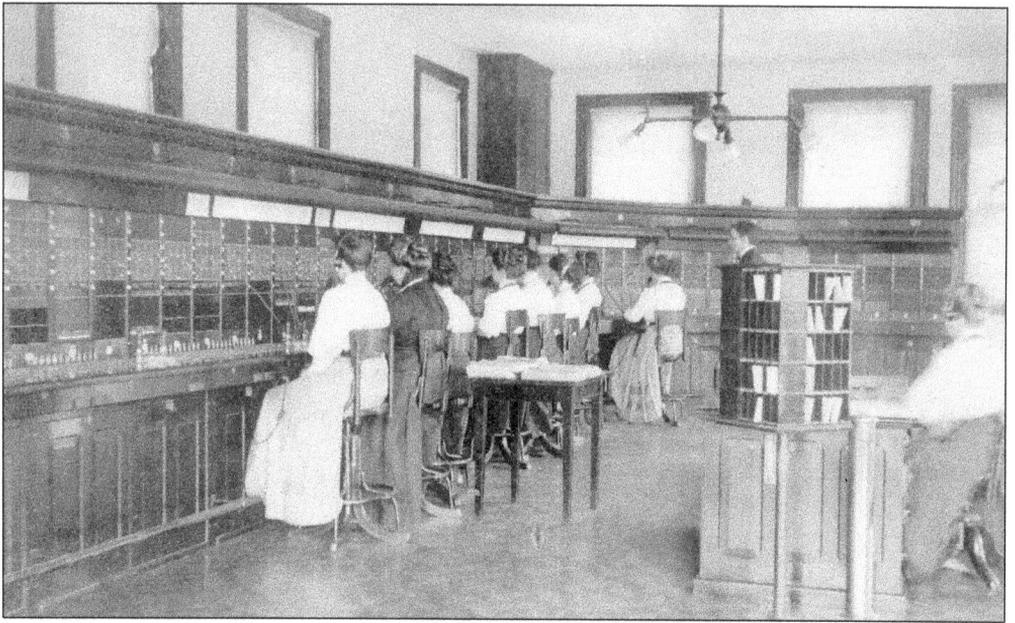

THE SOUTHERN NEW ENGLAND TELEPHONE COMPANY OPERATING ROOM. Clesson Allen supervises switchboard operators in 1908. Four years before this photograph was taken, Danbury's one-operator exchange was in the McPhelemy block at White and Bridge Streets. "The operator was not allowed to cross her legs. She was forbidden to blow her nose or wipe her brow without permission. Those who married were often discharged."

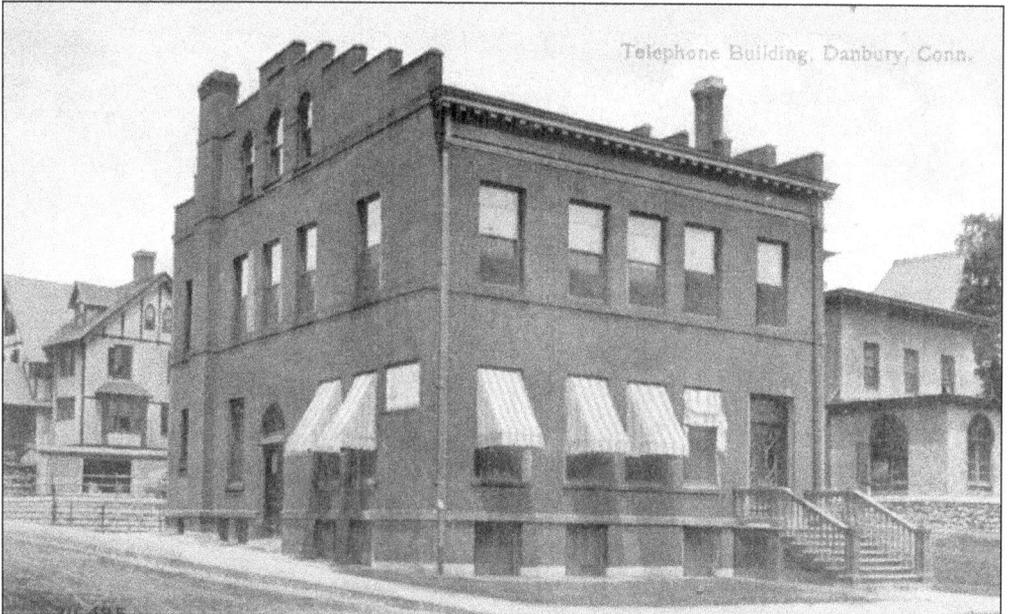

THE TELEPHONE COMPANY AT 31 WEST STREET. William Mallory started the nation's second telephone exchange in 1878 and founded the Danbury Telephone Dispatch Company at 277 Main Street. In 1883, Southern New England Telephone acquired the company and its 141 subscribers. This Dutch Colonial Revival building, erected in 1908, was the third location for the Danbury office of Southern New England Telephone.

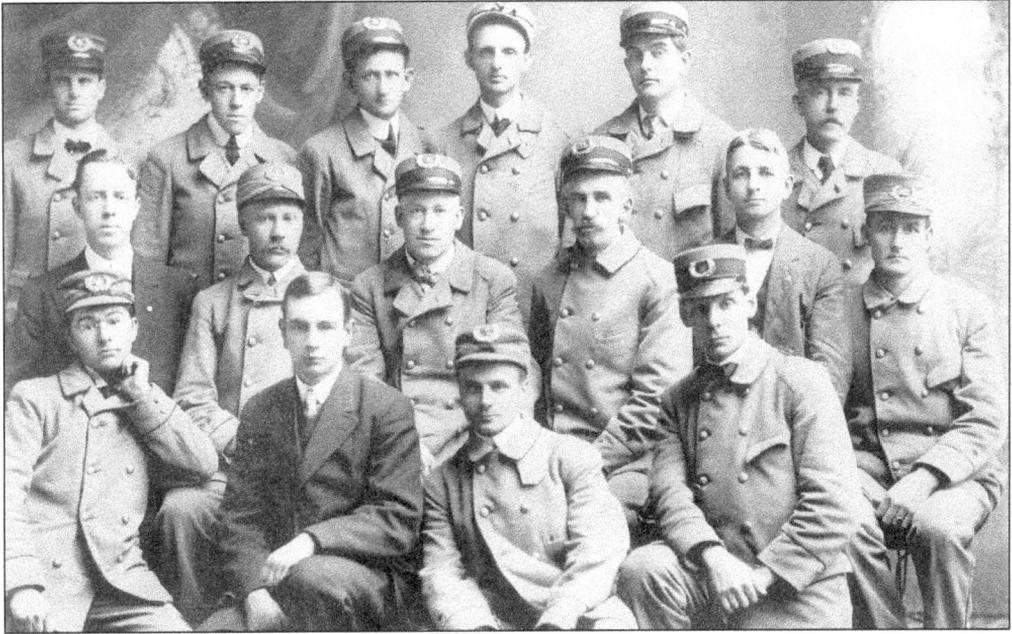

THE POST OFFICE DEPARTMENT, 1918. Postal personnel, from left to right, are as follows: (front row) William Hambidge, Frank Patrick, Ernest Stucky, George Oakley, and Sylvester Wixted; (middle row) Harry Rice, Phil Owen, S. Brimhall, Russell Lacey, and Louis Theurer; (back row) James Fuller, Charles Voegele, Thomas McClosky, Grant Silvernail, Thomas Everitt Banks, and James McPhelemy.

THE POST OFFICE AT 265 MAIN STREET. The train station relocated from this site to White Street in 1903. The neighboring railroad tracks made this location ideal for the construction of a new post office. The tracks, of course, expedited mail delivery; but first they facilitated the arrival of construction materials for the new building: limestone from Indiana, tapestry bricks from New York, steel from Pittsburgh, and marble wainscoting from Vermont.

DANBURY'S FIRST TRAIN STATION, MAIN AND POST OFFICE STREETS. The railroad came to Danbury 12 years after it arrived in New Milford in 1840. Nevertheless, in the second half of the 19th century, the town once again became a transportation center, with several lines connecting and intersecting the Danbury & Norwalk Railroad here. Stockholders David M. Benedict, Ephraim Gregory, Eli T. Hoyt, George White Ives, and Edgar S. Tweedy struggled to have the depot built in this central location (page 91).

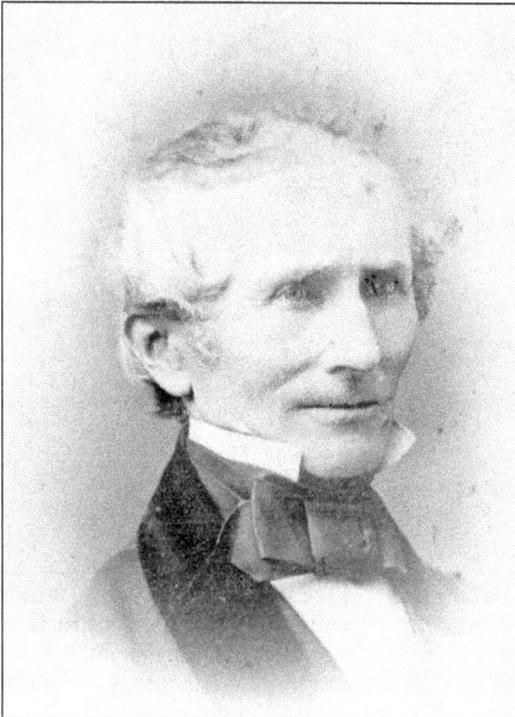

GEORGE WHITE IVES. Having helped to bring the railroad to Danbury, George White Ives decided to move the Savings Bank of Danbury out of his house and into its own building next door in 1852. Two years earlier Ives had planned Wooster Cemetery and in 1857, he became an incorporator of the Danbury Gas Company. He died before the birth of his grandchild, Danbury's most famous son, composer Charles Edward Ives.

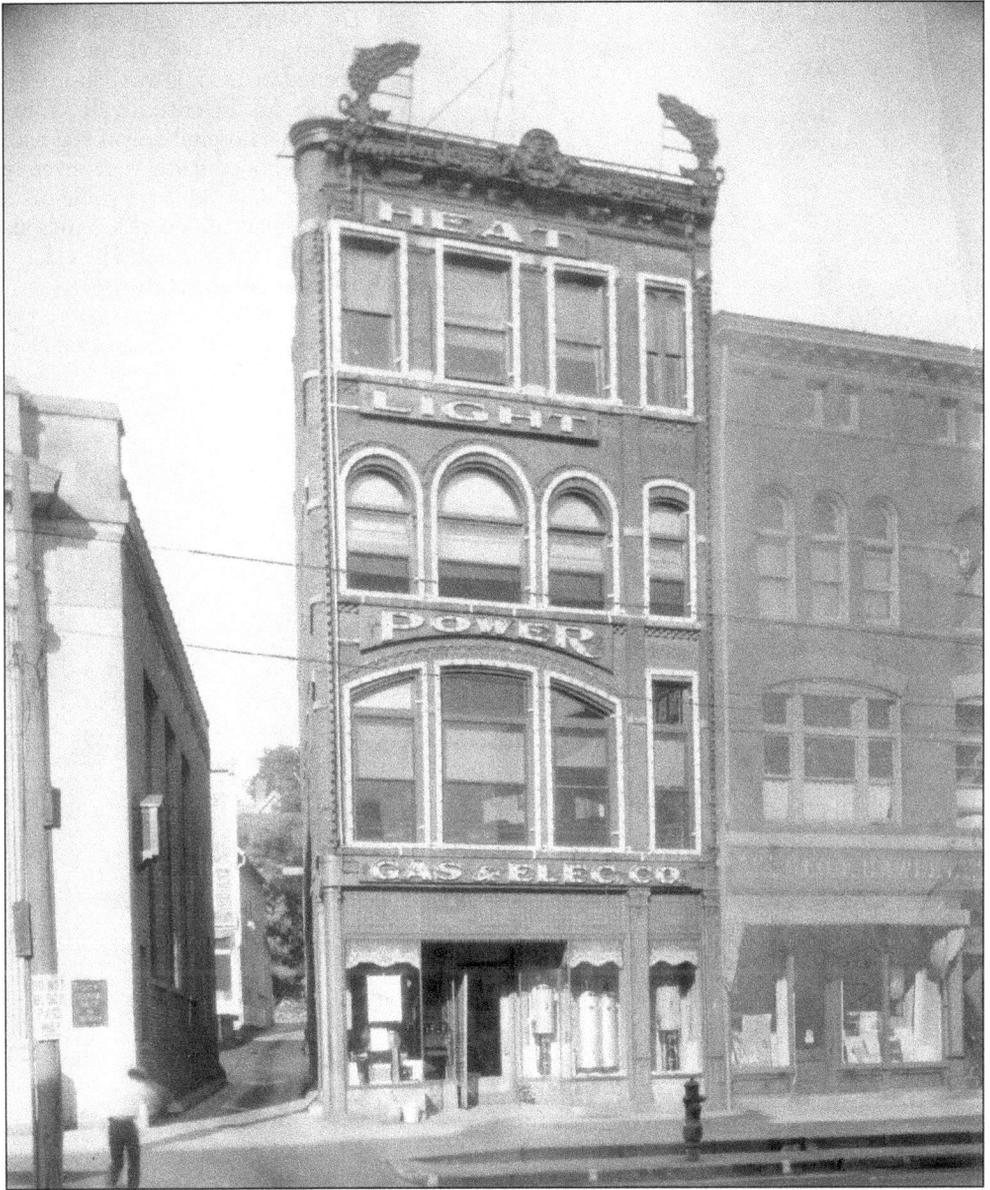

THE GAS AND ELECTRIC COMPANY BUILDING, 238 MAIN STREET. The Danbury Gas-Light Company was incorporated in 1854 and went into operation in 1857 at the Danbury and Norwalk Railroad Depot. In 1913, the Danbury and Bethel Gas and Electric Company purchased this building and electrified its exterior. Built in 1891 by Danbury designer Joel Foster, the terra-cotta Victorian was sold to the Zuccas in 1965.

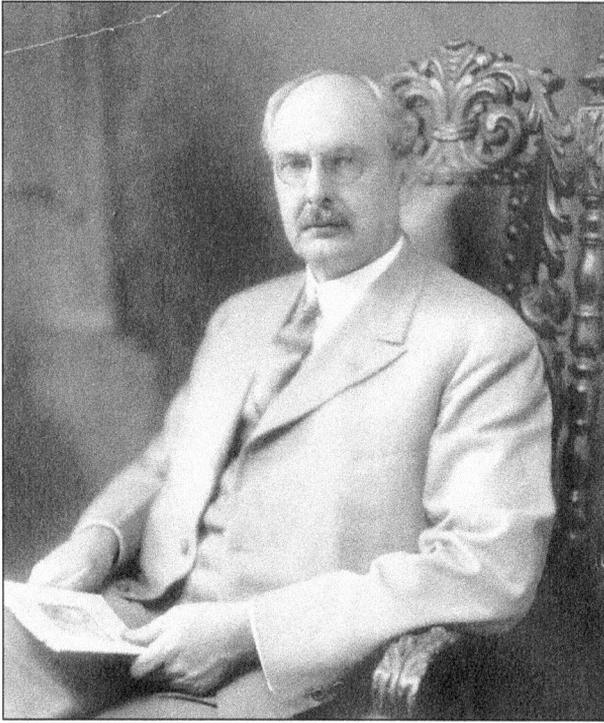

DR. NATHANIEL SELLECK, 1920. When the Danbury Hospital opened in 1885, it was considered a place for the critically ill. "You entered a hospital only if you had broken bones, if you were severely mutilated, or you were going to die," remarked Selleck's grandson, also called Nathaniel. The elder Selleck was one of the first doctors at the new institution. He treated many hatters affected by mercury poisoning (page 83).

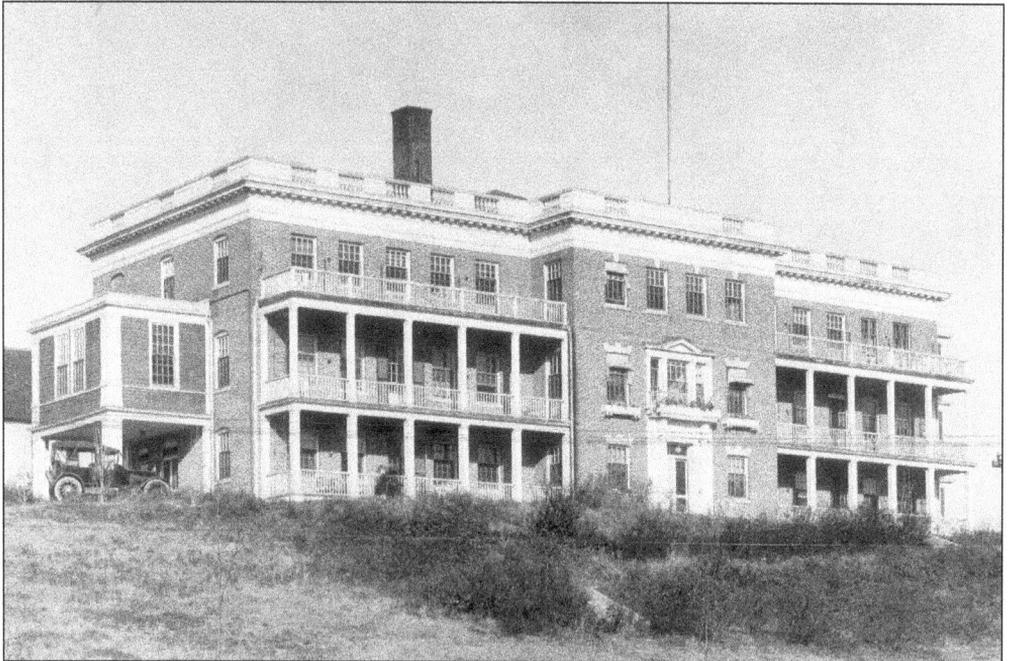

DANBURY HOSPITAL, c. 1920. Danbury's first physician was Dr. Samuel Wood, who came to the area before 1690. Danbury's first hospital was built in 1777 on Park Avenue near Pleasant Street. It closed shortly after the American Revolution, and Danbury had no hospital for over 100 years. This structure opened in 1910 when the hospital outgrew the Victorian building behind it.

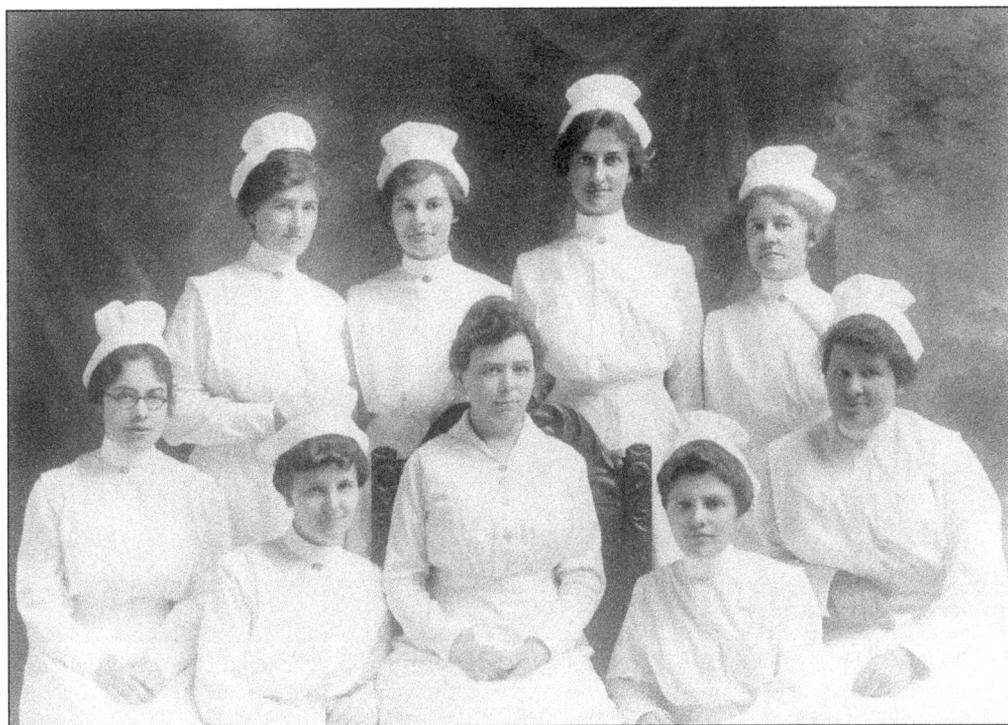

THE TRAINING SCHOOL FOR NURSES. The Danbury Hospital Training School for Nurses was established in 1892 and graduated progressively larger groups of women into the nursing profession until the end of the challenging three-year program in 1965. Shown on September 5, 1917, are the graduates of the Class of 1917.

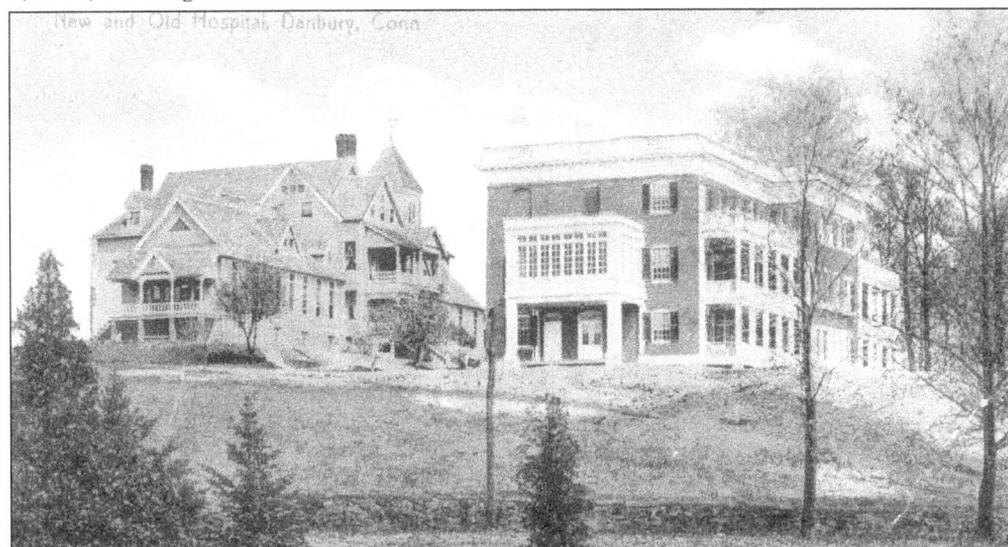

DANBURY HOSPITAL BUILDINGS. The gingerbread-style Victorian (left), designed by William Webb Sunderland, was built on a ledge on Locust Avenue offering a view of the city thought to have been therapeutic for the sick. When the brick building (right) opened in 1910, the nurses occupied the old building until it was moved in 1929. It served as a dormitory for hospital employees and a storage house before it was torn down for a parking lot in the 1970s.

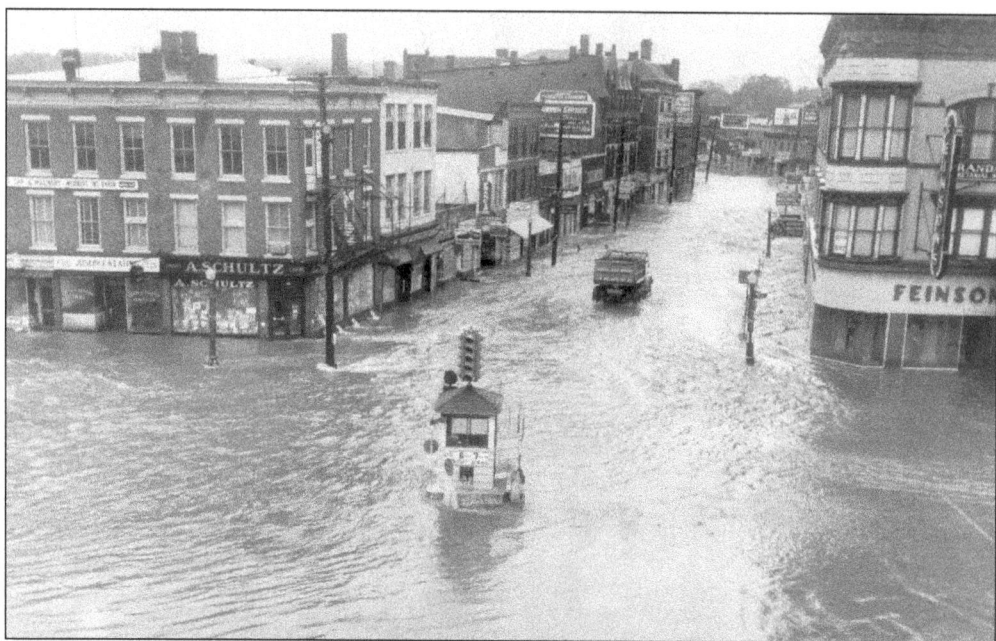

MAIN AND WHITE STREETS, OCTOBER 1955. The Still River refused to live up to its name when rain drenched the area first in August and then again in October 1955. The river's contents spilled onto the streets of Danbury's foremost retail area, causing Feinson's to lose the entire contents of its basement. The buildings (left) near the northeast corner of Main and White Streets disappeared when the U.S. Army Corps of Engineers rechanneled the river in the 1960s.

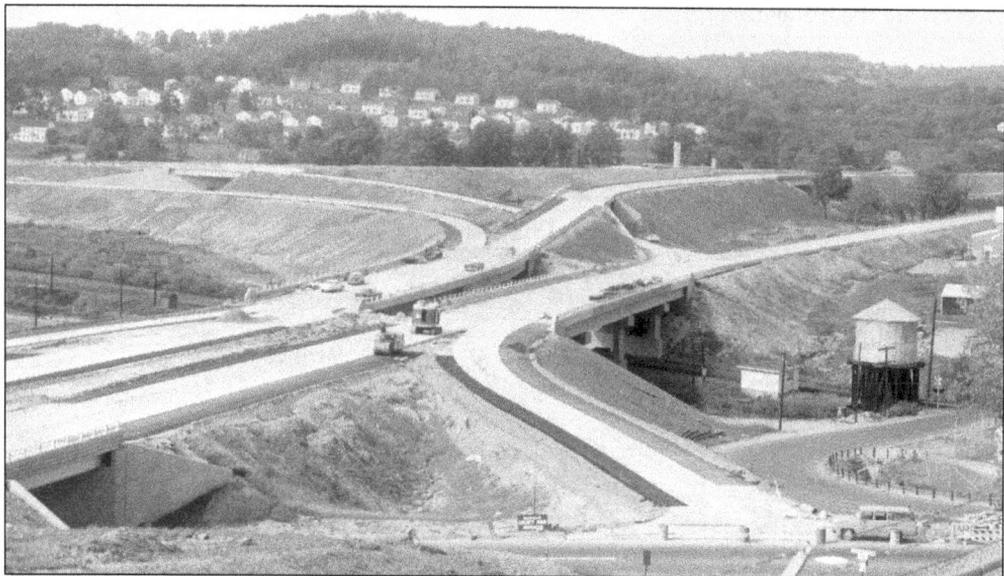

THE CONSTRUCTION OF INTERSTATE 84 NEAR SEGAR STREET. The first exits of Interstate 84 in Connecticut deposit motorists at office buildings on Ridgebury Road, the Danbury Fair Mall, the north end of Main Street, shopping centers, and Commerce Park in Danbury. The first section of the interstate highway system in Danbury opened in 1961. By 1969, drivers could travel nonstop from the New York State line to Hartford.

56

Four

THAT'S MY BUSINESS

There was the butcher, the baker, the milkman, the ice man, scissors grinder, peddler
with notions and the horseradish man in the spring. Each kept to a regular route whether
daily or two or three times a week and could be fairly well depended on as to their arrival.
— Jennie Stone, reflecting on life in Danbury at the start of the 20th century

Prior to the building of a train station on Main Street for the Danbury & Norwalk Railroad in 1852, the east side of Main between Liberty and White Streets contained only a few residences. Later, large business blocks with Italianate commercial buildings became the order of the day and older homes were altered for stores and apartments. In 1868, the Danbury News boasted: "Danbury has more handsome stores than any place of its size in Connecticut."

Most of the hat shops were located near downtown—the railroad and the Still River contributed significantly to the thriving hatting industry in Danbury. However, as early as 1879, the Danbury Industrial Association made an attempt (albeit unsuccessful) to attract new manufacturing businesses to town. The Danbury's Business Men's Association made a similar attempt in 1904.

When a committee of 25 met in August 1918, the country was at war and the hatting industry was suffering due to a shortage of rabbit fur. Many workers left the area for employment in munitions factories in other towns. The committee of civic and business leaders (mostly hatters) managed to raise $163,000 to purchase land for potential incoming industries, and the Danbury Industrial Corporation was established.

Success was slow in realization, but the organization had its first bona fide success with Bard-Parker in 1933. The 1940s saw the addition of Barden's, Risdon's, Republic Foil, Preferred Utilities, and Connor Engineering.

In the 1950s, Viking Wire, Heli-Coil, Davis & Geck, and Eagle Pencil moved to the area and numerous companies left New York for lower Fairfield County. As a result, Danbury became for businesses what it had been in 1684 for those overcrowded migrants from Norwalk: a sought-after place for relocation.

HENRY DICK. In 1903, Henry Dick decided to close down his saloon and open up a furniture store. Dick, who was born in Austria and came to Danbury via Hoboken, New Jersey, opened a store at 136 Main Street in 1912, which his son Abraham Dick took over in 1938. A founder and president of the United Jewish Center, Henry Dick donated a building at 30 West Street to the organization (page 25) in 1926.

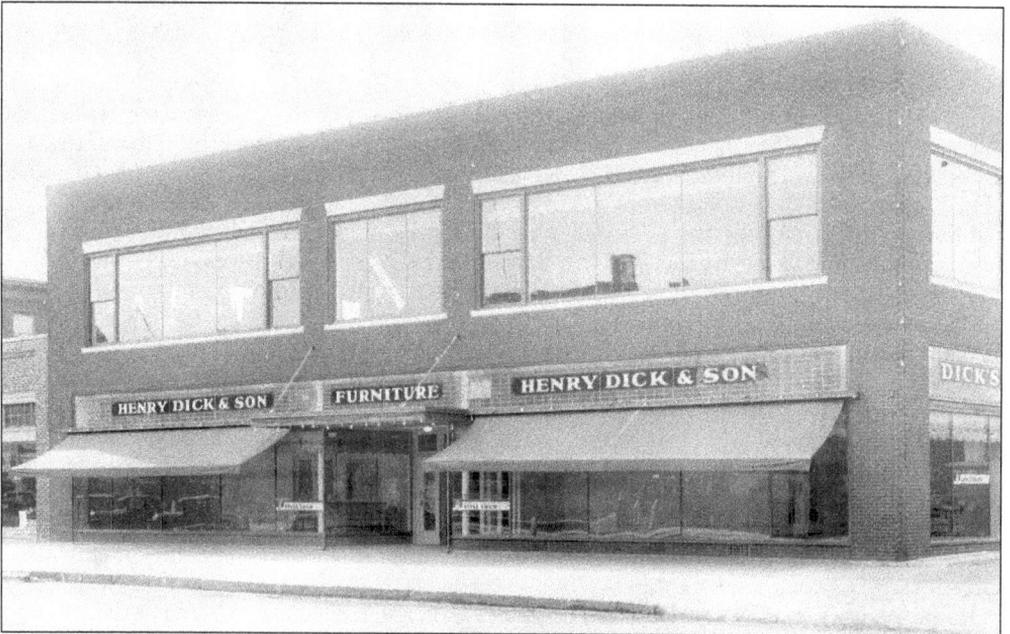

HENRY DICK & SON, 136 MAIN STREET. Henry Dick's business survived the Great Depression, and its owner was able to remodel the store in the 1930s. The enterprise saw a major renovation in 1967, and 10 years later the storefront was sectioned for room displays. The store closed in 1996 with the retirement of its president Joel Feinson, brother of Robert Feinson (page 59.)

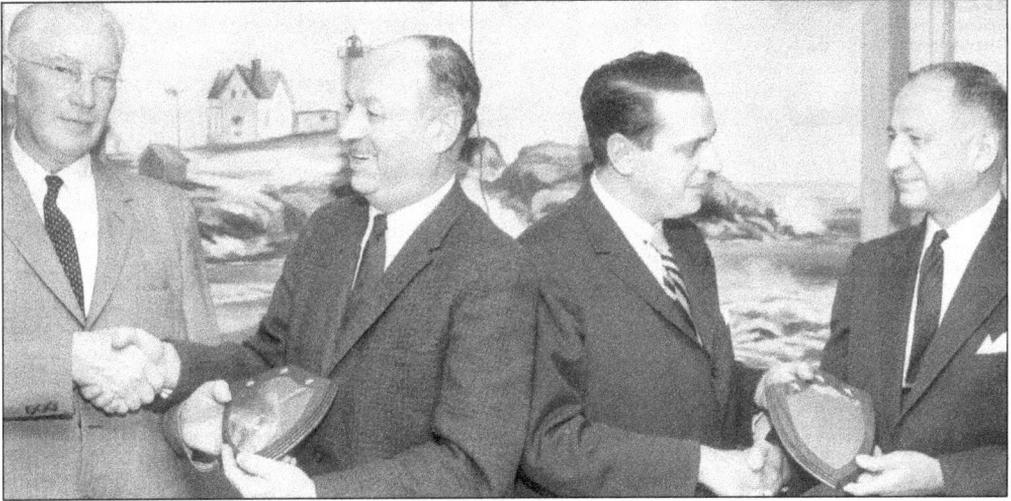

ALBERT MESERVE, ABE FEINSON, JOHN DEFINE, AND NATHANIEL ROGERS. Abe Feinson began his retail career delivering goods (placed in a trunk on a small cart) from the family store to customers. When his parents became ill, he ran the business and his son Robert Feinson joined him in 1963. His wife, Bertha, was the daughter of another retailer on Main Street: Henry Dick.

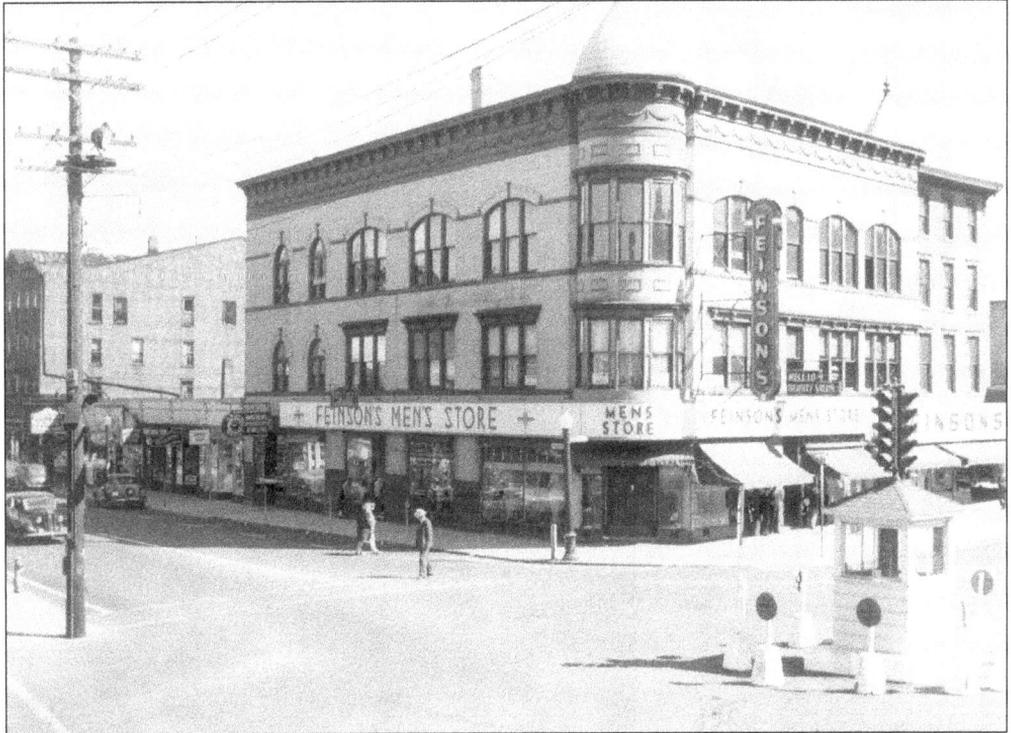

FEINSON'S, MAIN AND WHITE STREET, C. 1940S. Neither flood nor fire nor Danbury Fair Mall could stop the downtown operation of Feinson's Men Store. The store celebrated its 75th anniversary by displaying vintage clothing from the Danbury (Scott-Fanton) Museum in its store windows. The first store opened in 1908 on Elm Street and sold dry goods. In 2000, Robert Feinson, grandson of founder Morris Feinson, announced that the store would be closing.

HAROLD MEEKER. Harold B. Meeker was the grandson of the founder of Meeker's Hardware. He steered the company into successful competition with other local hardware stores. The son of Harold E. Meeker and grandson of Oscar H. Meeker, he was also well known locally for his passion for sky diving and as the founder of the Danbury Sky Diving Club.

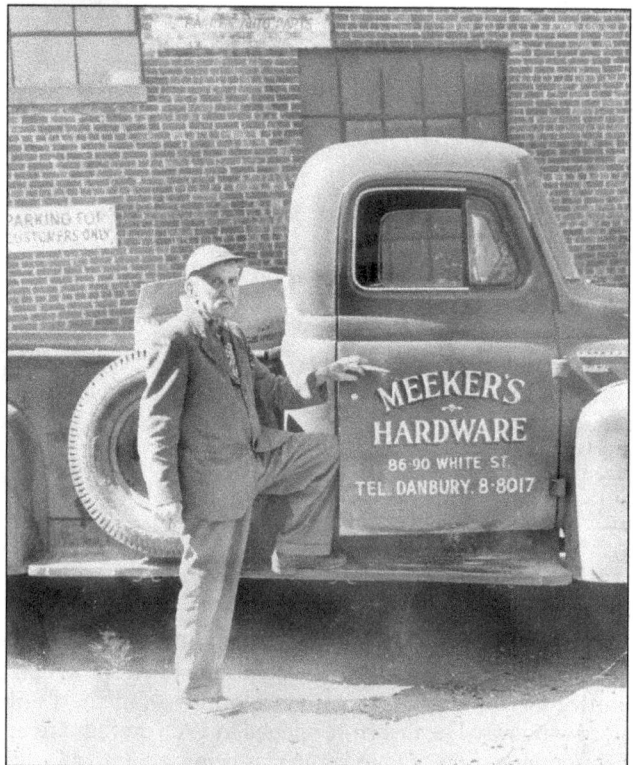

MEEKER'S HARDWARE TRUCK. Oscar H. Meeker was a retailer and wholesaler in hay, straw, flour, feed, grain, and bran when he opened his store in 1883. As time progressed and Danbury became less agricultural, hardware became the main source of income for the business. The store at 90 White Street continues to be owned and operated by the Meeker family and is a Danbury landmark.

FREDERICK A. HULL. Pictured is the son of Charles Hull, a tinsmith who came to Danbury from Norwalk in 1838, and Hannah Ambler Hull, daughter of Deacon Thomas Ambler. Frederick A. Hull was born in 1850. In 1890, the head of a match dropped in the Hull & Rogers building started a fire that destroyed a city block of five stores.

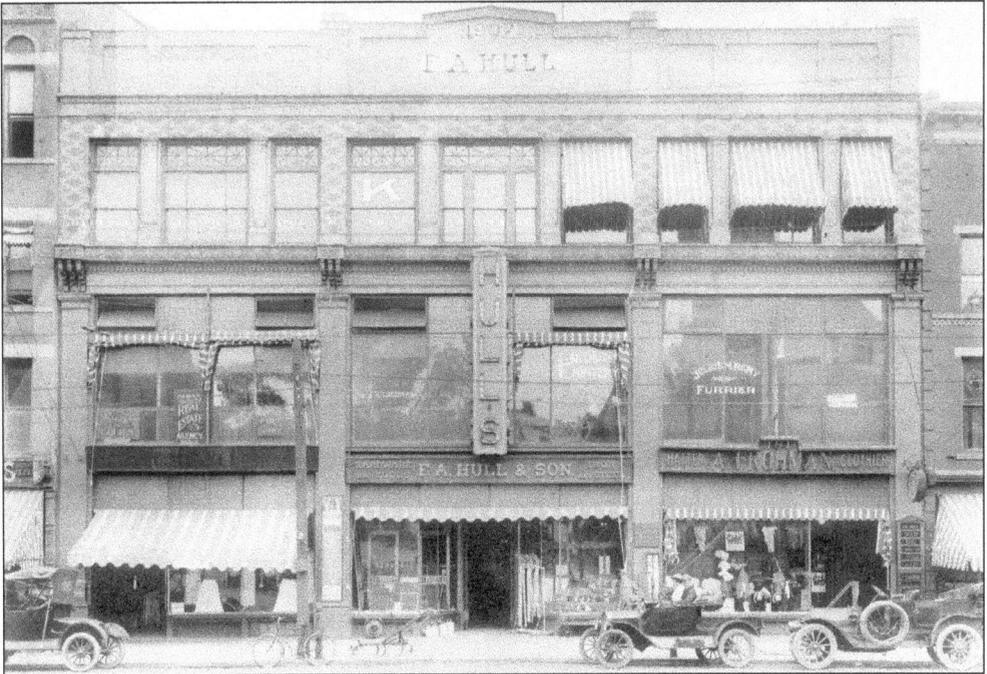

HULL & SON, C. 1916. This solid concrete and reinforced steel building replaced the "fire proof block" that was erected after a fire in 1890. One of the last persons to leave that building during the fire of 1907 was clerical worker May Dunn, who managed to gather account books and valuable papers and placed them in the vault. She also rescued money and carried it out of the store, narrowly escaping flames that nearly burned her clothes.

JOHN F. WOODRUFF. Employed at the tender age of 10 in a hat and furnishing store, John J. Woodruff was 26 when he purchased the retail business of George M. Tallant. An original director of the Danbury Industrial Corporation, Woodruff helped to situate the downtown post office building at its current site.

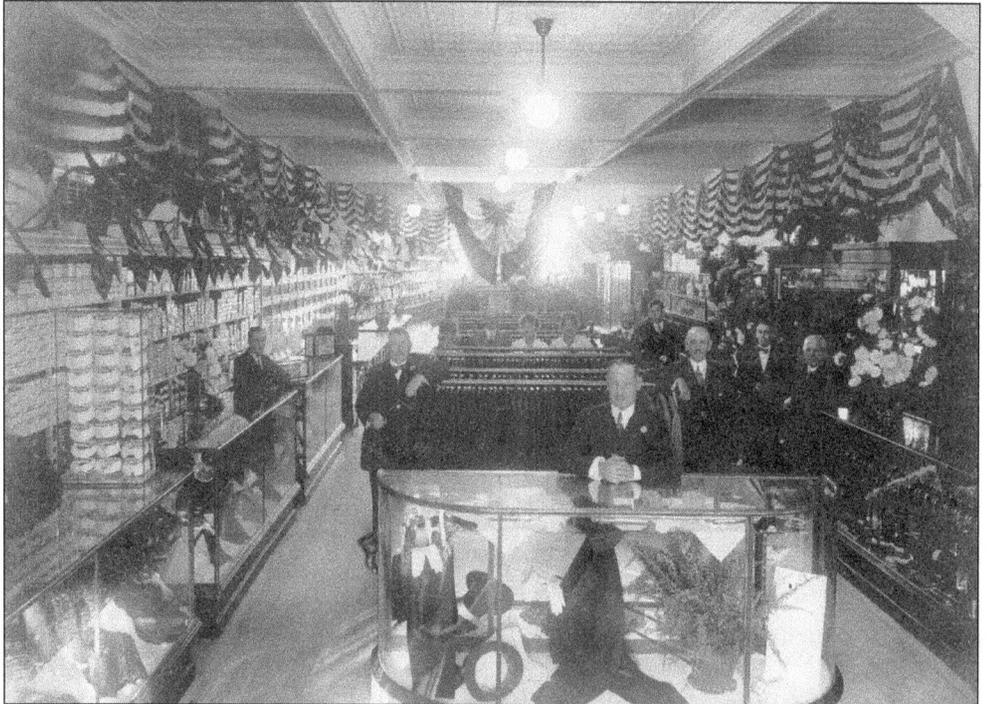

WOODRUFF'S MEN'S STORE, 261 MAIN STREET, 1931. Before John Flavel Woodruff built this store next to the post office in 1915, he had a store at 177 and 179 Main Street, across from the old Danbury City Hall. He discontinued the business on January 31, 1932. It was succeeded by First National and Scotty's Stationery stores.

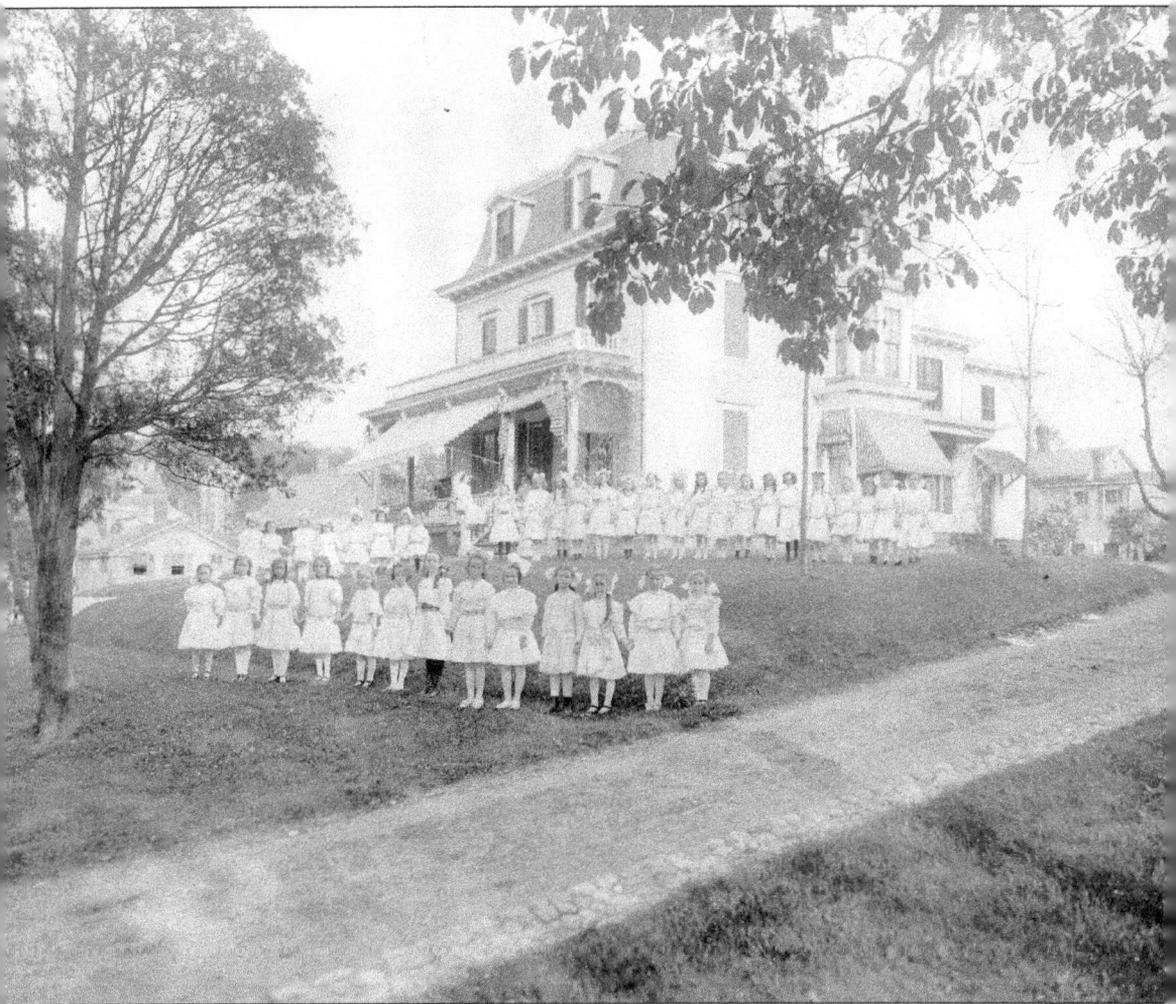

THE WOODRUFF HOMESTEAD. In this *c.* 1890 photograph, 39 young women pose during Geneva Seeley Woodruff's birthday party held at the John Flavel Woodruff homestead at 18 George Street in Danbury.

FRANK HENRY BAISLEY. A hatter in his younger life, Frank Henry Baisley had a studio in New Rochelle, New York, before he conducted a business at 197 Main Street in Danbury. At one time he took pictures for the International News Reel company and was the official photographer at the Danbury Fair. Many of his photographs survive today in the archives of the Danbury Museum, as well as in the hands of private collectors.

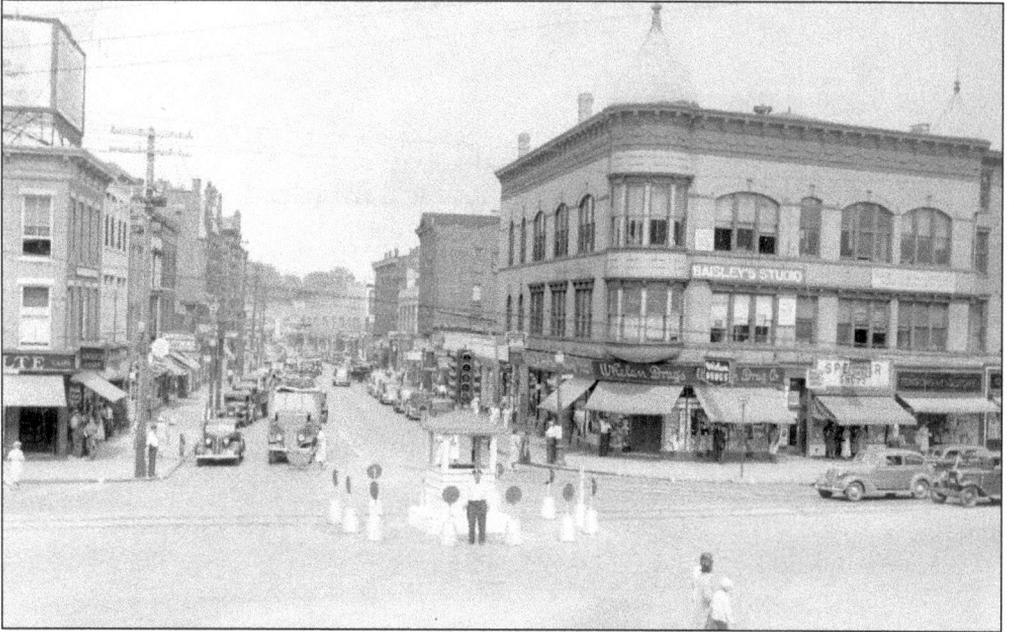

BAISLEY'S STUDIO AT MAIN AND WHITE STREETS, C. 1937. Frank Henry Baisley's studio window above Whelan's drugstore commanded a view of one of Danbury's busiest intersections. For the 25 years prior to 1936, his business was located in the Thompson block at 197 Main Street. His last studio was at 286 Main Street, the current location of the Cow's Outside.

FREDERICK L. WILSON. Frederick L. Wilson was a jeweler in Danbury as far back as 1874. In 1891, his business at 261 Main Street offered the services of an optician and silversmith. He sold a trademarked spoon made by the Whiting Manufacturing Company featuring the old Wooster House (page 13).

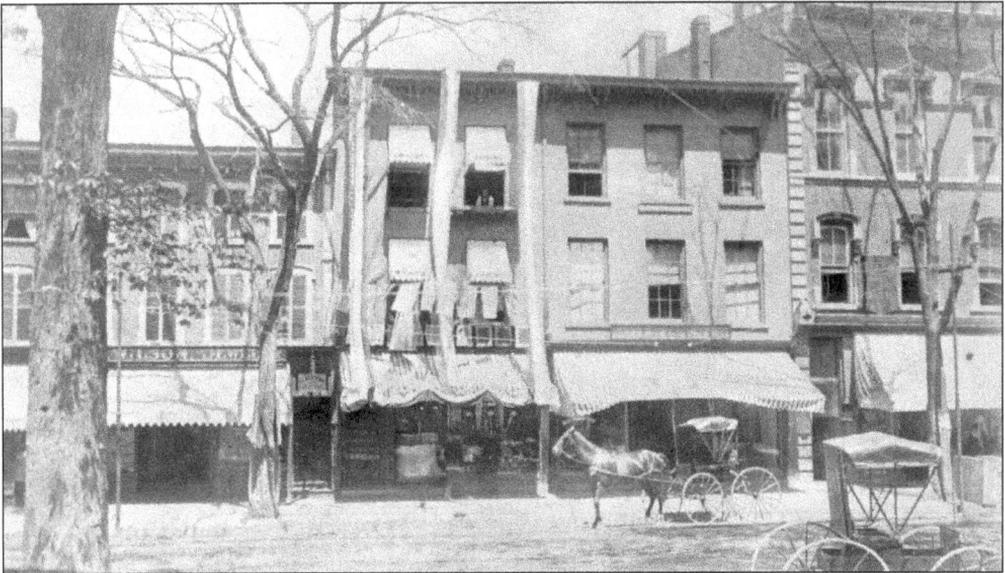

THE F.L. WILSON STORE. The first wireless apparatus in Danbury was installed in the F.L. Wilson store at 237 Main Street on February 18, 1914. This building was destroyed in a fire in 1965. By 1947, the store was located at 207 Main and its second floor was the home of radio station WLAD for several years. The shop became Addessi's Jewelry Store in the 1970s.

FRANK A. CANTWELL. When the Hotel Green opened in 1907, Frank A. Cantwell was its managing director. At that time Danbury had 1,000 telephones, ice was selling for 80 cents a pound, and the town was in the middle of a real estate boom. Convenient to the Taylor Opera House, the hotel was undoubtedly busy accommodating concert-goers and performers.

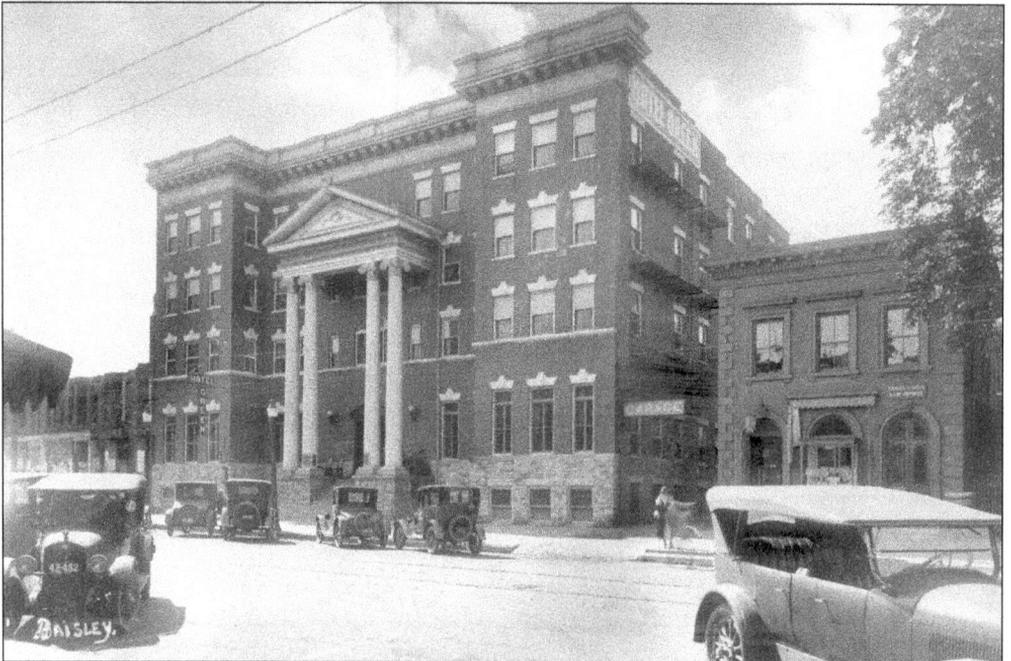

THE HOTEL GREEN, 198 MAIN STREET, C. 1926. In 1927, the first radio station in Danbury was broadcast from this hotel's lobby. The station lasted only a few months but in 1947, the AM station WLAD began here, moving across the street in less than a year. The hotel was razed in 1959 but its replacement, the New Englander, became the home of WLAD in 1962. Today, 198 Main Street is Ives Manor and WLAD continues to broadcast here, along with FM station WDAQ.

66

ARNOLD TURNER. Arnold Turner was the grandson of pioneers of the hatting machinery industry in England. He came to America in 1893 at the age of 22 and had a business on Maple Avenue in Danbury. Turner resided in a 22-room mansion at the corner of Franklin Street and fashionable Farview Avenue. The building was torn down in 1980 to make way for condominiums.

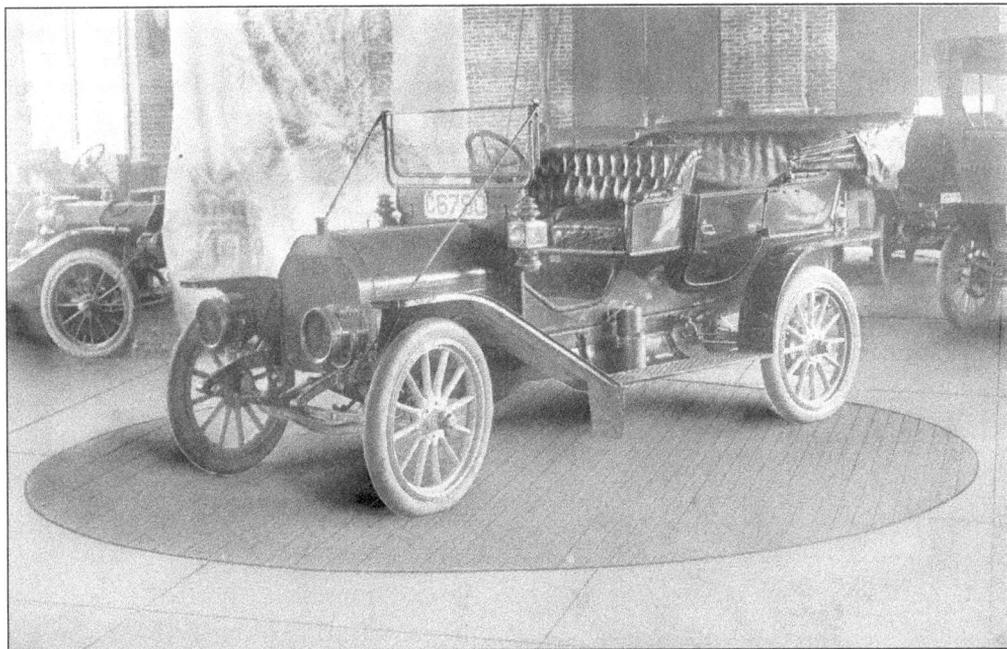

AN AUTOMOBILE TURNTABLE MANUFACTURED BY THE TURNER MACHINE COMPANY. The Turner Machine Company was started by John Turner, father of Arnold Turner, in Denton, England, in 1860. The factory on Maple Avenue in Danbury produced hat-making equipment and New York City subway cars.

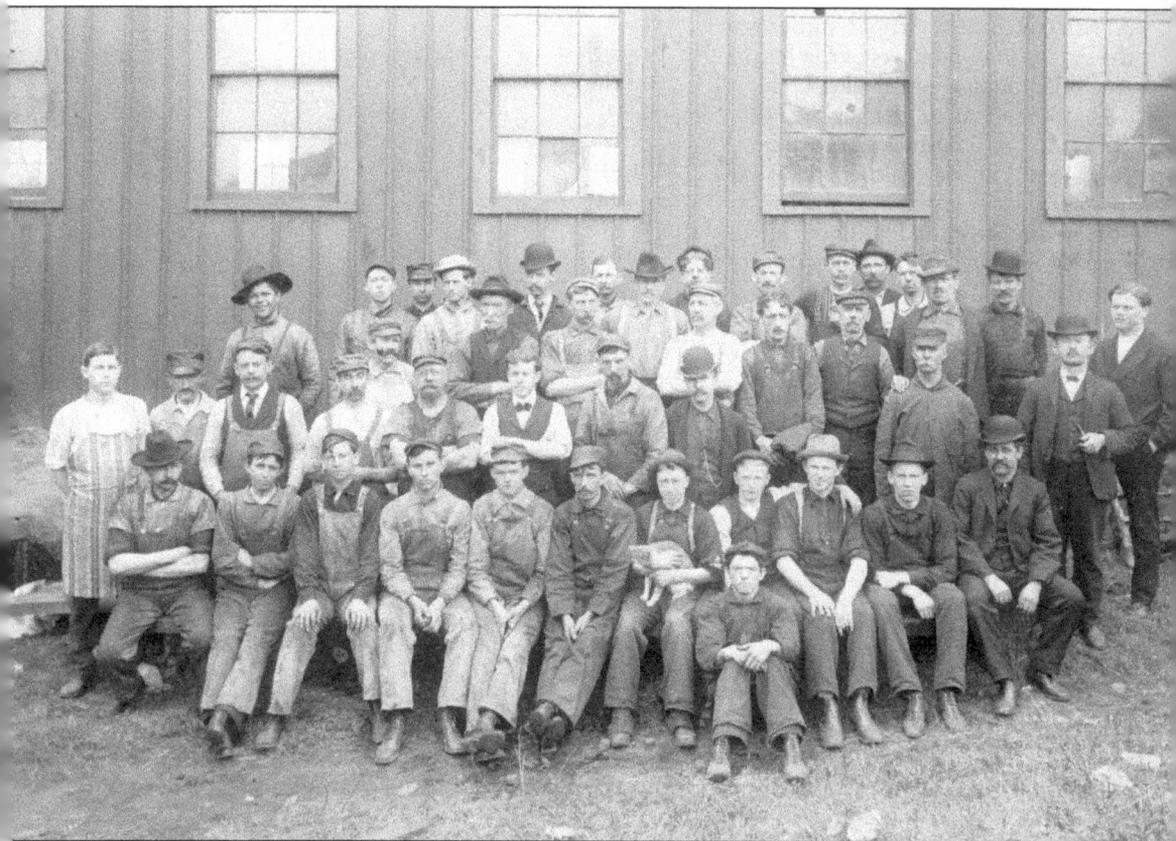

THE TURNER MACHINE COMPANY, 28–38 MAPLE AVENUE, C. 1909. Besides the factories in Danbury and England, Turner Machine had branch offices in Barcelona, Berlin, Melbourne, Paris, Rio de Janeiro, Vienna, and Warsaw. The firm manufactured wood blocks, hatters tools, and fur and wool hat machinery. Many Turner machines could still be found in the 1980s at the Danbury Hat Company on Rose Hill.

Five

MAD ABOUT HATTING

In the peak years of hatting, between 1910 and 1920, six thousand people were employed in hat shops in Danbury, manufacturing sometimes 10,000 hats per day.
—*Connecticut Business Review*

Several publications on Danbury relate that the first hat made in this country was made here during the American Revolution. However, decades before the Stamp Act, Townshend Duties, and the Intolerable Acts, King George II issued an edict in 1731 to impede hat making in the colonies. By not allowing finished or unfinished hats to leave the country and by requiring a seven-year apprenticeship, England aspired to retain hatters in Europe (where they were required to join a guild), thereby stifling the competition.

There is good reason to believe that there was a hatter among the original eight settlers of Danbury, and hatting tools were listed in some early probate records. Zadoc Benedict, a descendant of one of those settlers, had a hat shop as early as 1780 and is the first acknowledged hatter in Danbury. (The British destroyed records when they burned the town in 1777.)

Danbury was producing 20,000 hats a year by the beginning of the 19th century. By 1808, it had 50 shops employing three to five people, and one manufactory had 50 employees in 1810. The New York market and the opening of retail shops in the south by Danbury hatters helped establish Danbury as the Hat Capital of the World. However, several influences had a negative effect on the industry and the years were not always prosperous. Wars, lockouts, panics, price wars, shortages of fur, the Depression, and fashion trends left many hatters without food on their table.

BIG BAD BEAVER. The main ingredient in hat making is fur. More specifically, the short hairs close to the pelt of certain animals when manipulated and wet have a natural felting capability. Nature supplies the beaver with its best felting fur on its belly. The fur trade brought about the exploration and trailblazing of our nation, but the scarcity of the beaver resulted in a high-priced hat.

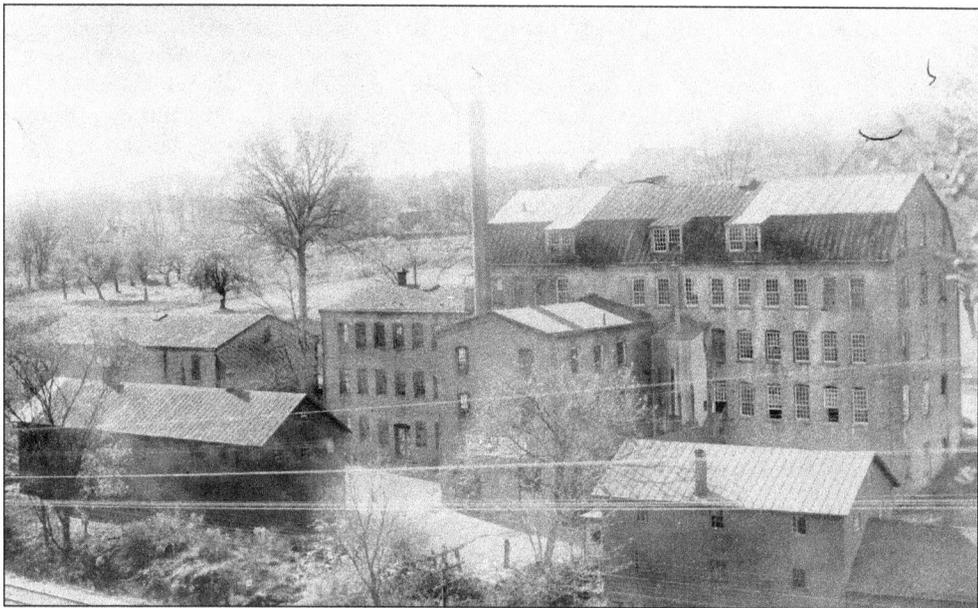

P. ROBINSON & COMPANY, 51–59 OIL MILL ROAD. Today's Danbury Mill Apartments were once the home of the Robinson Fur Cutting Company. It is one of the few hat buildings in Danbury constructed of brick, which may account for it being extant. The fur was prepared, sorted, and placed in paper bags to be delivered to hat factories. The skin that was shredded from the fur was bundled and used for the making of rabbit-skin glue.

EDWARD VON GAL. Edward Von Gal was born in Danbury in 1862 and was employed at the E.S. Davis box shop. Later, he apprenticed under hatter Henry Crofut and had a hat shop on Taylor Street with partner A.B. Davenport. Von Gal was president of the Hat-Finisher's Association at the age of 22 and was a member of the Hospital Aid Association.

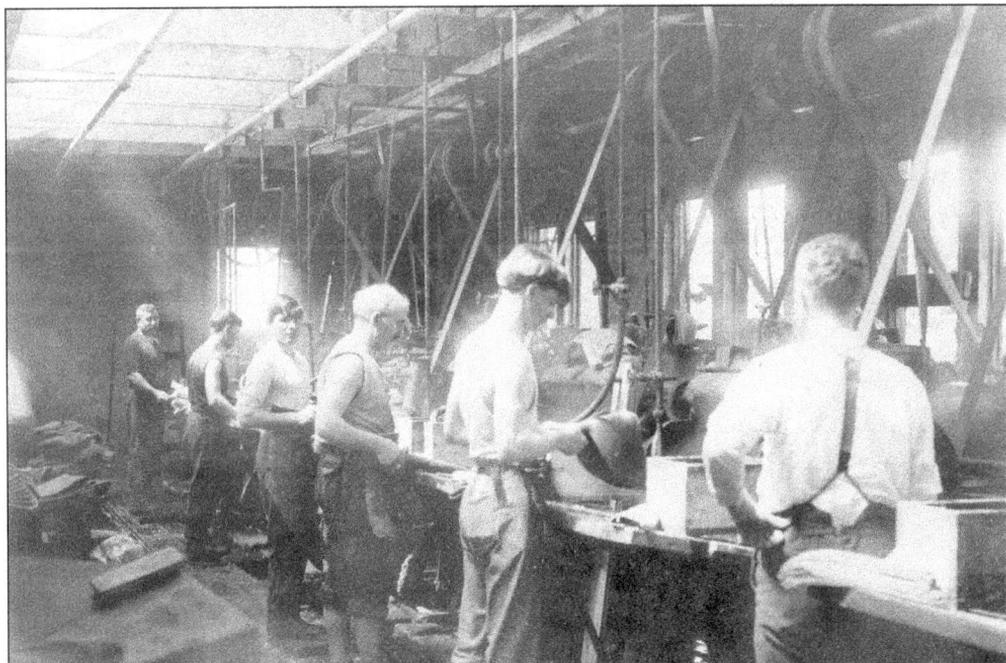

SIZING MACHINE WORKERS, DAVENPORT & VON GAL, C. 1890. A back shop operation, sizing a hat consisted of several passes of the hat body between rollers. Pressure applied to the fur causes the fiber to bend and straighten, interweaving to form a light, but strong, smooth fabric. Tubs of hot water used to "start" the hat body before sizing created a significantly moist atmosphere.

TAKEN IN 1869, AGED 44. Taken Dec. 24, 1900. AGED 75.

JAMES S. TAYLOR. Henry Christie, a hatter and a member of Parliament in Great Britain, lauded James Taylor when he patented his sizing machine in the 1850s. He said Taylor had triumphed in solving the problem of felting by machinery where Christie's, the largest hat manufacturer in England, had failed. Taylor, born in 1825, was the great-great-great-grandson of Thomas Taylor, an original settler of Danbury.

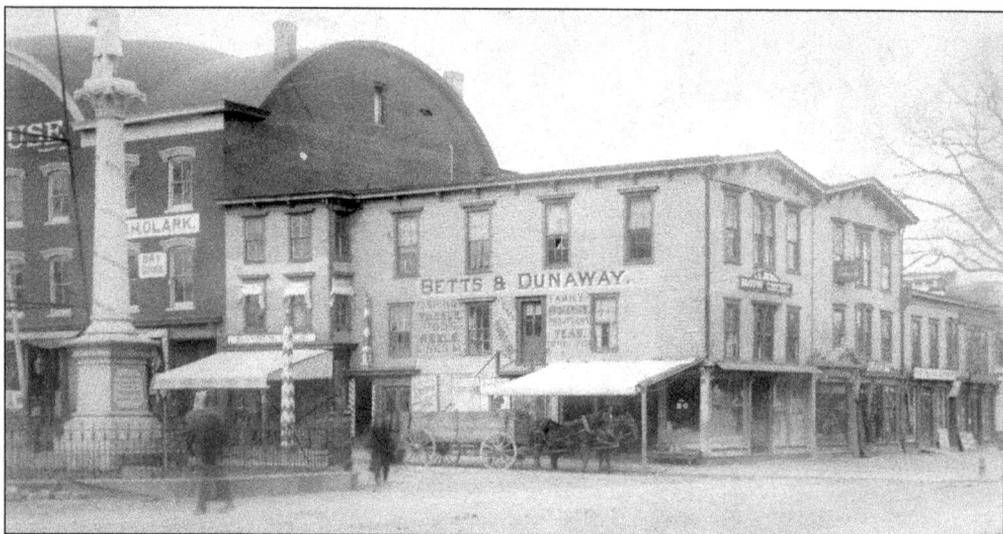

THE TAYLOR OPERA HOUSE, MAIN AND WEST STREETS, C. 1885. The success of the Taylor sizing machines, which ruled the hatting industry for over 60 years, generated the capital that led to construction of the Taylor Opera House. The building, with its unique domed roof, opened on July 4, 1871, and served as a venue for operas, plays, concerts, motion pictures, and high school commencements.

72

JOHN W. GREEN, 1890. John Green emigrated from England in 1857 and opened a hat shop in Newark, New Jersey. He brought with him his expertise in the manufacture of the derby, and its popularity took the country by storm. He moved his business to Danbury in 1879, first occupying a former sewing machine plant on Canal Street. Sadly, he died before construction of his upscale Hotel Green on Main Street was completed.

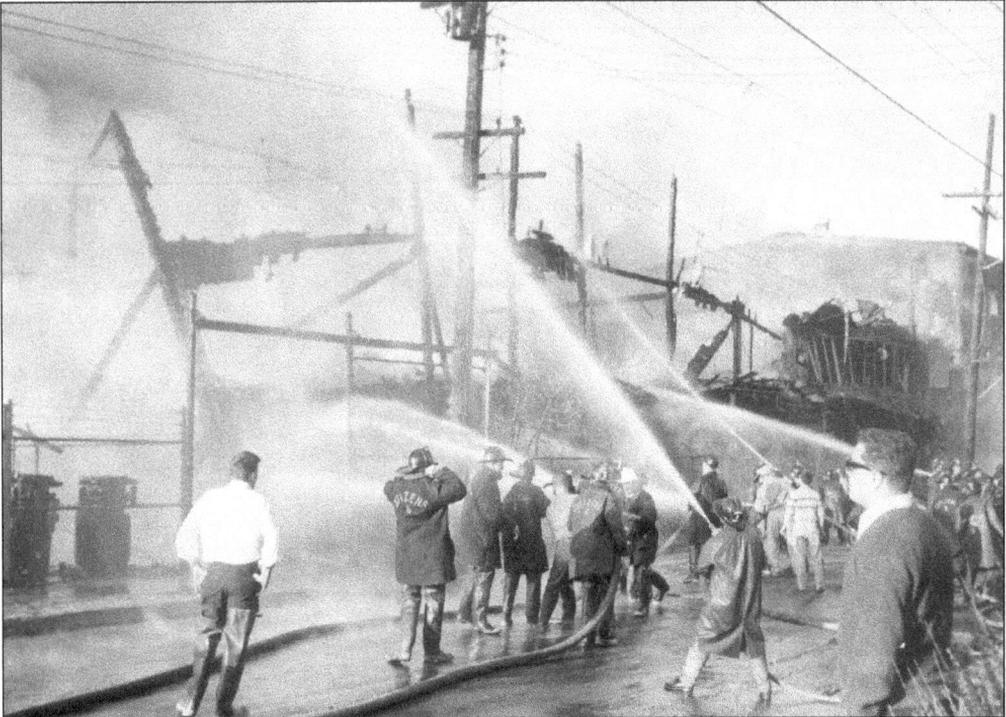

THE JOHN W. GREEN & SONS FIRE. Fortunately, the Green Hat Factory on Pahquioque Avenue was vacant when it burned to the ground on May 2, 1964. Two adolescents were responsible for the accidental fire that resulted in fourteen injuries and one death.

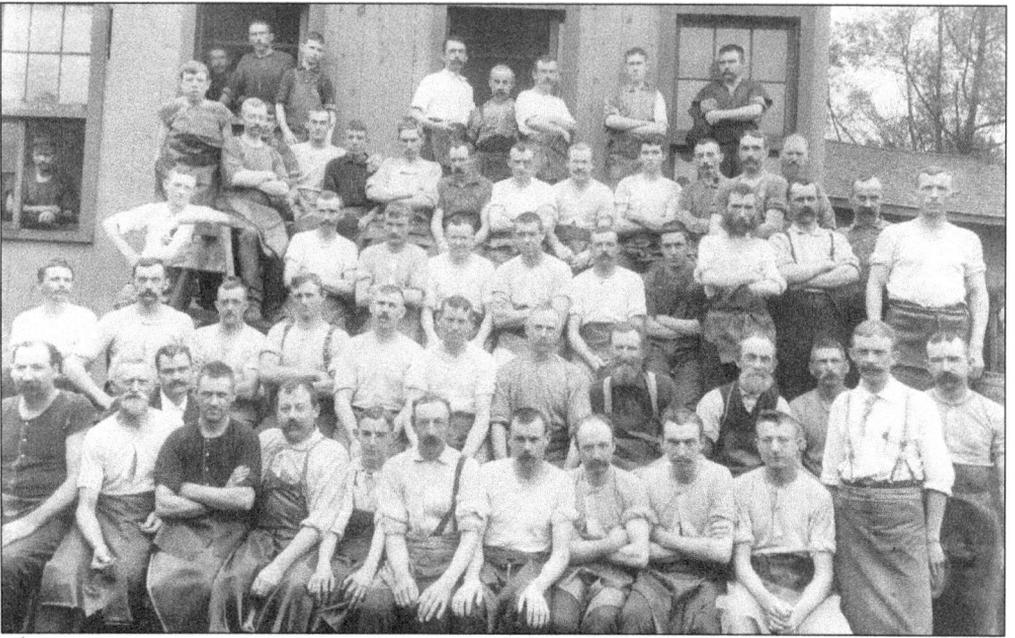

THE MALLORY HAT SIZING DEPARTMENT, 1890. The Mallory hat factory had been in operation in the Rose Street area for about 30 years when this photograph was taken. Ezra Mallory started the business on Great Plain Road *c.* 1820, but its success came under the leadership of Mallory's son, also named Ezra.

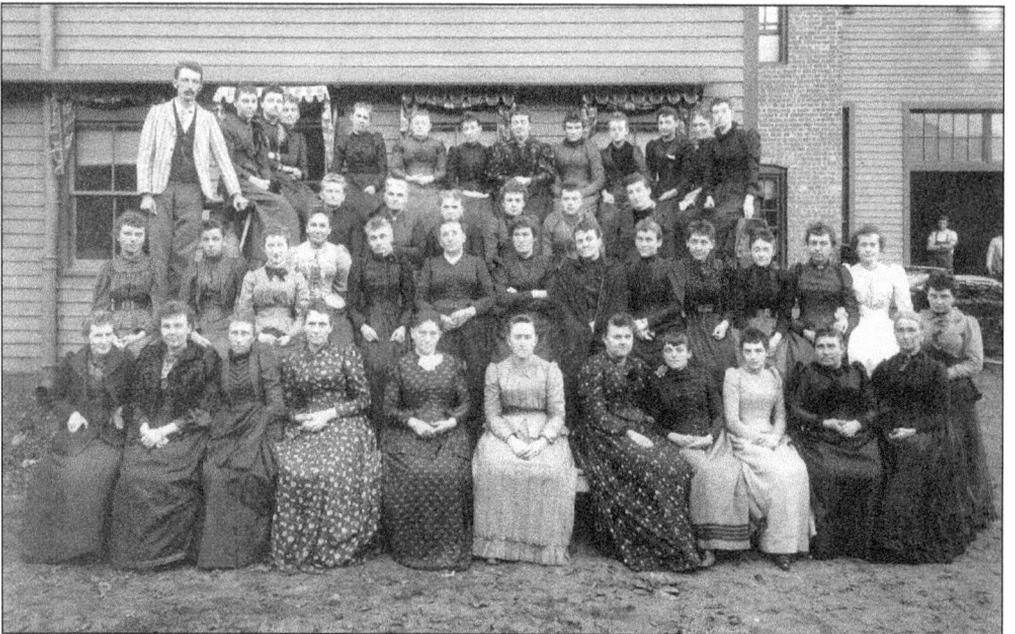

THE MALLORY TRIMMING DEPARTMENT. A felt hat is unique due to its fabrication from a singular piece of material. However, most styles are finished with a sweat leather inside and a decorative band where the crown meets the brim. These adornments are attached with thread sewn by hand or machine in the female-dominated trimming room. The Hat Trimmers Association was involved in several strikes and lockouts in the late 19th century.

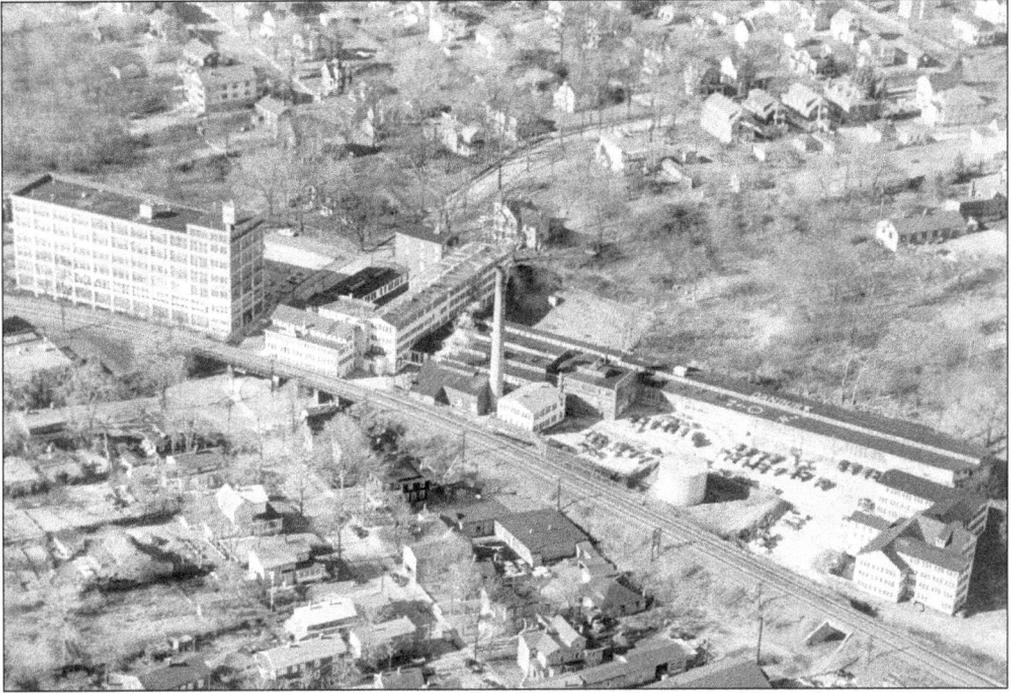

THE MALLORY HAT COMPANY. Except for the wood trim on its windows, the tall structure on the left, erected in 1919, was built of concrete for Mallory's finishing shop. Today, it is occupied by Fairfield Processing, but the buildings across the street have gone the way of the wrecking ball.

HARRY BURTON MALLORY, 1957. Harry Burton Mallory, born in 1916, was the great-great-grandson of Mallory Hat founder Ezra Andrews Mallory and the great-great-great grandson of John Rider. Harry Mallory was 16 when baseball great Babe Ruth visited the family estate on Briar Ridge Road. He learned the hatting trade from the family business and in 1954 was a general manager for Resistol Rough Hats in Newark, New Jersey.

GEORGE MCLACHLAN. "I got kicked out of every school I went," crowed George McLachlan in 1949. This would include St. Peter's Grammar School and Stillman's Business College in Danbury. Nevertheless, McLachlan was making hats at the age of 13 for his brother Harry McLachlan and began his own business when he was 26. In 1907, he discovered an inexpensive and more efficient way to dye hats. Moreover, he had a fur-cutting business on White Street and a hat-finishing plant in Norwalk.

FRANK H. LEE. A Brookfield-born son of Irish immigrants, Frank H. Lee began his hatting career as an apprentice at the Judd & Company factory in Bethel. By 1920, his 900 employees were producing 200 dozen straw hats and 13,000 felt hats a day. He was the first president and director of the Danbury Industrial Corporation.

76

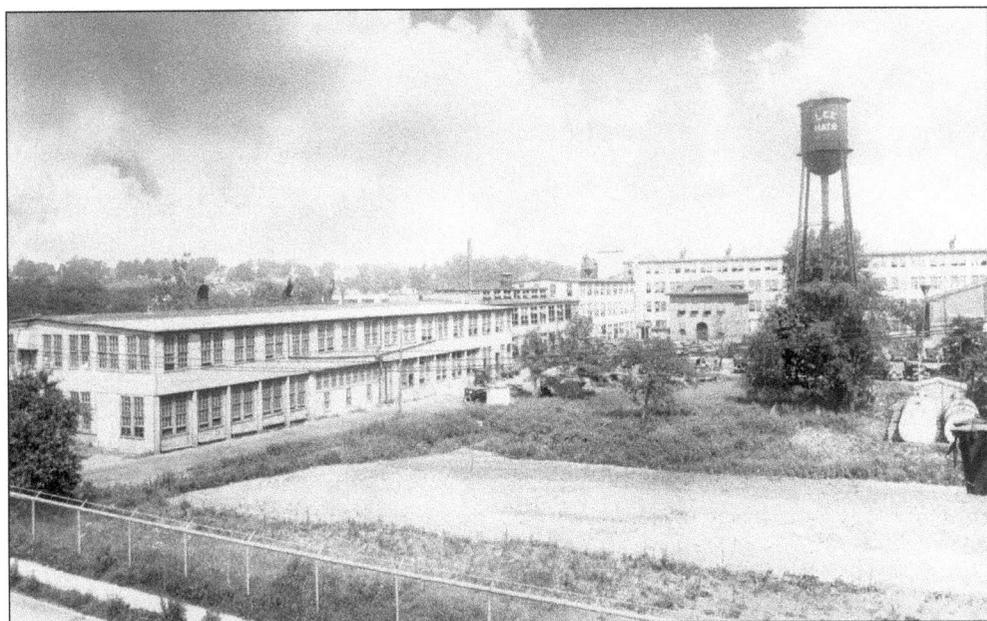

THE LEE HAT FACTORY, SHELTER ROCK ROAD AND LEE MAC AVENUE, C. 1920. Frank Lee's goal of becoming the largest hat manufacturer in Danbury came to fruition when he moved his operations from Railroad Avenue to this plant in 1909. The factory was the largest employer in Danbury for several years. It closed in 1965, less than 10 years after it was bought by the John B. Stetson Company.

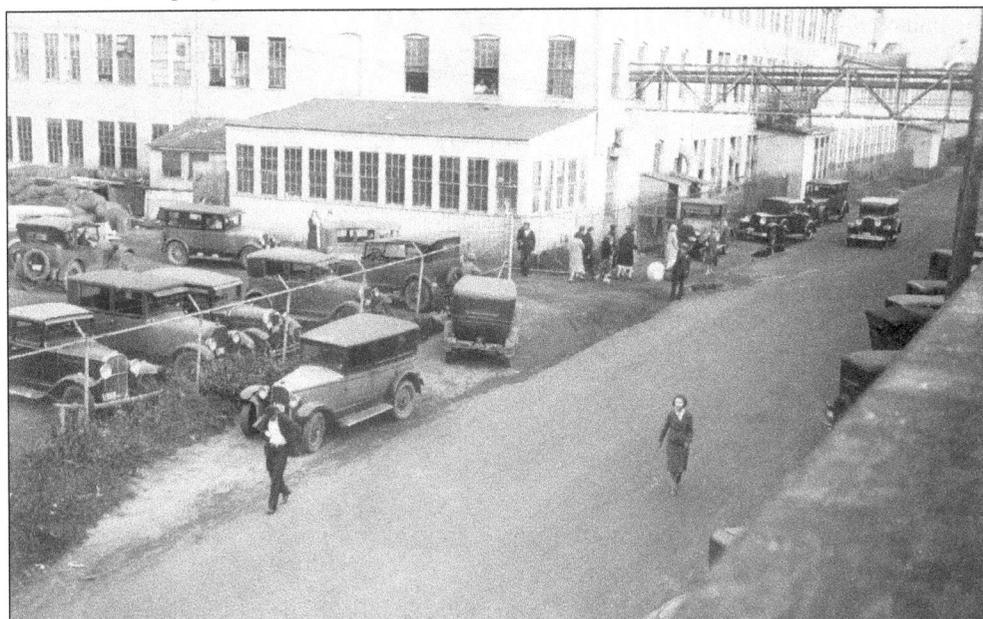

THE LEE HAT FACTORY, NORTH AND WEST SIDE, C. 1931. On December 7, 1898, the John W. Green Hat Shop on this site on Shelter Rock Road burned in a fire. Then, 70 years later, 17 buildings of the International Warehouse complex on the old Lee Hat factory property were similarly destroyed by fire. The Green hat factory loss was $110,000; the 1968 fire damage was estimated at $5 to $6 million.

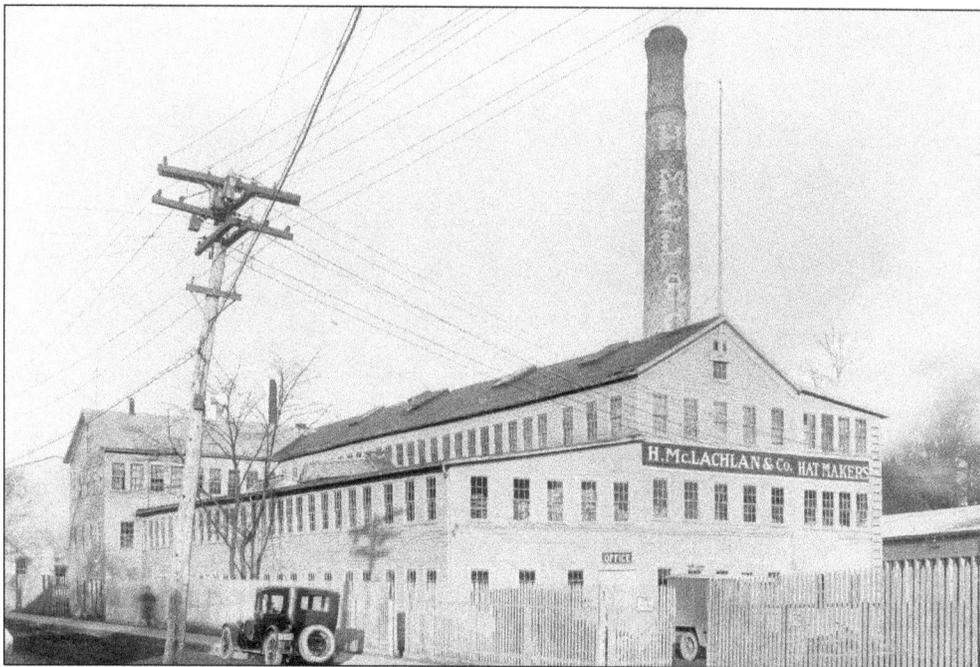

THE HARRY MCLACHLAN HAT FACTORY, ROWAN STREET. Harry McLachlan (the Mac in Lee Mac Avenue) and Frank H. Lee joined forces to create the U.S. Hat Machinery Company. Later, McLachlan had a plant on Rowan Street, where he perfected the production of hat bodies in the rough (unfinished hats). The building on Rowan Street was torn down in the mid-1990s.

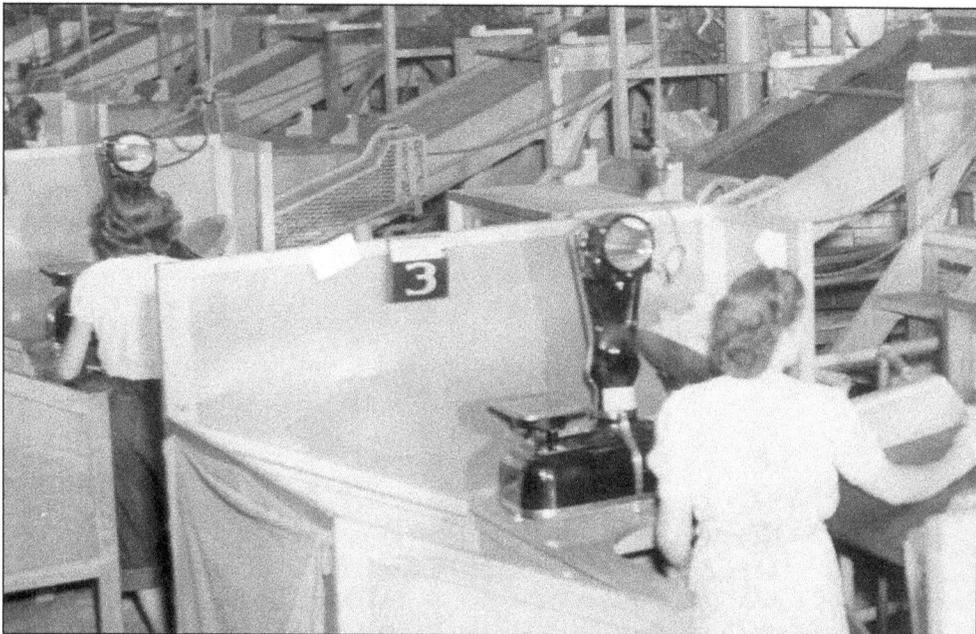

THE HARRY MCLACHLAN FACTORY, WEIGHING AND FEEDING DEPARTMENT. Sophisticated scales were required to measure the exact amount of fur for each hat. The fur was placed on a conveyor belt and transported to a compartment in the forming machine.

D.E. LOEWE. Like other German hatters in Danbury, Dietrich Loewe held public office and was a member of the fire department—coincidentally, most hat shops were made of wood. After learning the hat trade, Loewe established an "open" hat shop, hiring union and nonunion workers. This prompted a boycott in 1901 of Loewe's business, compelling wholesalers and consumers to "look for the union label."

The United Hatters of North America.

DANBURY, CONN., September 14, 1903.

DEAR SIR:

You are named as one of the defendants in the two (2) suits brought by D. E. Loewe & Co., against The United Hatters of North America, and other parties.

The United Hatters of North America are going to defend anyway in *their own name*, both of the suits, but unless each individual member who is sued, also enters an appearance judgment will go against him any way by default. The United Hatters of North America, however, are willing to enter an appearance for each individual who has been sued individually, and pay all expenses of such defense and save such individual from all liability from either of the suits, provided such individual authorizes in writing such appearance to be made for him. The United Hatters of North America will also, at their own expense, apply for, and if possible, obtain releases from attachment of the private property of any individual defendant whose defense they undertake.

If you desire to save yourself any further expense, please sign the annexed paper, and return in the enclosed stamped envelope *by return mail.*

If you had any deposit in any bank which you think may have been attached, please write the amount and the correct name of the bank where it is deposited, so we can apply for its release. Our reason for asking this, is that the attachment papers of D. E. Loewe & Co. are drawn so blindly that it is impossible to tell whose bank deposit has been actually attached, without going to the banks and running through two hundred (200) names, or else getting the names from each defendant. And it is quicker to get it direct from each defendant.

Yours truly,

THE UNITED HATTERS OF NORTH AMERICA.

BY P. H. CONNOLLEY.

"HERE'S YOUR BLOOD MONEY." In the trial of the famous Danbury hatters case, 240 hatters had their bank accounts and houses attached in retaliation for the boycott of D.E. Loewe & Company. Begun in 1903, Loewe vs. Lawlor dragged on for years, culminating in 1917 with the lawyer for the United Hatters handing Loewe his "blood money." It was the first time the Sherman Anti-Trust Act challenged a union.

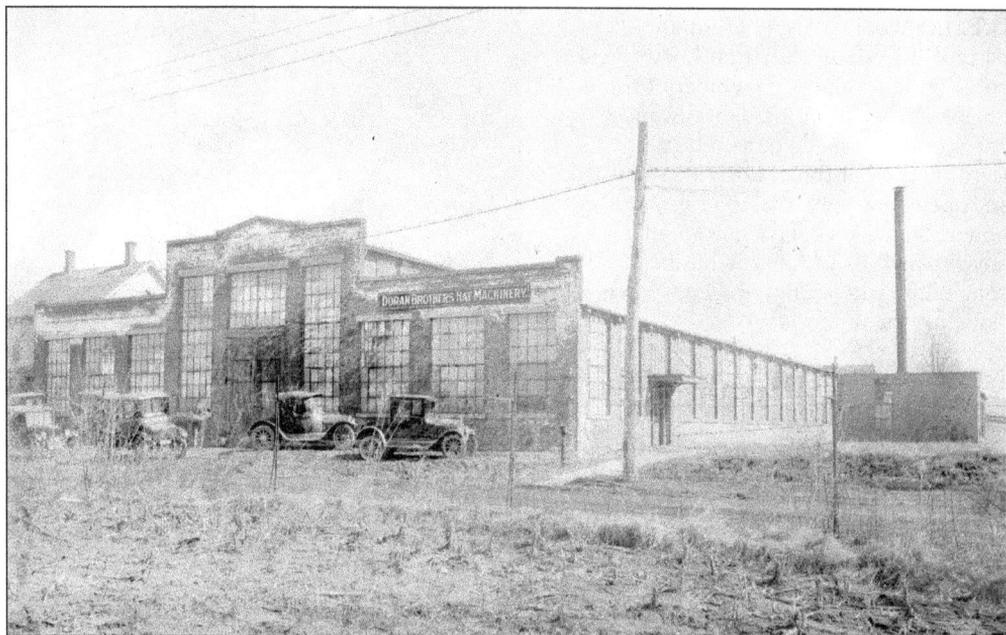

THE DORAN BROTHERS HAT MACHINERY FACTORY, SHELTER ROCK ROAD. When Charles H. Reid came to Danbury from Waterbury, his employment at the Marlin and Fanton sewing machine plant gave him ideas for producing equipment for the hatting industry. Already an inventor of a patented drill chuck, Reid had shops on North Main Street and Balmforth Avenue that produced hat-brim rounding, sandpapering, and ironing devices. Reid's nephews, John and James Doran joined the business and the name was changed to Doran Brothers.

JOHN CHARLES DORAN. Born in Waterbury in 1874, John Charles Doran was the son of John W. and Elizabeth (Reid) Doran. He came to Danbury in 1900 and worked for his uncle Charles Reid. He and his brother James Doran took over their uncle's business in 1903 and changed the name to Doran Brothers. In 1920, the business moved from River Street to Shelter Rock Road. John C. Doran was the second president of the company.

JAMES FINTAN DORAN. An original director of the Danbury Industrial Corporation, James F. Doran was vice president of Doran Brothers. He spent time in England setting up machinery and was issued patents for hat crown-pouncing machines in 1912, a steam chamber for softening felt in 1926, and a hat-clipping machine in 1931. The company survived the decline of the hatting industry by developing machinery for defense needs and components for the space program.

MRS. JAMES F. DORAN AND FAMILY. Members of the Doran family, from left to right, are Marion Doran, Sarah C. McNiff Doran, and Edward, Raymond, and Frank Doran. Sarah Doran's sister Mary McNiff married John C. Doran, the brother of James Doran.

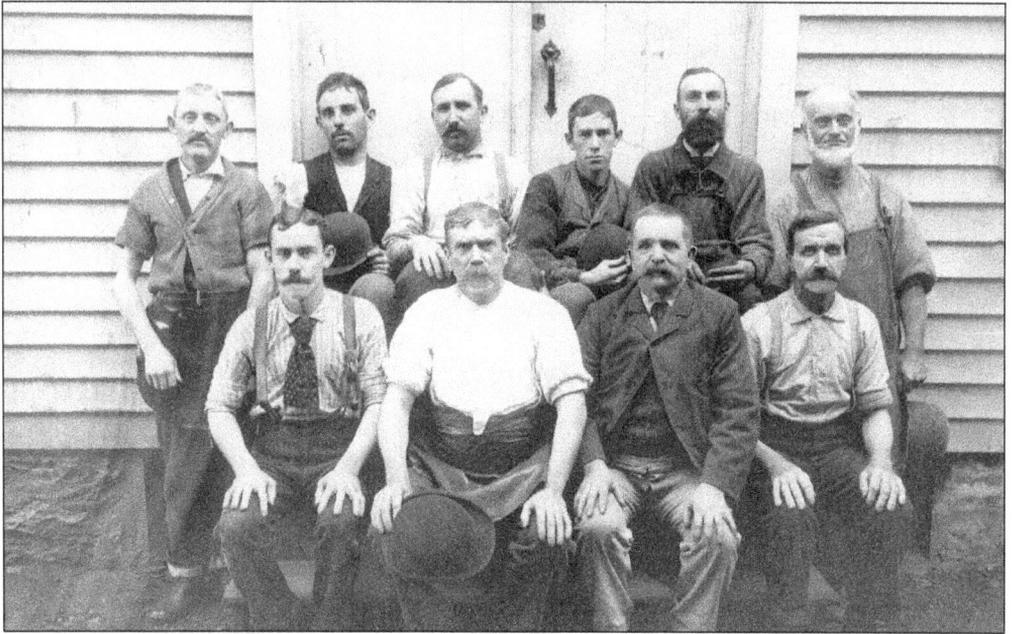

THE MALLORY FORMING DEPARTMENT, 1890. A hatting concern was measured by the number of forming machines used in production. Introduced in the 1840s, the forming machine was able to form 30 hat bodies in the same amount of time it took to bow one by hand.

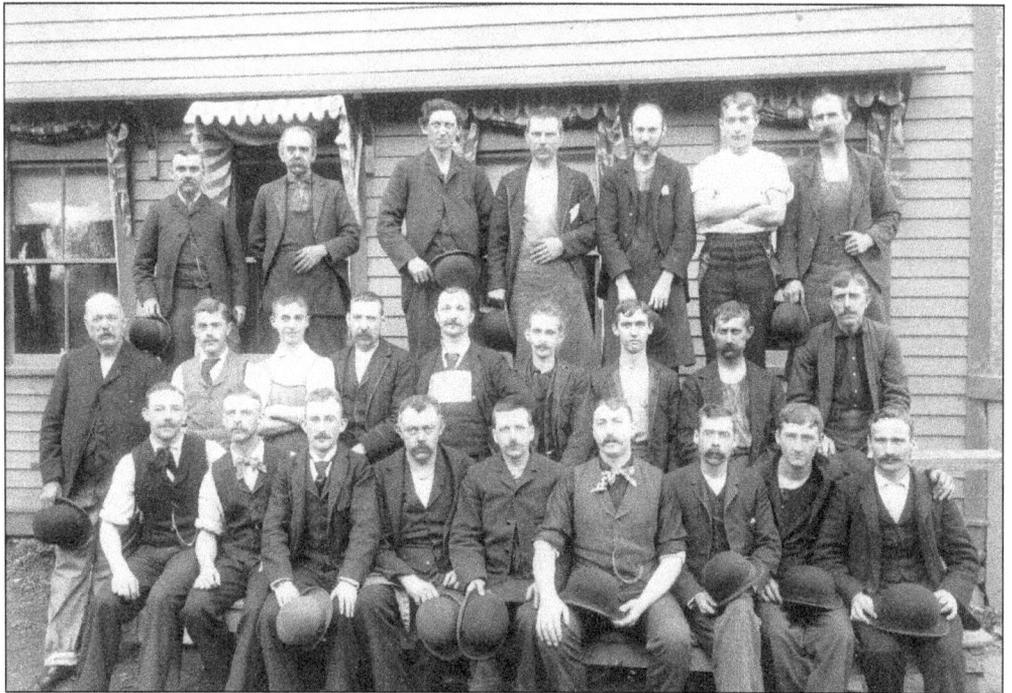

THE MALLORY STIFF FINISHING DEPARTMENT, 1890. An application of shellac was used to firm the hat body. The brims of soft felt hats were slightly stiffened with shellac that was cut with a soda and salt solution. In the 1890s, stiff hats such as the highly popular derby, received a heavy treatment of an alcohol-prepared shellac.

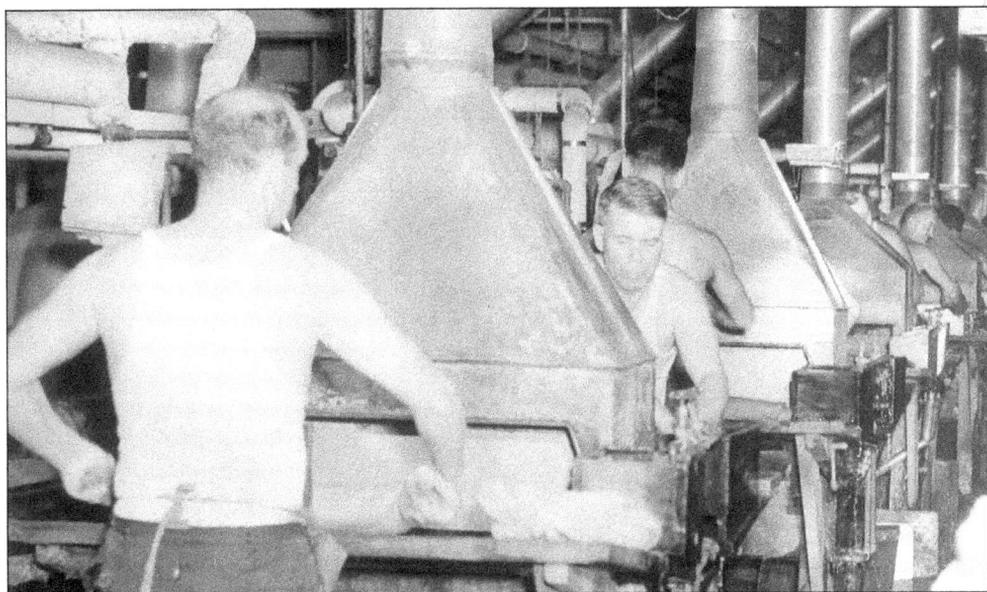

H. McLachlan & Company Wetting Down Department. An aspect of the hardening process was the wetting down of several hat bodies that were piled and rolled and then placed in a machine that kneaded them rapidly. This was one of the methods in fur felt hat making that shrank and at the same time strengthened the fur, using pressure.

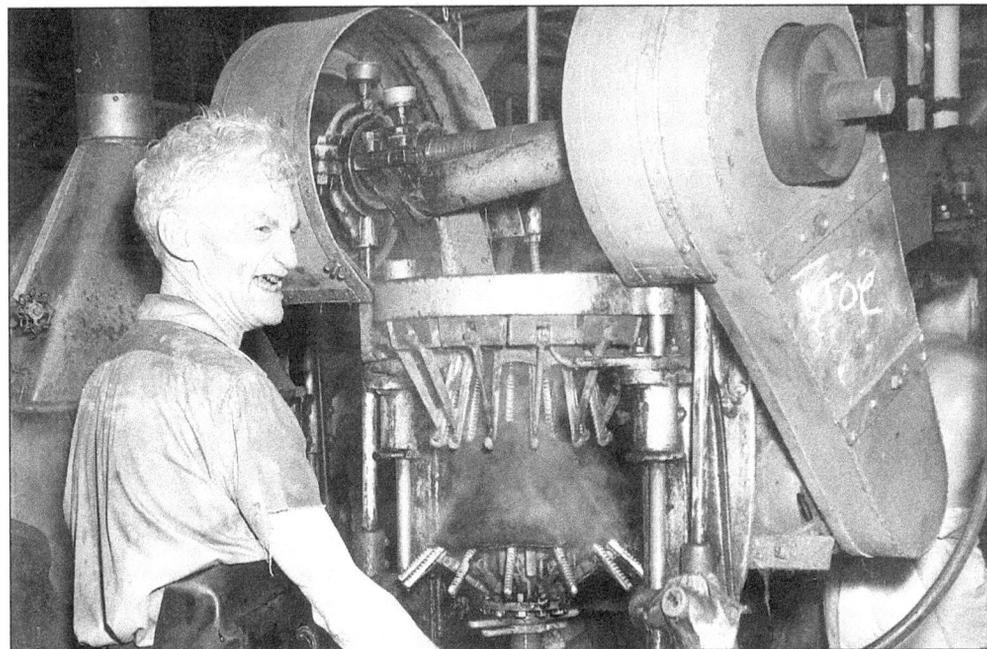

The Mad Hatter, H. McLachlan & Company, Brim Stretching. Mercury nitrate had been applied to fur for centuries to aid in the felting process. Steam produced at various stages was inhaled by the hatters and this affected their neurological systems. "Hatters' shakes," a palsy resembling a symptom of Parkinson's disease, and recessed gums were some of the effects of the mercury poisoning. In the 1930s, a patent for a nonmercuric substance was issued and in 1941, mercury was outlawed in 26 states.

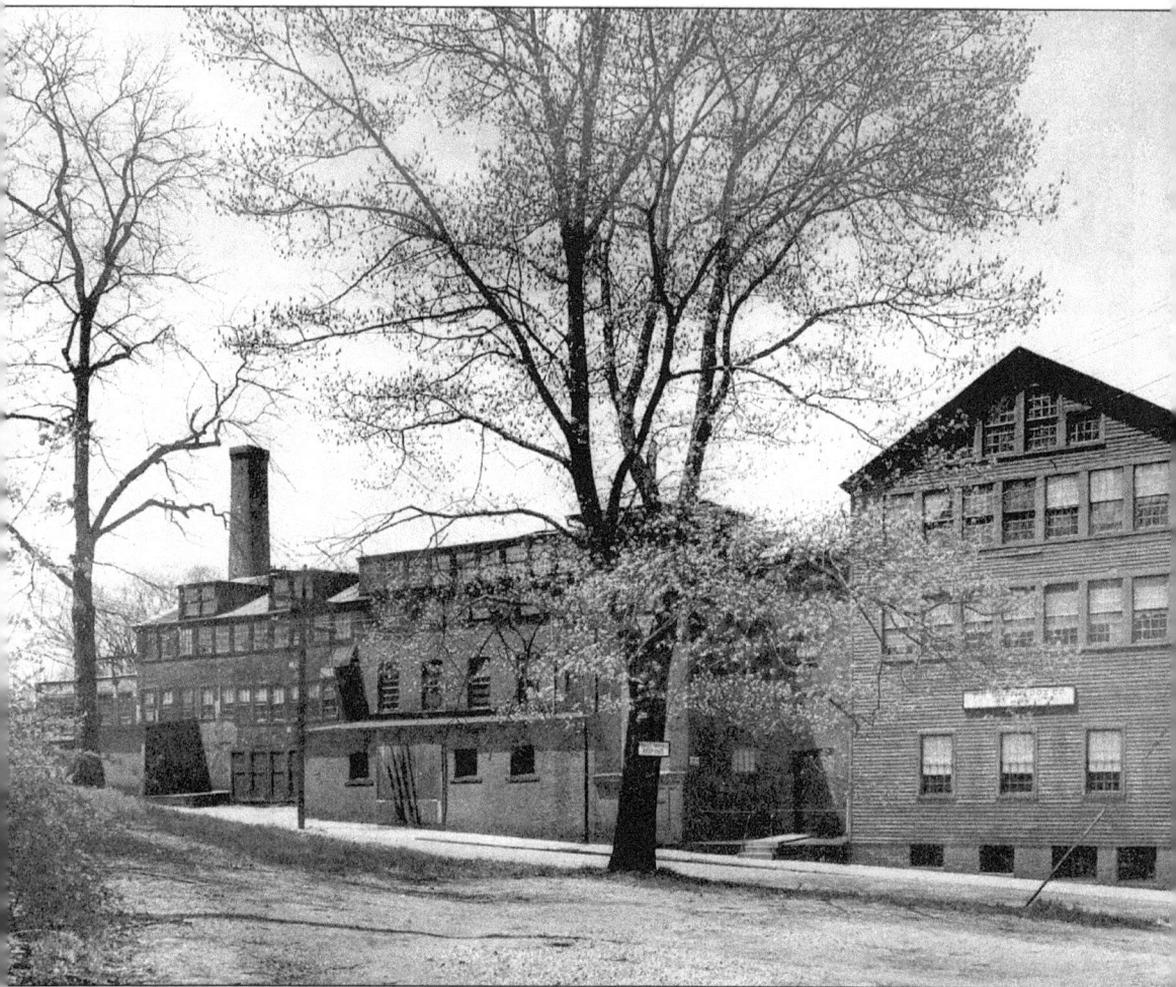

THE CLARK BOX COMPANY, 1956. A successor of Theodore Clark & Company, the Clark Box Company was located at Main and Water Streets on the site of the former Merritt Hat Company. In 1891, the company was making cases and bandboxes, in addition to tip printing (stamping the hat lining with a logo) and stitching hat sweats. Box making, or hat-case manufacturing, fur cutting, the production of hat machinery, and the fabrication of silk for hat trimming and linings were considered allied businesses of the hatting industry.

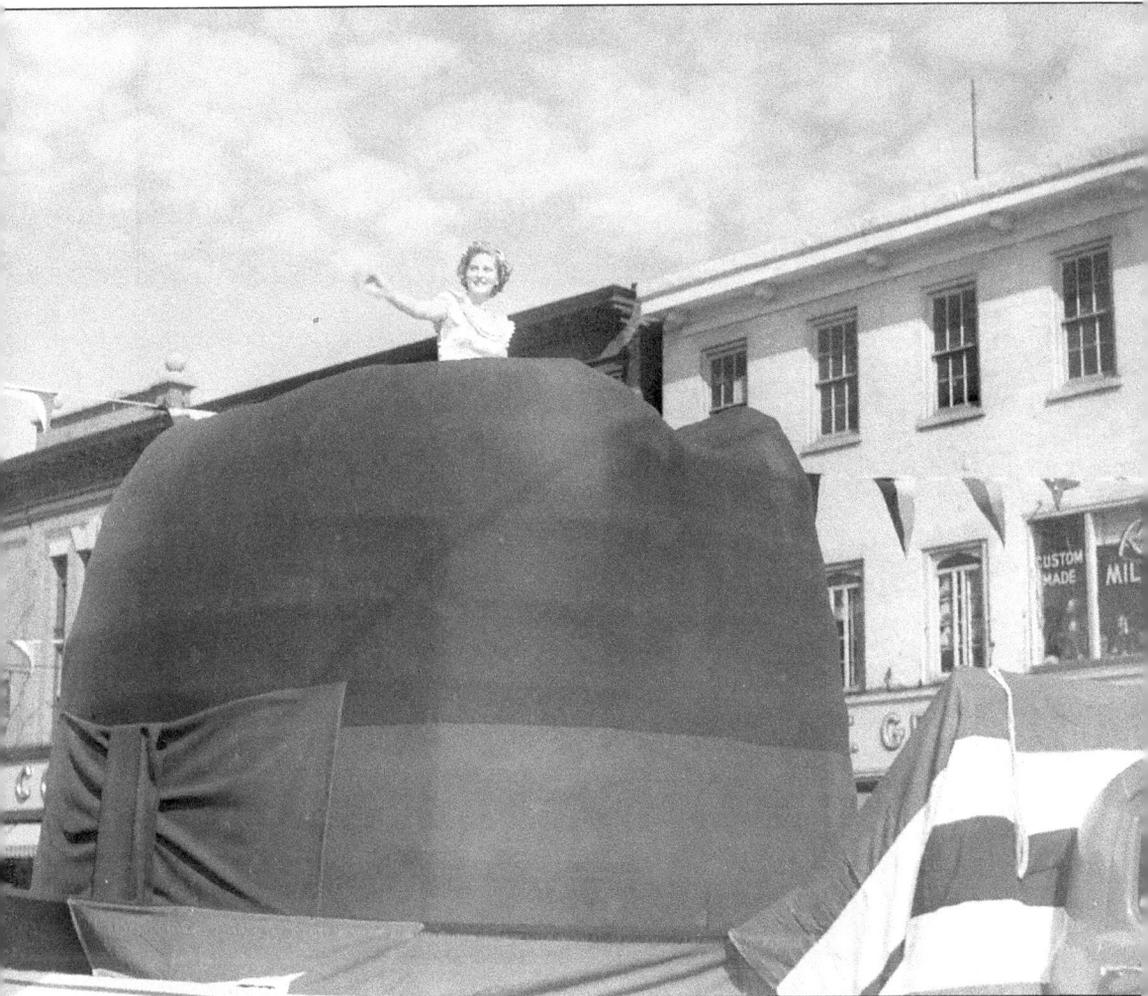

THE HAT PARADE, OCTOBER 1950. Considered to be the largest hat in the world, this 20-foot-wide by 8-foot-tall chapeau was constructed by students of Henry Abbott Technical School (HATS) and sponsored by the Danbury News-Times. Passenger Irene Fenick, the queen of the Hat Parade, had to keep an eye out for banners strung across the parade route. Members of the Kiwanis Club in Keystone Cop attire were on the lookout for bareheaded spectators, whom they locked up in the "Jail on Wheels."

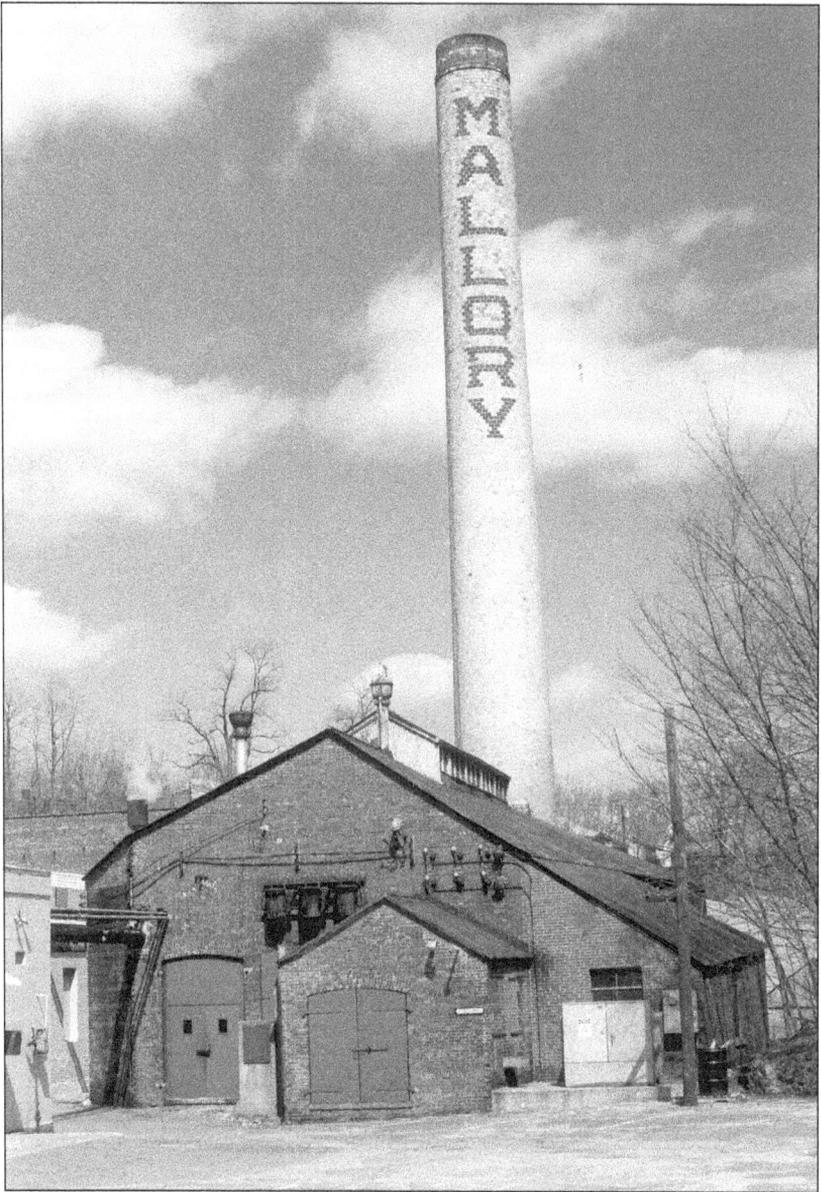

THE MALLORY HAT FACTORY, ROSE HILL AVENUE, 1982. Five years after this photograph was taken, the hatting industry in Danbury came to an end. After World War II, Americans returning home from service brought with them a hatless trend (instigated by the invention of the automobile) that was already fashionable in Europe. Shortly afterward, the John B. Stetson Company of Philadelphia bought the Mallory plant and in 1956, it moved the front shop operations to Philadelphia. In 1965, it closed the shop on Rose Hill Avenue, terminating the 148-year-old Mallory business. In 1968, Bieber-Goodman of Bethel relocated here and became the Danbury Hat Company. The trend of western dress, aided by Hollywood in the 1980s with the movie *Urban Cowboy*, and the growing popularity of country-western music wasn't enough to sustain hat making in Danbury. On December 18, 1987, the Danbury Hat Company closed its doors. By the year 2000, all the Mallory buildings at the northeast corner of Rose Street and Rose Hill Avenue were gone.

Six

THAT WAS NOW, THIS IS THEN

If the past holds any lessons for the present and for the future, it is that change is inevitable.
—Stephen Collins, editorial director of the New-Times, 1983

Although downtown Danbury has traditionally been the center of activity for the town, it seems that it has almost always had an abundance in one area and a lack in another—the former being traffic and the latter being parking.

A hatless trend was already in evidence by the end of the First World War. However, clothing and food chain stores began to spring up in the center of town and helped to keep the economy going. The popularity of the automobile, a major contributor to the downfall of the hatting industry, was also seen as a deterrent for shopping downtown. In the 1940s, Main, West, White, and South Streets could scarcely accommodate the traffic on Routes 6, 7, and 202, components of the highway system.

Developers looked to the outskirts of town for building retail centers. The Berkshire and North Street shopping centers were convenient to the soon-to-be-finished Interstate 84. And although an unwanted 10 feet of water in 1955 resulted in a revitalization of downtown, Main Street struggled to compete. An ill-fated downtown mall and the modernization of some storefronts were fortunately counteracted by the preservation of the Old Jail, the Martha Apartments, and the old Danbury Library.

Community services received a boost in the second half of the 20th century with a new police station, fire department headquarters, library, and courthouse. The establishment of the CityCenter historical, dining, and entertainment district has helped to retain the cultural aspects of Danbury.

THE SAVINGS BANK OF DANBURY, MAIN AND CHAPEL PLACE. This institution and the Ives homestead were neighbors for almost 120 years. The bank's first business was actually transacted in the parlor of that home in 1849 by treasurer George White Ives, the grandfather of Charles Ives. (Ironically, it was because of banks that the house was moved twice: first for a new building for the Danbury National Bank in 1924 and then for the Fairfield County Trust's parking lot in 1966.) Built in 1909, this is the main branch of the Savings Bank of Danbury at its fourth and current location.

THE CONGREGATIONAL CHURCH, MAIN AND CHAPEL PLACE, C. 1890S. The fourth building erected for the First Congregational Church in Danbury is flanked by the Ives homestead on the left and the United Bank building on the right. The church had considerable influence on composer and 1947 Pulitzer Prize winner Charles Edward Ives. It was destroyed by a fire in 1907.

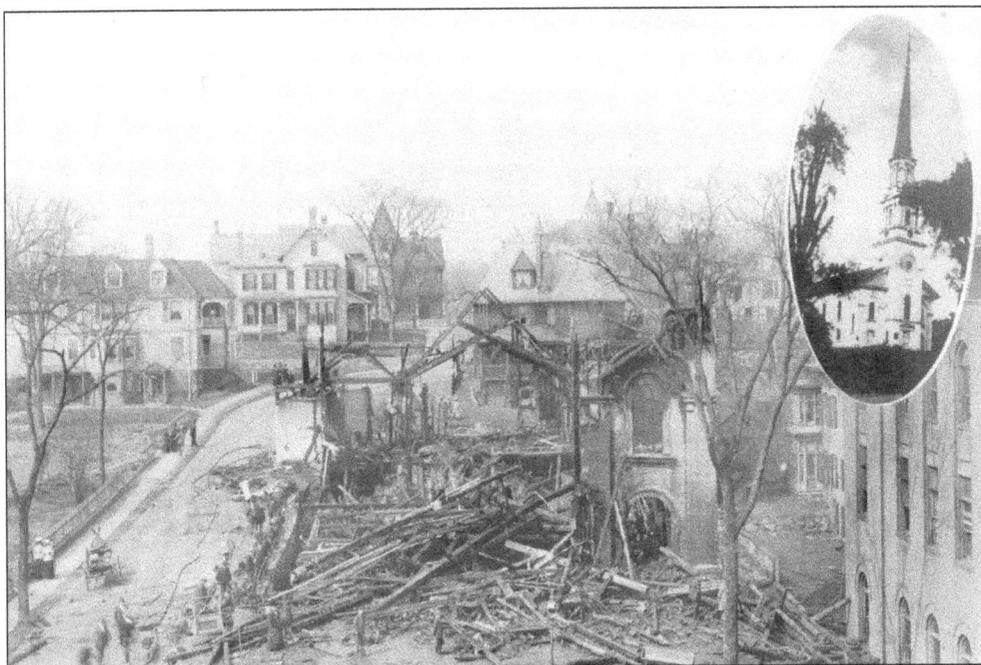

THE CONGREGATIONAL CHURCH RUINS, MAY 6, 1907. Soon after the church burned to the ground, area residents who had relied on the building's clock and bell had to get used to the loss of that familiar sight and sound. The weather vane on top of the steeple had been visible from nearly everywhere in town. The congregation voted to buy the Hull property on West Street for a new church.

MAIN AND STATE STREETS, 1961. Built in 1881 by downtown developer D.P. Nichols, 85–87 Main Street was separated into stores and apartments in the early 20th century. From 1956 to the 1990s, Shea's Photo Studio was located at 87 Main Street. Farther up the street, 97 Main Street was Shanley's market from 1924 to 1962, succeeded by the New York Bake Shop.

MCNIFF'S, MAIN AND STATE STREETS. When James McNiff bought this property (85 Main Street) in 1886, 31 of the 40 saloons in Danbury were run by Irishmen. Like the other neighborhood bars at 103 and 109 Main Street, McNiff's closed in the 1920s.

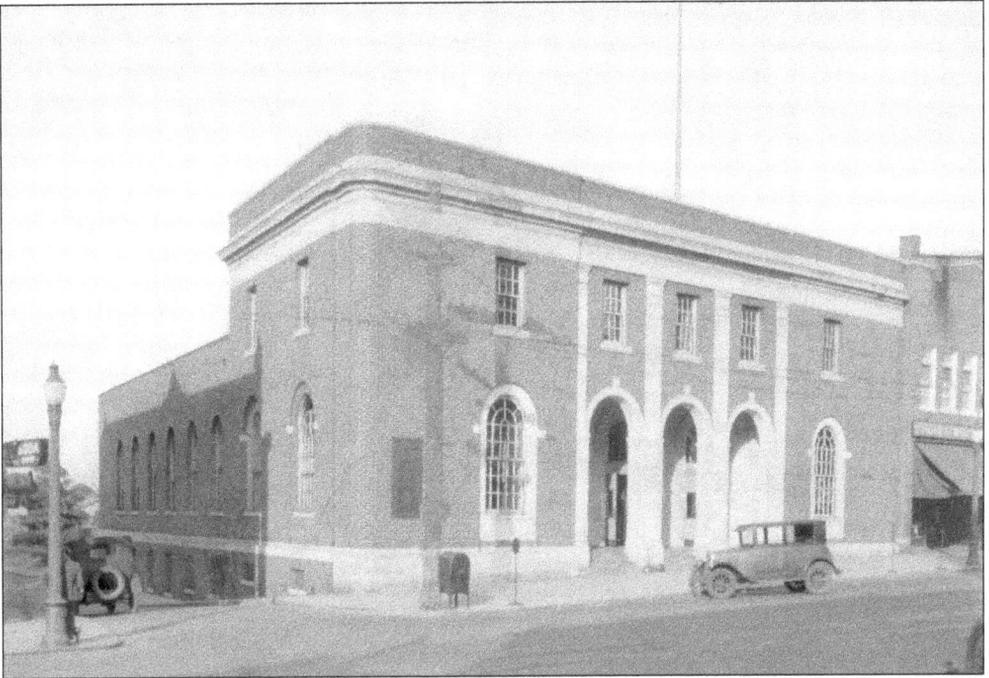

THE POST OFFICE, MAIN AND POST OFFICE STREETS, C. 1930. When the post office was built in 1915, the middle of the street in front of the structure was the meeting point of the corners of the city's four wards. On August 31, 1916, the public was allowed to inspect the work area of the new post office. It opened on September 2, 1916.

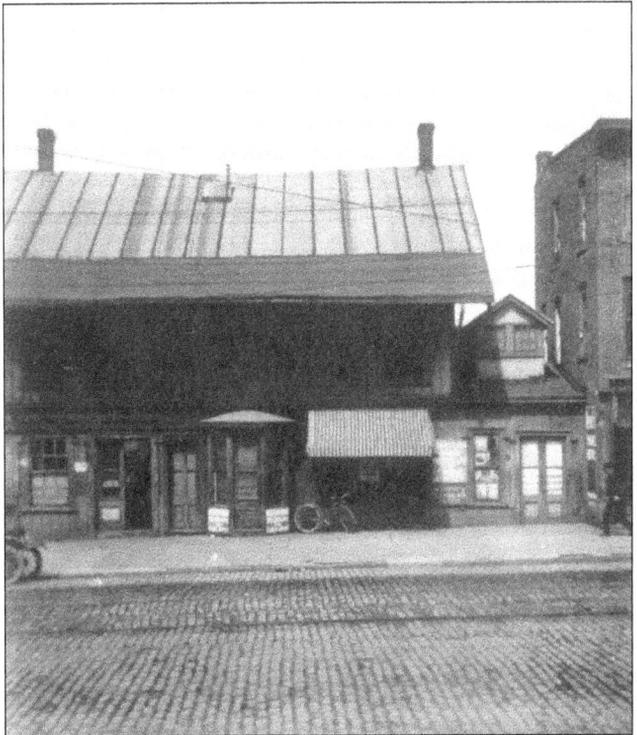

THE OLD DANBURY AND NORWALK TRAIN STATION, MAIN STREET. In 1907, the Danbury Business Men's Association, led by merchant John Woodruff, started a crusade to have a post office built on the site of the abandoned train station. Similarly in the 1850s, businessmen had grappled for the railroad depot to be built here instead of on a site in the southern part of Danbury (page 52).

DUNKIN DONUTS, WHITE STREET AND BALMFORTH AVENUE. Miller's Diner occupied this site for several decades before Dunkin Donuts arrived in 1967. Within walking distance of the railroad station, it has been a convenient stop for commuters prior to boarding the train.

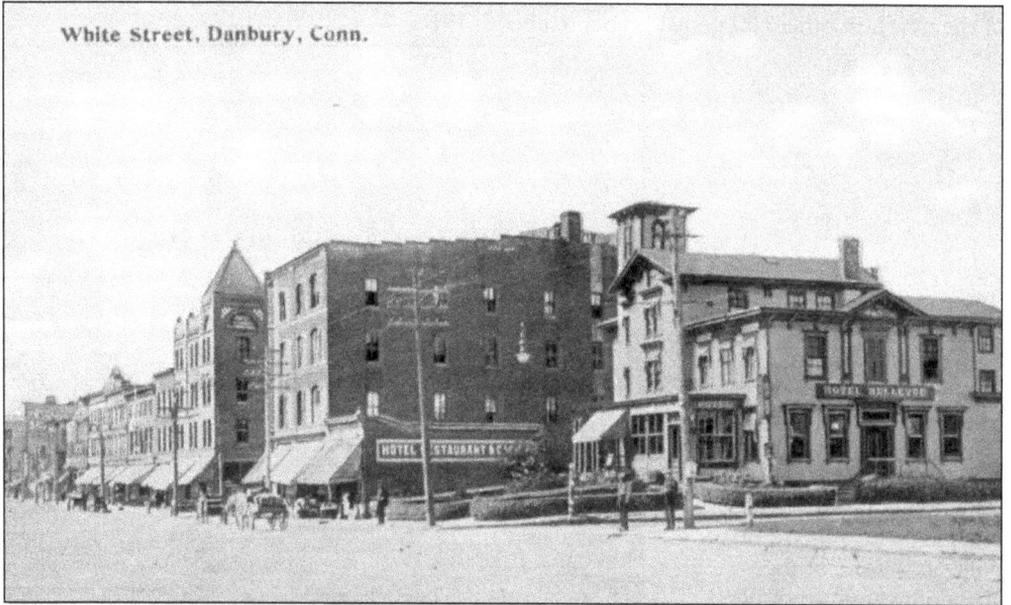

THE HOTEL BELLEVUE, WHITE STREET AND BALMFORTH AVENUE. The streetscape west of White Street at Maple Avenue (left of hotel) in this picture postcard bears little resemblance to the scene today. The unfamiliar buildings were torn down in the 1960s as part of a downtown redevelopment project. The edifice between Balmforth and Maple began the 20th century as the Wooster Inn and then became the Hotel Bellevue. In 1912, it was rechristened the Hotel Edelweiss.

THE POLICE STATION, 120 MAIN STREET. This property's significance in the history of Danbury began during the American Revolution, when the British invaded the town in 1777. On April 26 of that year, the occupants of the house on this site fired at the opposing army as it proceeded down Main Street. Setting fire to the building, the British destroyed the home of Maj. Daniel Starr, as well as the patriots inside. Included in this group was a black slave from Redding.

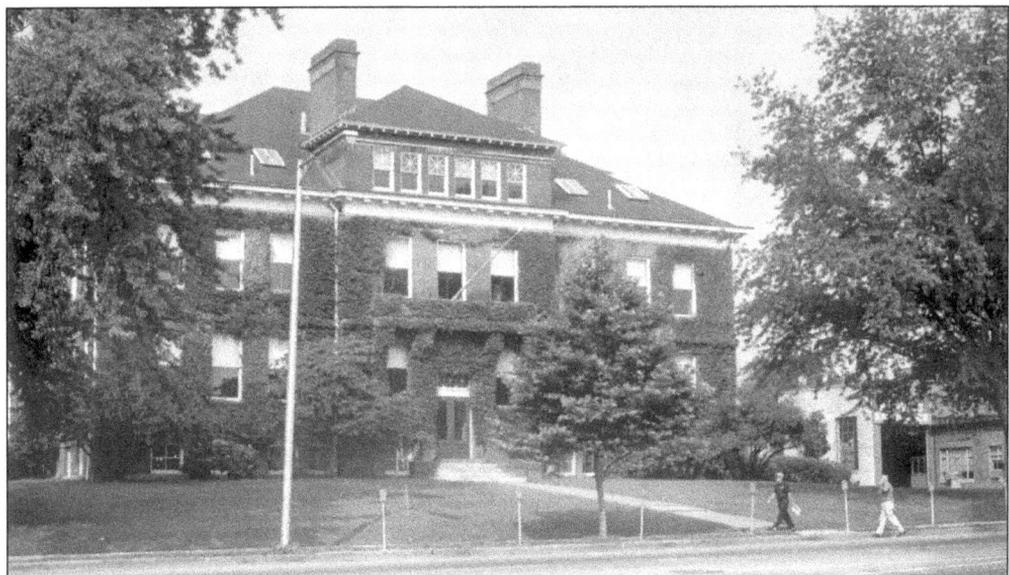

MAIN STREET SCHOOL, 120 MAIN STREET, 1927. The first high school was organized in 1874, but a building specifically for grades 9 through 12 was not erected until 1903 on this site. Overcrowding resulted in high school students moving to new buildings—on White Street in 1927 and Clapboard Ridge in 1965. In the meantime this building was used as a junior high until 1965. The police department occupied it beginning in 1967 until it was bombed in 1970. (page 112).

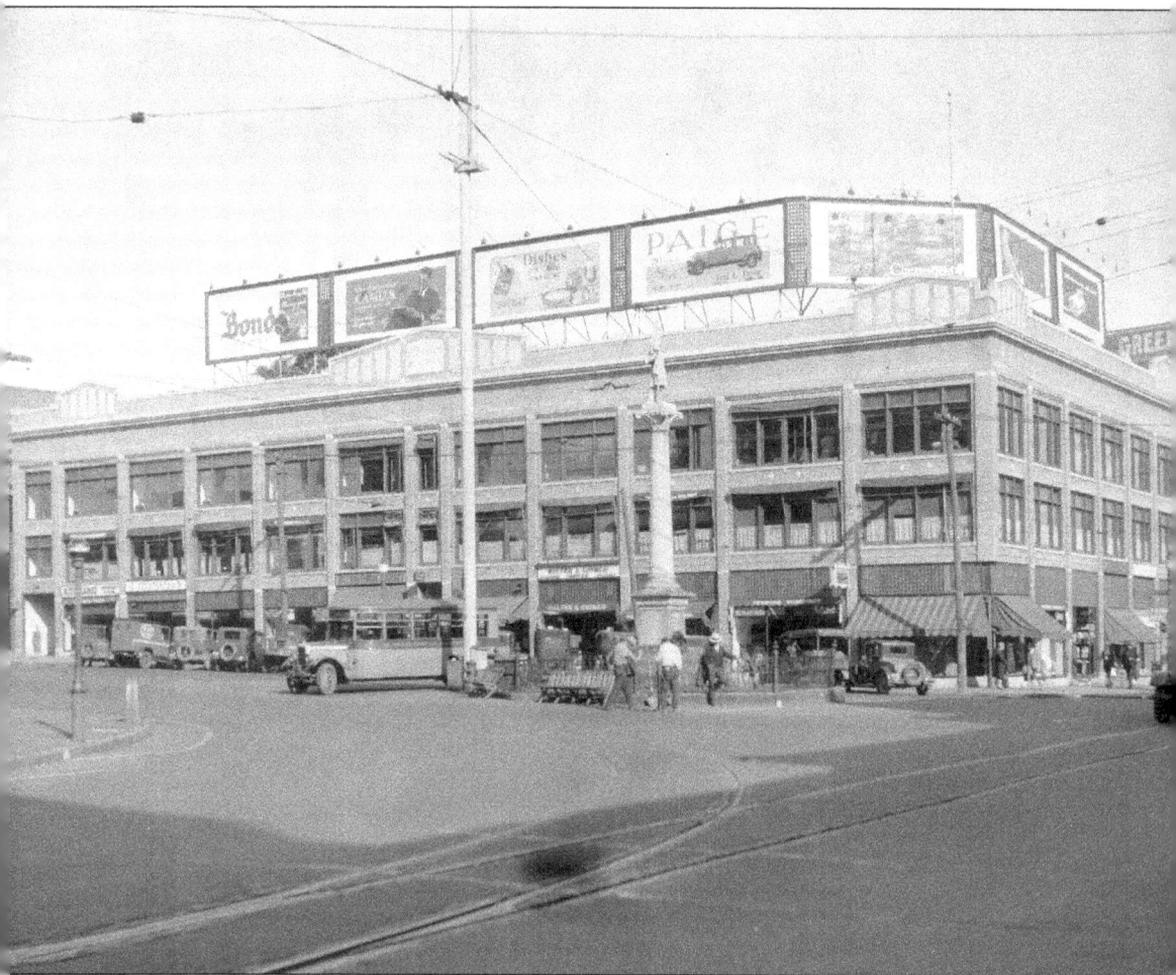

THE PERSHING BUILDING, WEST AND MAIN STREETS. Erected in 1923 on the ruins of the Taylor Opera House, this building was named for John Joseph Pershing, the general and chief of staff of the U.S. Army. Pershing, however, did not attend the dedication ceremony. At 35,000 square feet, with 14 stores on the ground floor and 58 offices in the upper levels, it was the largest commercial building at the time. For a while it was connected to the Hotel Green on Main Street; its third floor converted into hotel rooms.

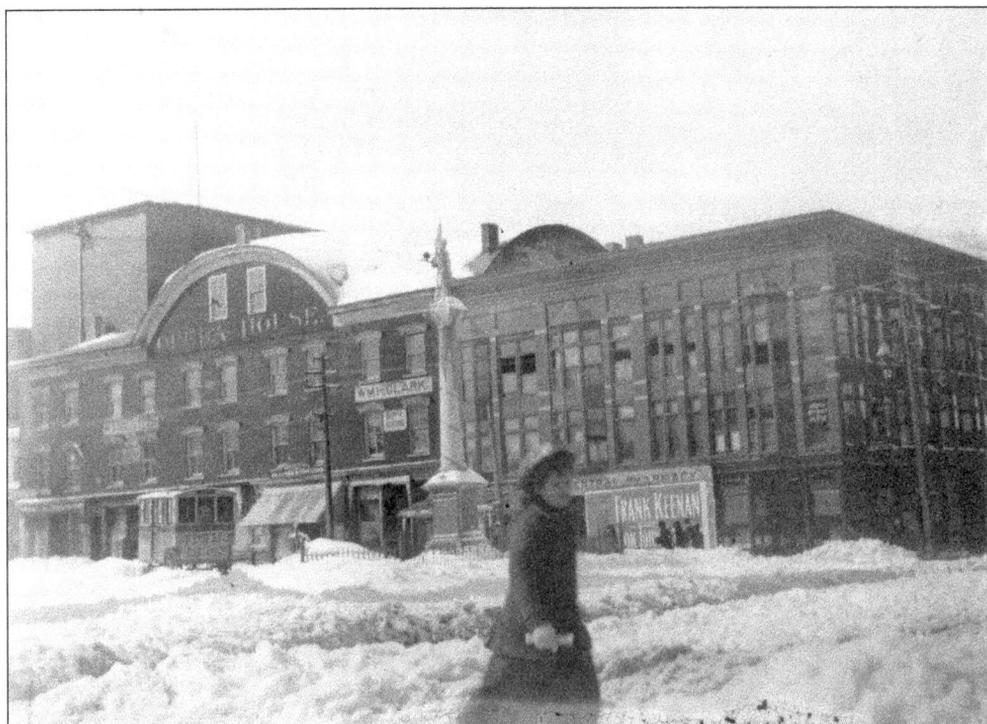

THE TAYLOR OPERA HOUSE, WEST AND MAIN STREETS. A performance of *Belshazzar* at the Taylor Opera House helped raised money for the Civil War monument that was erected at this intersection in 1880. Over the years the opera house has held walking matches on a 160-foot track and has staged several performances of *Uncle Tom's Cabin*.

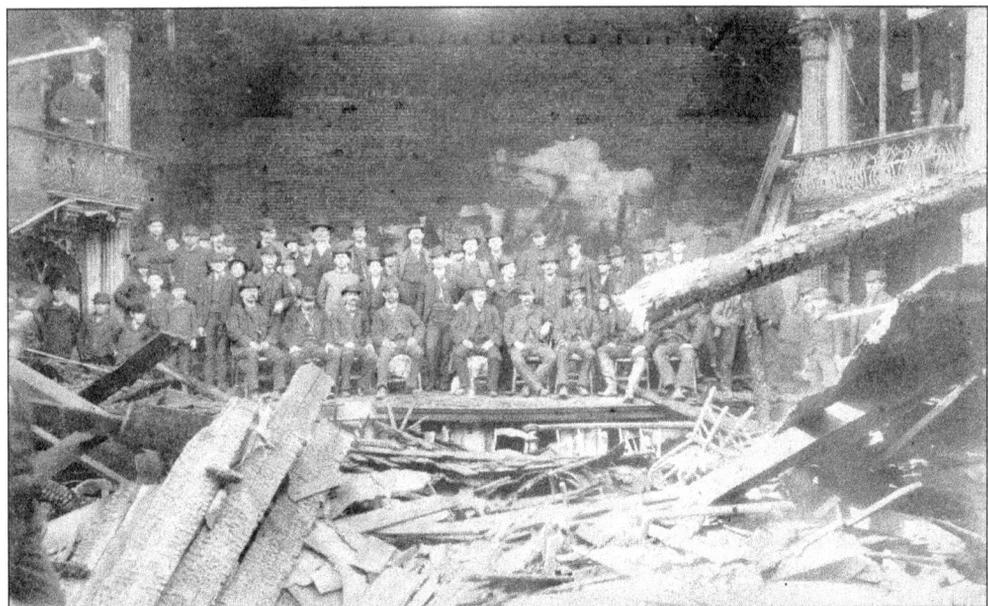

THE SHOW MUST GO ON. The Taylor Opera House, built in 1870, was damaged by a fire in 1884 and then burned to the ground on October 29, 1922. The fire started in the building on Main Street and spread to 15 businesses before it was contained.

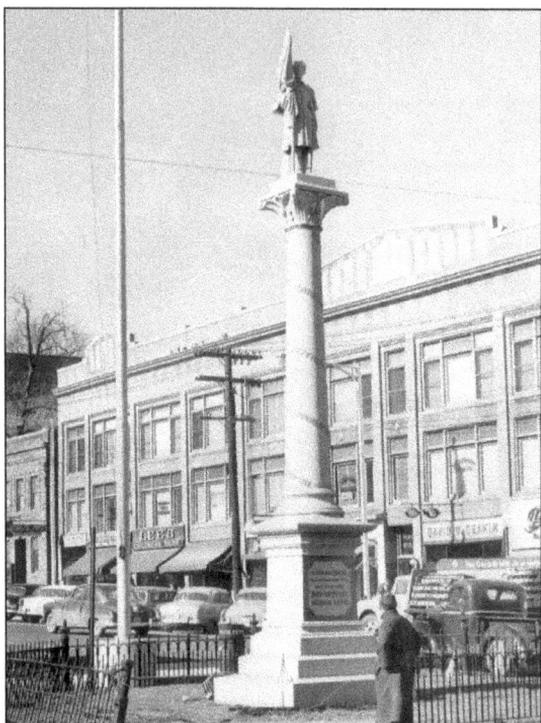

THE SOLDIERS MONUMENT, MAIN AND WEST STREETS. This monument was erected in 1880 at the intersection known as Concert Hall Square, later called City Hall Square. Plans for a memorial to the Civil War actually began in 1862, before that conflict ended. The soldier figure composed of Italian marble sits atop a granite column embroidered with the names of famous battle sites.

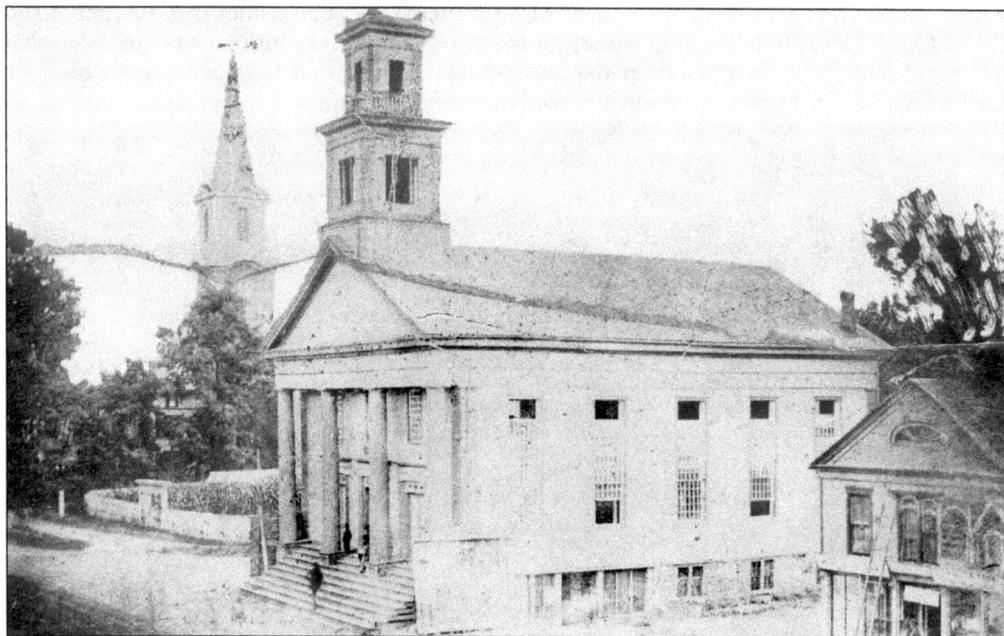

THE CONCERT HALL, MAIN AND WEST STREETS, C. 1860S. The third Congregational meetinghouse (center) was built in 1785. In 1858, a new church was erected at Main Street and Chapel Place and this building was converted to a concert hall and town gathering place. It was a carriage salesroom before it was moved to Center Street. The Soldiers Monument now occupies this spot, and the Danbury Public Library is now on the site of the Methodist Episcopal church in the background.

Seven

MEET THE PRESS

*And in making our exit we suggest our epitaph: "Since so soon we're done for,
We wonder what we were begun for."*
—The one and only Woman's Edition of the *Danbury Evening News*, July 15, 1895

In 1983, the News-Times celebrated 100 years of publishing a daily newspaper. James Montgomery Bailey, proprietor of the Danbury News, began printing the daily on September 8, 1883. Bailey had been publishing the *Danbury News* since 1870 and had attempted to publish an edition every day in 1871 (the *Daily News*), but it was short-lived. The *Danbury Evening News* was circulated every day except Sunday and Wednesday, and the *Danbury News* was published on Wednesday.

The *Danbury News* was circulated worldwide, and the publisher's wit was well known and imitated. Bailey even heard his words being sold on the streets of London in 1874. A sample: "The ball game yesterday between Brookfield and New Milford, played in the old cow pasture, ended abruptly when Tom Smith slid into what he thought was second base."

In 1790, the first newspaper in Danbury, the *Farmers' Journal*, was published weekly and carried little local news. The majority of space was occupied by advertisements and notices. P.T. Barnum's *Herald of Freedom and Gospel Witness* was first published in 1831. In 1832, Barnum was incarcerated (page 23) in Danbury for libel.

The first newspaper to be called the *Danbury News-Times* was published in 1933 after a merger of the Danbury News and the Danbury Times. The *Danbury Times* was a rival newspaper begun in 1927 on Library Place and funded by Danbury hatter Frank H. Lee. Danbury was dropped from the title in 1962, and the first Sunday paper was issued on September 24, 1972.

JAMES MONTGOMERY BAILEY. Referred to by Walter Winchell as the "first columnist," James Montgomery Bailey's name was synonymous with the news of Danbury from when he began publishing here shortly after the Civil War until his death in 1894. He and his partner, Timothy Donovan, acquired the Danbury Times and the Jeffersonian and inaugurated the printing of the *Danbury News* in 1870. One of the founders of the Danbury Hospital and a Sunday school teacher, he was asked to run for mayor (shortly after Danbury became a city in 1889) but refused.

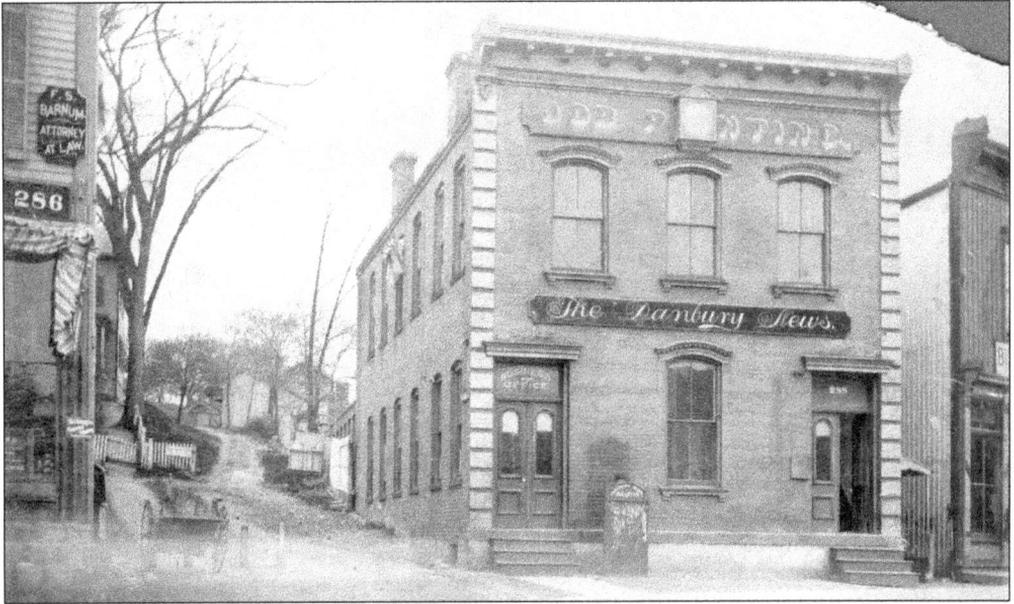

THE FIRST DANBURY NEWS BUILDING, 1888. In 1873, the first building for a Danbury newspaper was constructed by local builder William Webb Sunderland at the corner of Main and Elm Streets. The newspaper had been printed previously at the corner of Main and White Streets, close to the Still River, a source of water for the presses. Slogans utilized were "A Record of a Yankee Town" and "A Journal of Today."

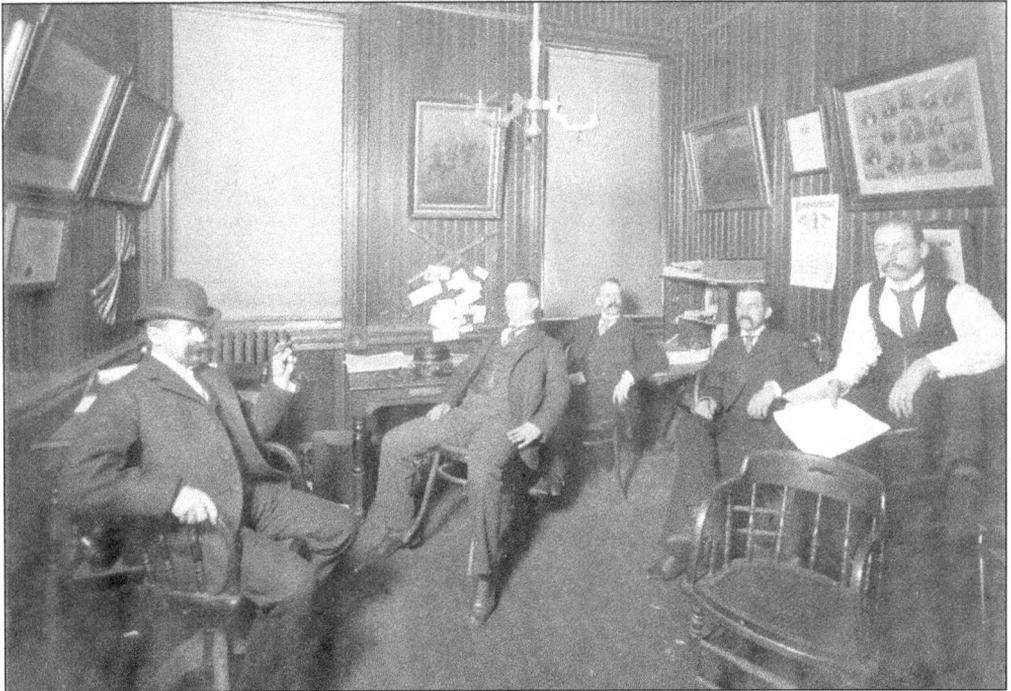

THE DANBURY NEWS OFFICE, 1895. Shown in the news office, from left to right, are George W. Flint (who succeeded James Montgomery Bailey as publisher), William E. Bulkely, John Rhodemeyer, George Hallock, and Fred B. Dalton.

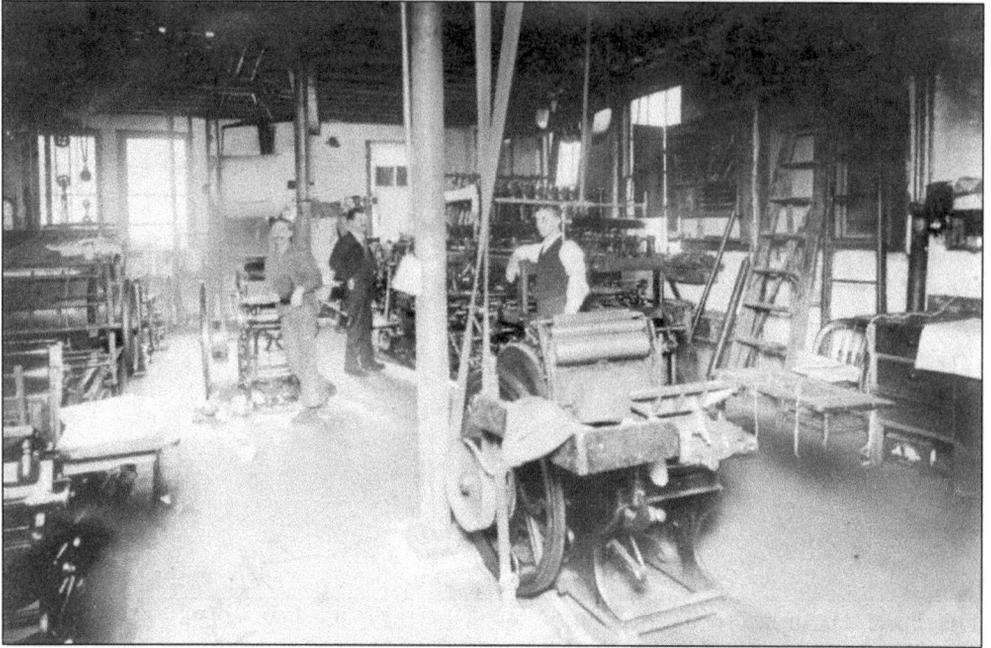

THE DANBURY NEWS PRINTING ROOM, 1894. "Following the custom of many years, the *Danbury News* will be published early tomorrow in order that its employees may have an opportunity to attend the Danbury Fair and enjoy Danbury Day with their families at the grounds. The paper will go to press at noon and will be on the streets a few minutes later."

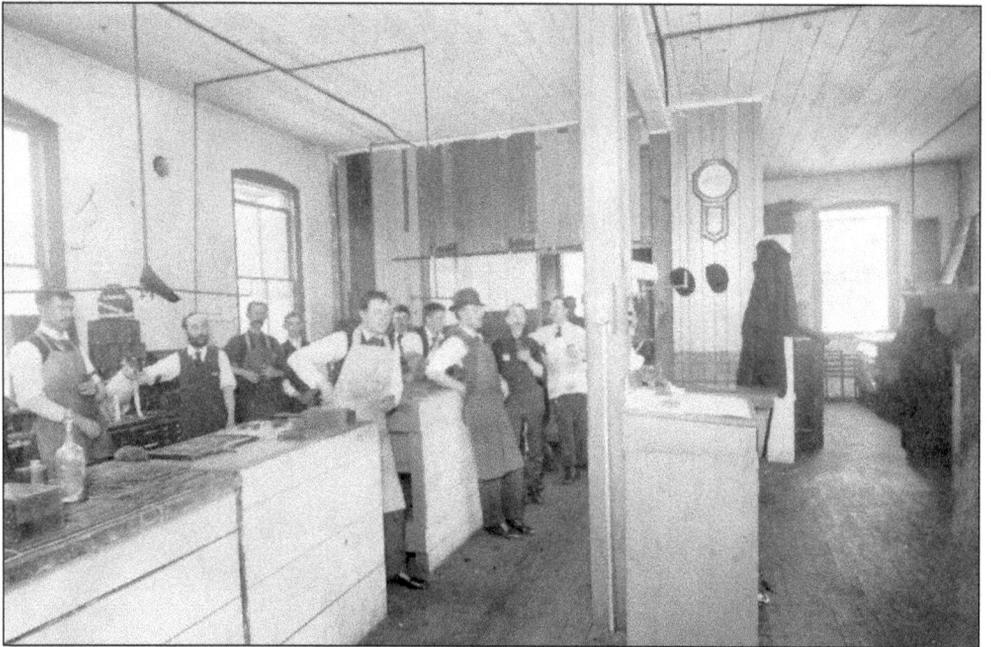

THE DANBURY NEWS EMPLOYEES, 1894. Employees, from left to right, are F.C. Capron, J.S. Warren, S.C. O'Connor, W. Hahn, C.T. Peach, H. DeLong, A.W. Morehouse, W.F. Dobbs, John Canfield, and Jesse Ketcham. In the stereotype room are Foster Fuller and George W. Morehouse.

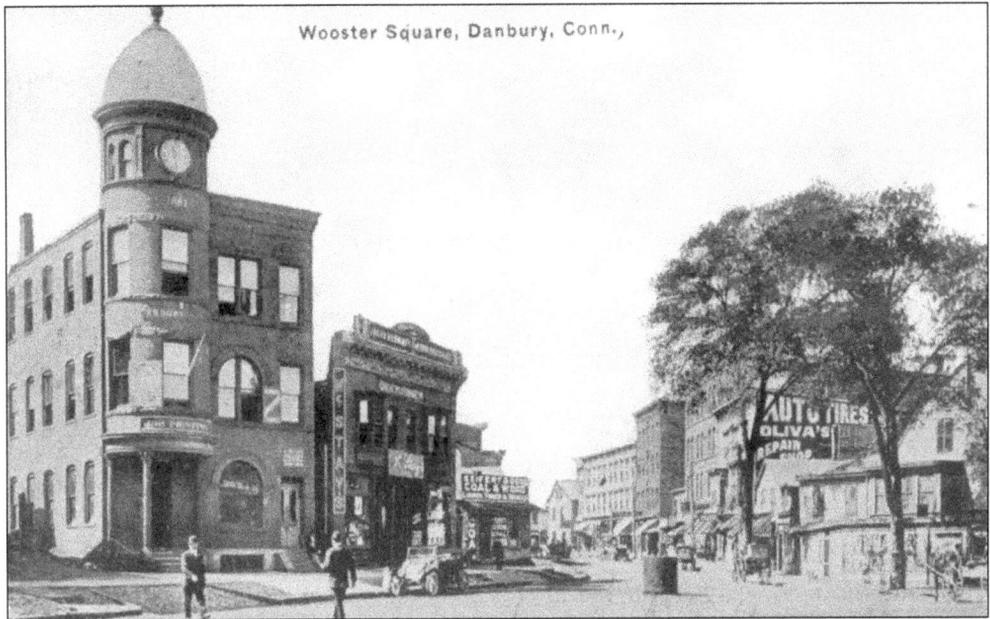

THE DANBURY NEWS BUILDING WITH TOWER. In 1893, the length of the Danbury News building was doubled and a third story was added. Philip Sunderland conceived the familiar tower constructed in two sections. The News merged with the Danbury Times in the 1930s and, by 1956, the Danbury News-Times had overtaken seven floors and three buildings. The building was featured on the November 12, 1955 cover of the *Saturday Evening Post*.

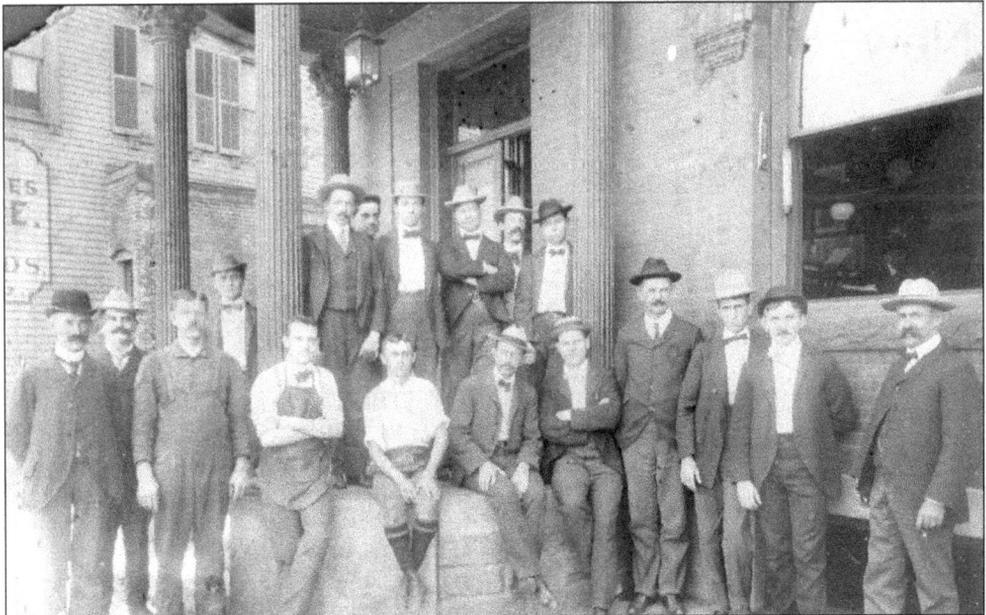

THE DANBURY NEWS EMPLOYEES, 1901. The last newspaper to be published at 288 Main Street was the January 17, 1970 edition. William Webb Sunderland, grandson of the original builder and son of the architect who redesigned that building in 1893, was selected to plan the renovation and enlargement of its new and current home at 333 Main Street. The *News-Times* was published for the first time as a morning paper on April 25, 1983.

THE CHRONICLE STAFF, 1912–1913. In days gone by, Danbury High School published a small magazine, the *Chronicle*. It was authored by the student body and contained essays, short stories, and poetry. By all accounts it was an honor to be on the staff charged with reviewing submissions and editing and producing several editions of the magazine every school year.

THE *NEW STREET MONTHLY*, MAY 11, 1892. Edited and published by J. Moss Ives, brother of composer Charles Ives, this issue of the school paper contained an appeal for a new park between Mountainville and Coalpit Hill Road. Also, an article warned of the dangers of hitching rides on vehicles: "scholars run out into the street, catch on the end board of a passing wagon and hang there with feet dangling dangerously near the spokes of the wheels."

Eight

ME JOHNNY HAS GONE FOR A SOLDIER

*The songs of liberty that my ears, thrilled through my heart . . . These feelings
induced me to enlist in the American Army where I served faithfully for about ten months.*
— Jehu Grant, escaped slave who enlisted in Danbury in 1777

There was much excitement in Danbury on that day in April 1775 when a courier announced to the town the news of the Battle of Lexington. Subsequently, 98 men were recruited under Danbury's Capt. Noble Benedict and they joined the campaign in Lake Champlain.

Also recruited for the American cause was a group of artificers: a regiment of craftsmen exempt from fighting, who supplied nails, wheels, wagons, harnesses, and shoes for the war. They also manufactured links for the chain that stretched across the Hudson River at West Point, used to prevent the British from attacking the fort.

In every war since the 1740s, Danbury has sent its residents to defend the nation. Although the War of 1812 was not popular in New England, Danbury sent its quota of men. Danbury's Wooster Guards was the first company in the state to report for duty at the outbreak of the Civil War. A total of 20 local men fought in the Spanish-American War. More than 500 Danbury residents served in World War I and 3,500 in World War II.

In the Korean War, 17 Danbury area soldiers died or were listed as missing. The war in the country formerly known as French Indochina took the lives of 42 local residents. More than just a war, it was referred to as the Vietnam Era and Danbury, like the rest of the country, was caught up in protests, veterans against the war, draft dodgers, and a local war moratorium.

DAVID WOOSTER (1711–1777). "Come on, my boys, never mind such random shots!" David Wooster shouted, rallying his men as they attacked the retreating British in 1777 in Ridgefield. Soon afterward the general, who had captured 15 of the enemy, was transported back to Danbury, having receiving a fatal wound in that confrontation. Born in Stratford, he was a resident of New Haven at the time of the American Revolution. The Danbury chapter of the Daughters of the American Revolution is named for Wooster's widow, Mary Clapp Wooster.

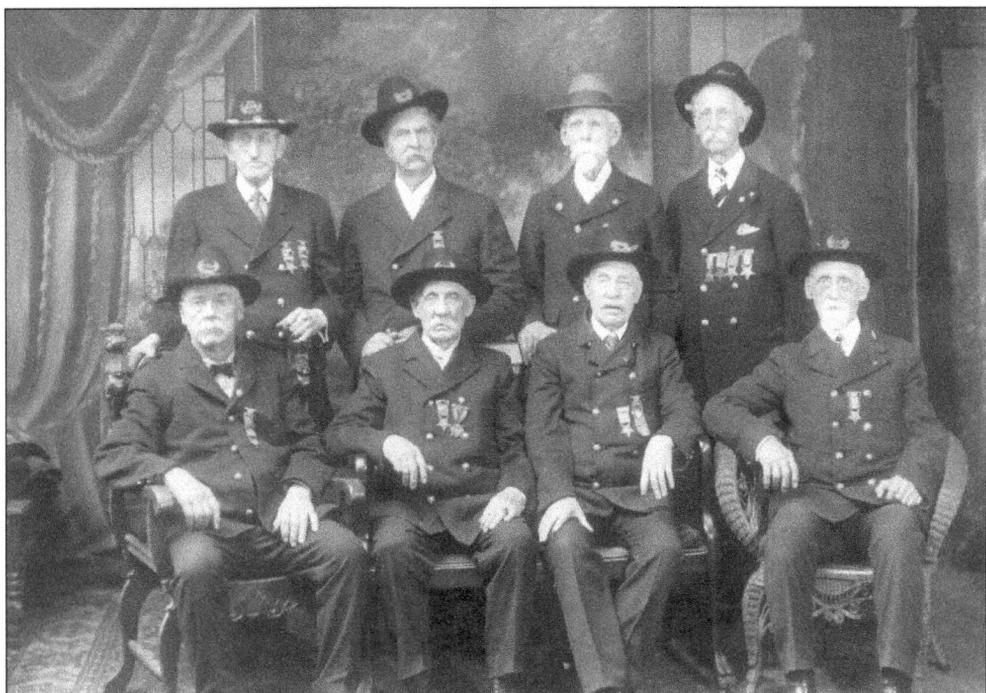

MEMBERS OF THE GRAND ARMY OF THE REPUBLIC, JAMES E. MOORE POST NO. 18.
Capt. James E. Moore, who died rallying his men in the Civil War, commanded a company that included newspaperman Pvt. James Montgomery Bailey. Wooster Cemetery donated a plot for the James E. Moore Post's monument to unknown graves. Besides the 1,000 men who were sent to fight in that war, assistance from Danbury also came in the form of local women's organizations.

DONALD TWEEDY. "From a very solemn lieutenant to his very kind & considerate Dad. Christmas, 1918," wrote 1st Lt. Donald N. Tweedy when he was in France during World War I. The Danbury Veterans of Foreign Wars post is named after Pvt. Raymond A. Walling, who was killed in action in World War I.

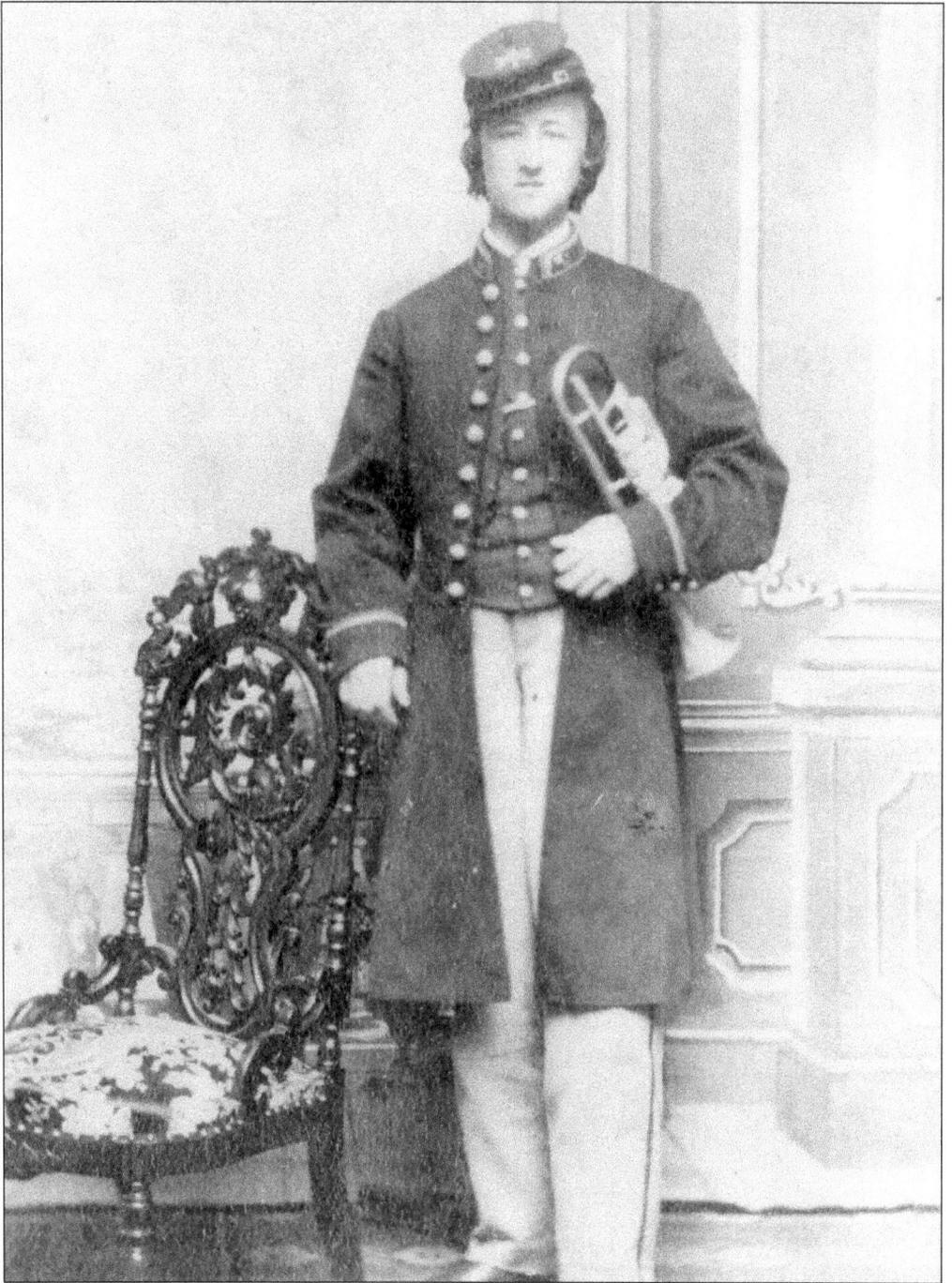

GEORGE EDWARD IVES. "That's a good band," Pres. Abraham Lincoln remarked. "It's the best band in the Army, they tell me," Gen. Ulysses S. Grant replied during the War between the States. The band they were referring to was the Brigade Band of the First Connecticut Heavy Artillery, led by the youngest bandmaster in the Civil War. The bandleader, George Ives, father of composer Charles Ives, enlisted in the Union Army in 1863 at the age of 17. After the war he returned to Danbury and became the town's leading musician and bandmaster.

COL. J. MOSS IVES. During the First World War, J. Moss Ives, son of Civil War veteran George Ives and brother of Charles Ives, was a member of the Military Emergency Board and adjutant general in the Connecticut State Guard. He later became a major with the U.S. Reserves. Lawyer, judge, and author, he was a director of the Danbury National Bank and of the Savings Bank of Danbury, which his grandfather helped found in 1849.

THE CHILDREN OF J. MOSS IVES, 1918. With Sarane Ives in front, the others, from left to right, are W. Bigelow, Brewster, Richard, Moss White, and Chester Ives.

A FAREWELL TO WORLD WAR I SOLDIERS. Thousands said goodbye to soldiers from Danbury, Bethel, New Fairfield, Ridgefield, Sherman, and Brookfield on September 20, 1917. They assembled at the courthouse on Main Street, formed a line at Elmwood Park, and proceeded marching to the reception of high school students, car horns, and well-wishers. Their line was disrupted at the station by friends and relatives, a fife and drum corps, fainting women, and the waving of handkerchiefs, hats, and flags.

WORLD WAR II WOMEN'S AIR FORCE SERVICE PILOTS. These women were bay mates at Sweetwater, Texas, and graduated in October 1943. The are, from left to right, Fran Snyder, Ann Waldner, Lana Cusack, Betty Scantland, Eleanor Feeley Lawry (of Danbury), and Ruth Hageman. Some members of the WASP program (begun in 1941 to relieve male pilots from noncombative flying missions) were trained to operate the four-engined B-17, the "Flying Fortress."

DONALD WOOD, U.S. NAVAL RESERVE, 168 SOUTH STREET, 1943. In 1941, when the Japanese bombed Pearl Harbor, several area residents were already enlisted in the armed forces due to the recent Depression—food, shelter and a paycheck had been hard to come by in the 1930s. Although military regulations exempted at least one family member from service, all five sons of Joseph and Mary Grandieri of Morris Street (Donald, Francis, Julius, Modesto, and Peter Grandieri) not only served but also survived the war.

DANNY SKANDERA, 19TH BOMB GROUP. Danny Skandera was the most highly decorated man from Danbury in World War II. Veterans from World War II joined organizations started after World War I: the Veterans of Foreign Wars and the American Legion.

MR. AND MRS. LEE HARTELL. Lt. Lee Hartell, who won the Congressional Medal of Honor for sacrificing his life in the Korean War, also fought in the 192nd Field Artillery of the 43rd Division in World War II. On January 17, 1952, his widow received her husband's medal at the Pentagon. At the ceremony Hartell's youngest child, 16-month-old John Lee Hartell, got hold of the encased medal and refused to relinquish it.

JAMES THORNE JR., VIETNAM. In 1987, a groundbreaking ceremony was held in Rogers Park for the Greater Danbury Vietnam Veterans Memorial. After the fall of Saigon in 1975, 350,000 refugees came to America—about 500 settling in the Danbury area. Danbury schools introduced immersion classes, and shortly thereafter Cambodian, Laotian, and Vietnamese students were at the top of their graduating class.

Nine

JUST PASSING THROUGH

You must expect if you come to Danbury to be a good deal noticed and perhaps gazed at, for to be the Minister's sister, you know, in a Country Town is a considerable thing.
—Rev. Ebenezer Baldwin (Congregational minister) to his sister, 1771

Composer Charles Ives was born in Danbury in 1874, and contralto Marian Anderson chose Danbury as her home for several decades. Felix Cavaliere of the rock-and-soul group the Rascals, singer-songwriter Laura Nyro, and Laura Ingalls Wilder's daughter Rose Wilder Lane also resided here. However, Danbury is a nice place to visit, too.

Danbury has seen its share of entertainers perform at various local theaters and benefits. The Palace Theatre has received celebrities such as Louis Armstrong, Liberace, Paul Robeson, and Arthur Treacher. To commemorate the anniversary of Charles Ives's 100th birthday, Leonard Bernstein and Michael Tilson Thomas conducted a program of Ives's music on July 4, 1974, at the fairgrounds. The proceeds from this concert were used to establish the Charles Ives Center for the Arts.

Several sports figures have visited Danbury: Gene Tunney, Babe Dedrickson, Gene Sarazen, John L. Sullivan, and Joe Louis made appearances in the first half of the 20th century. Others came here for pleasure rather than business. Babe Ruth was a guest of Harry B. Mallory in 1932. He was here for a hunting trip as was the "March King," John Philip Sousa, in the early 1900s.

In 1899, former Pres. Ulysses S. Grant stopped at the Wooster House at the corner of Main and White Streets. Royalty came in the form of the Crown Prince Muiaba Mkabouri Cetewayo of the Mossi people, Upper Volta, West Africa. Not really—it was Edward Lee Woods of Philadelphia, who was serving a sentence for impersonation at the Federal Correctional Institution in 1960.

On Monday, September 11, 2000, Pres. Bill Clinton definitely surpassed the five-minute speech given by Theodore Roosevelt, the only other sitting president of the United States to visit Danbury. Clinton addressed crowds at the Amber Room and at Western Connecticut State University, where he stopped at the entrance of the campus to shake hands.

THE *HINDENBURG*. This dirigible airship, named for German Gen. Paul Von Hindenburg, passed over Danbury in 1935. The following year its top air speed of 84 m.p.h. helped the Zeppelin to brake transatlantic dirigible records when it traveled from Germany to New Jersey in $61^{1/}_2$ hours. At Lakehurst, New Jersey, 36 lives were lost when the Hindenburg caught fire and burned on May 6, 1937.

CRIME AFTER CRIME. James Pardue (front left) and his brother John Pardue (next to James) were arrested less than a month after a crime spree on Friday, February 13, 1970, that began with the bombing of the Danbury Police Station. The disabled alarm system at the station enabled the pair to bomb and rob the Union Savings Bank, and that act was followed by a blast in the downtown Danbury Mall parking lot. The brothers had also committed several murders.

"DID YOU SEE JACKIE ROBINSON HIT THAT BALL?" It has been more than 50 years since Jackie Robinson (center) hit that ball for the Brooklyn Dodgers on April 15, 1947, when he became the first African American to play baseball in the major leagues in the 20th century. On August 10, 1957, he spoke to the newly organized Danbury chapter of the National Association for the Advancement of Colored People (NAACP).

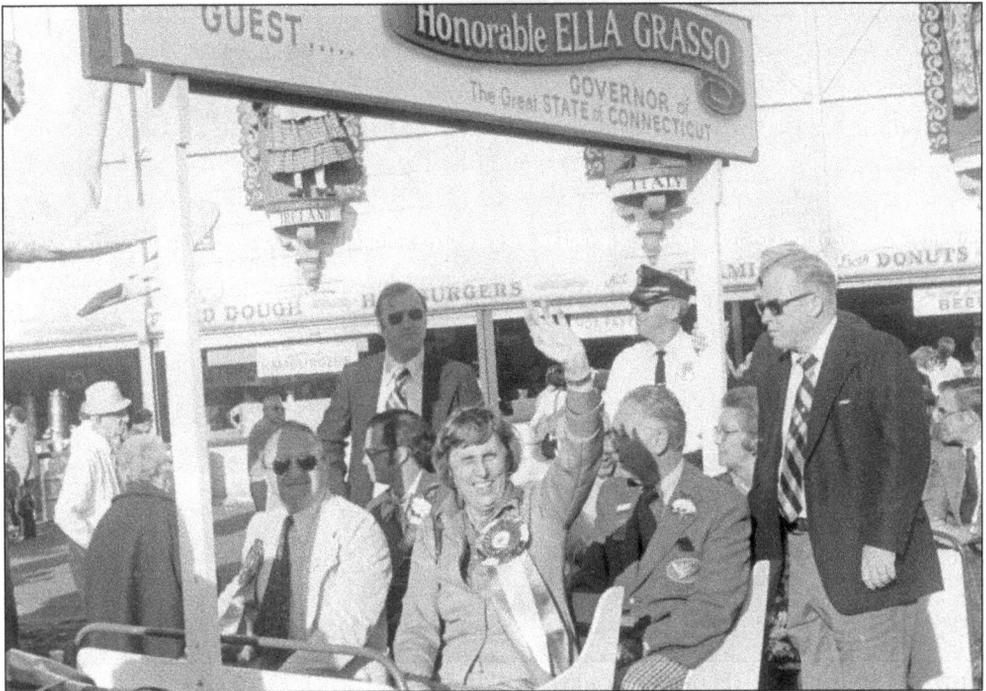

GOV. ELLA GRASSO AT THE DANBURY FAIR. Governors were treated like royalty on Wednesday, the traditional Governor's Day at the Danbury Fair. In 1978, Ella Grasso, who in 1974 was the first woman elected a state governor in her own right, was attending the funeral of Pope John Paul I and, therefore, Governor's Day was held on Monday. Western Connecticut State University's Grasso Hall in Danbury is named for her.

REV. DANIEL BERRIGAN AT THE FEDERAL CORRECTIONAL INSTITUTION, C. 1970. Daniel Berrigan (center) and his brother Philip Berrigan, Catholic priests, were sent to the "popsicle prison" for their antiwar protests, which included burning draft registration files in Catonsville, Maryland. Philip Berrigan was the first priest to speak out against the Vietnam War. They were paroled in 1972.

THE FBI AT THE FCI (FEDERAL CORRECTIONAL INSTITUTION). G. Gordon Liddy (center), former member of the FBI (Federal Bureau of Investigation), was sentenced to 20 years for his part in the break-in at Democratic Headquarters in 1972. He wrote about the Federal Correctional Institution in his autobiography *Will*. Former CIA (Central Intelligence Agency) employee and White House consultant Howard Hunt and four other Watergate burglars were transferred to the institution from Washington, D.C., in 1973.

TOASTMASTER GENERAL OF THE UNITED STATES. George Jessel (center) attends a United Fund benefit on October 24, 1969. Behind him, from left to right, are Willard Hogg (chairman of the United Fund Drive), Mrs. Gino Arconti, Mayor Gino Arconti, and State Sen. T. Clark Hull. Jessel, an actor, writer, producer, and composer, was inducted as an Abbot of the Friars Club in 1933. In 1970, he received a special Academy Award for his humanitarian work.

WILLIAM F. BUCKLEY JR., DECEMBER 7, 1972. The great debater William F. Buckley Jr. (third from the left) went one-on-one with the audience and media after an address at Western Connecticut State College. The speech, "Reflections on Current Disorders," was a commentary on Buckley's trip to China with Pres. Richard Nixon. With Buckley, from left to right, are Mayor Gino Arconti, radio broadcaster Paul Baker, and Ruth Haas, the president of the college.

115

ELIZABETH TAYLOR, OCTOBER 5, 1957. Cowboys and western gear were a popular trend when actress Elizabeth Taylor visited the Danbury Fair. In the front with her are her husband Mike Todd (left) and children Christopher and Michael. Behind her are John Leahy and C. Irving Jarvis, both sporting light-colored wide-brimmed hats, presumably made in Hat City: Danbury. Other luminaries who visited the Great Danbury State Fair include Sen. Joseph McCarthy, Sen. Prescott Bush (father and grandfather of Presidents George and George W. Bush), entertainers Ernie Kovacs and Edie Adams, Julie Nixon (daughter of Pres. Richard Nixon), actress Polly Bergen, aeronautical engineer Igor Sikorsky, New York Mayor Jimmy Walker's Irish terrier, and Borden's Elsie the cow.

116

Ten

FAIR THEE WELL

Don't it always seem to go, that you don't know what you've
got 'til it's gone. They paved paradise and put up a parking lot.
 —Joni Mitchell, "Big Yellow Taxi," 1970

You could say that the Danbury Fair and the *Danbury News* grew up with each other. The first fair was held in 1869, and the *Danbury News* was first published in 1870. Only during Fair Week did local news grace the front page of the paper. When the *Danbury News* reported on the fair, terms such as "excelsior!" "immense attendance," "largest and finest," and "sensations of pleasure" were used with pride.

The Danbury Fair had its origins with the Fairfield County Agricultural Society, which began in 1821. The fair rotated between Danbury, Bridgeport, Stamford, and Norwalk. In Danbury its location was near White Street. When officials decided to keep the event in Norwalk, Danbury took a gamble and held its own fair at Pleasure Park, where just a few months earlier an inaugural trotting race had been held. The Danbury Agricultural Society soon bought the racetrack, and racing was associated with the Danbury Fair until it closed in 1981.

A different fair opened in 1946, John Leahy's Fair. The fair had been dormant since 1941, and Leahy had spent the war years buying fair stock until he became the sole proprietor. A self-made businessman, he managed to make his "hobby" a full-time, year-round job.

Shortly after John Leahy died in 1975, the property was sold and the Danbury Fair Mall opened in 1986. Although the community lost a vital part of its culture, the mall brought an increase in Danbury's year-round retail dollars, thereby continuing the town's trading center tradition.

FAIR WEEK, MAIN AND WEST STREETS. Flags and bunting, similar to the patriotic drapings found inside the Big Top, decorated the downtown area during Fair Week. Streetcars were available at this intersection to transport passengers to the fairgrounds. However, most exercised the most common mode of transportation: walking. Special trains were employed to carry out-of-towners to the fair.

HATS, TIES, AND DARK APPAREL AT THE DANBURY FAIR, OCTOBER 11, 1901. This group may have seen a booth with a baseball game that utilized a target marked "the assassin of President McKinley," at the first Danbury Fair held in the 20th century. In the group are Marian Starr, Sue Clark, Maude Tweedy, Gwen Hartwell, Grace George, Christine Rundle, Marie Rogers, Janette Rogers, Marguerite Rundle, and Mattie Pettit.

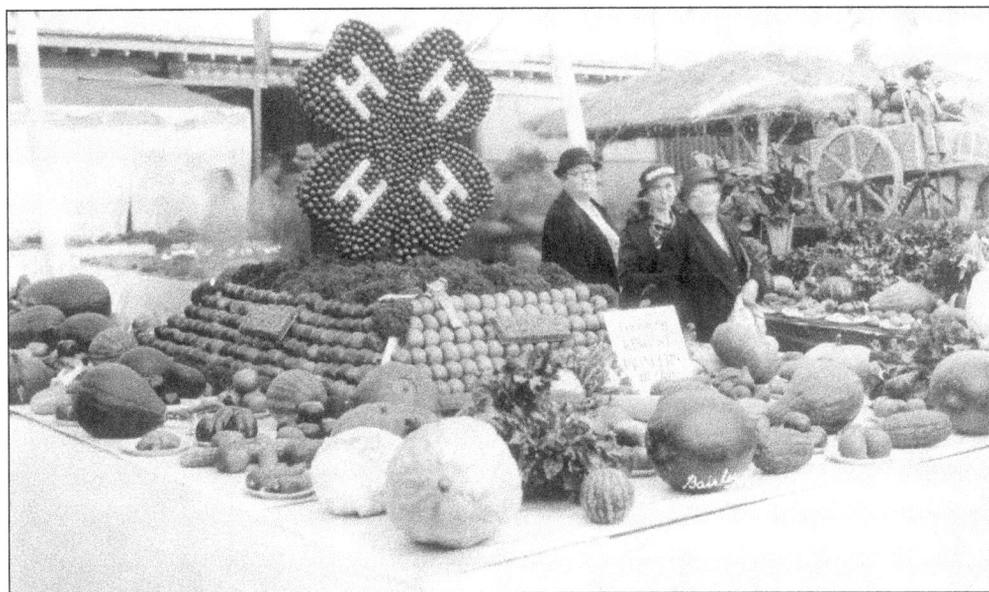

THE KING STREET PIONEERS, 4-H CLUB, C. 1920. The King Street Pioneers won third prize for this entry displayed in the Big Top. The Danbury Fair provided an opportunity not only to submit an entry in the various produce, homemaking, and animal categories but also to inspect the latest gadgets, to watch automobile and motorcycle races, to visit the midway, and to take in a show.

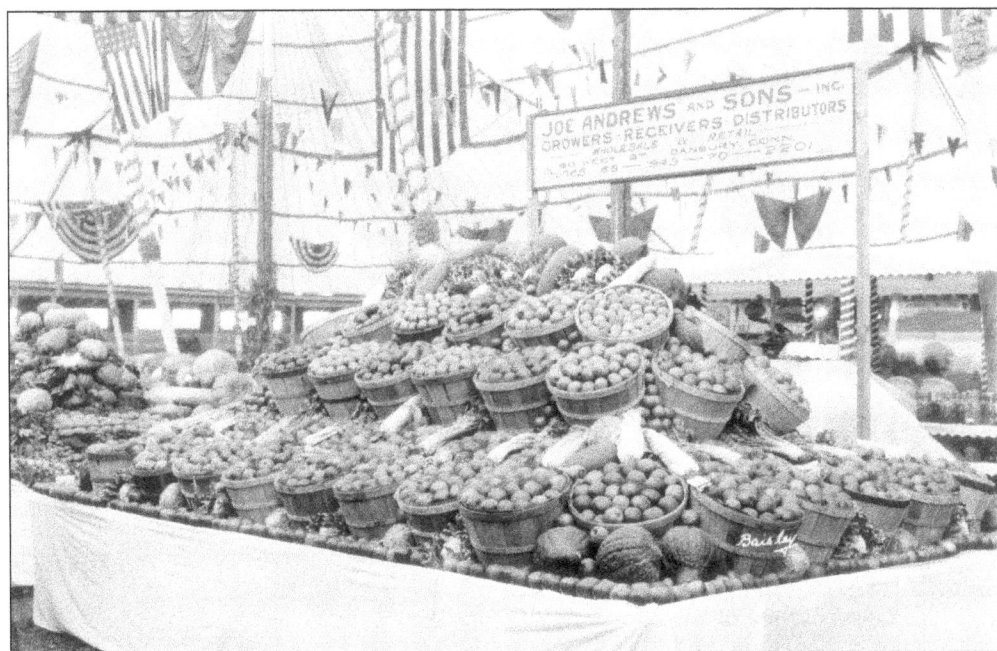

HOW 'BOUT THEM APPLES. When this photograph was taken, the number of farms in Danbury was declining, resulting in a decrease in agrarian displays. As the competition waned, the Big Top exhibitors took on the role of adviser and educator. Arlene Yaple, supervisor of the Big Top for 35 years, related how backyard growers and city dwellers would seek information from the agricultural experts on hand.

QUEEN FOR A FAIR, OCTOBER 6, 1953. C. Irving Jarvis, assistant general manager, presents Vicki Mills with a ribbon at one of her daily appearances as queen of the Danbury Fair. Known locally as Carmella Marie Melillo, Vicki Mills was the daughter of Mr. and Mrs. Vincent Melillo. In 1953, she appeared on NBC's *Name That Tune*. Jarvis's involvement in the Danbury Fair went back to 1922; his uncle Leo Lesieur brought the first merry-go-round to the area. Jarvis also worked for Leahy's Cities Services.

"THAT'S JUST GROOVY, BABY." The 1973 queen of the Danbury Fair sits next to her escort, Staff Sgt. Gary W. Maxam, recruiter for Norwalk and Stamford. Susan Blomberg of Newtown wears a casual empire-waist dress with a peasant-style neckline.

120

G. Mortimer Rundle. Even though John Leahy, by 1945, had controlling interest in the Danbury Fair, he insisted that George Mortimer Rundle (front right) retain the title of president. Rundle, the son of Danbury Fair founder and president Samuel Rundle, learned the wool hat-making process at Rundle and White, the River Street hat business owned by his father and George White. The vice president of the city's oldest bank, Danbury National Bank, Rundle became Danbury's third mayor in 1895.

Marian Anderson and John W. Leahy, c. 1951. Two of Danbury's greatest entertainers stand in front of an advertisement for musicals that were staged at the fairground in the early 1950s. World-famous contralto Marian Anderson moved to Danbury in the 1940s and lived here for about 50 years. Leahy's summer performances began in a theater-in-the-round in a tent and then moved to a 40-foot stage on the racetrack. The program books for *The Student Prince*, *Finian's Rainbow*, and *Carousel* were an opportunity to advertise the upcoming Danbury Fair.

121

NICE KITTY, 1972. Gene Holter's wild animal show was staged every afternoon at the Danbury Fair before a grandstand crowd. In 1965, ostrich racing was introduced.

PERCY FERRIS AND FRIEND, 1969. Ox pulls were staged at every Danbury Fair that was held from the first in 1869 to last in 1981. The Ferris families of Newtown were a part of the competition for most of the Danbury Fairs held in the 20th century. Another attraction at the fair was the Cattle Parade of Champions.

KOCHMAN HIGH SKI. The High Ski was one of the most popular segments of Jack Kochman's Hell Drivers routine. The drivers ran one side of the car over a ramp and then drove, precariously balanced on two wheels. Other death-defying acts that appeared for the grandstand audience were Ward Beam's World Champion Auto Daredevils, Irish Horan's Lucky Hell Drivers, Joie Chitwood's Hell on Wheels, and Lucky Teter's Hell Drivers.

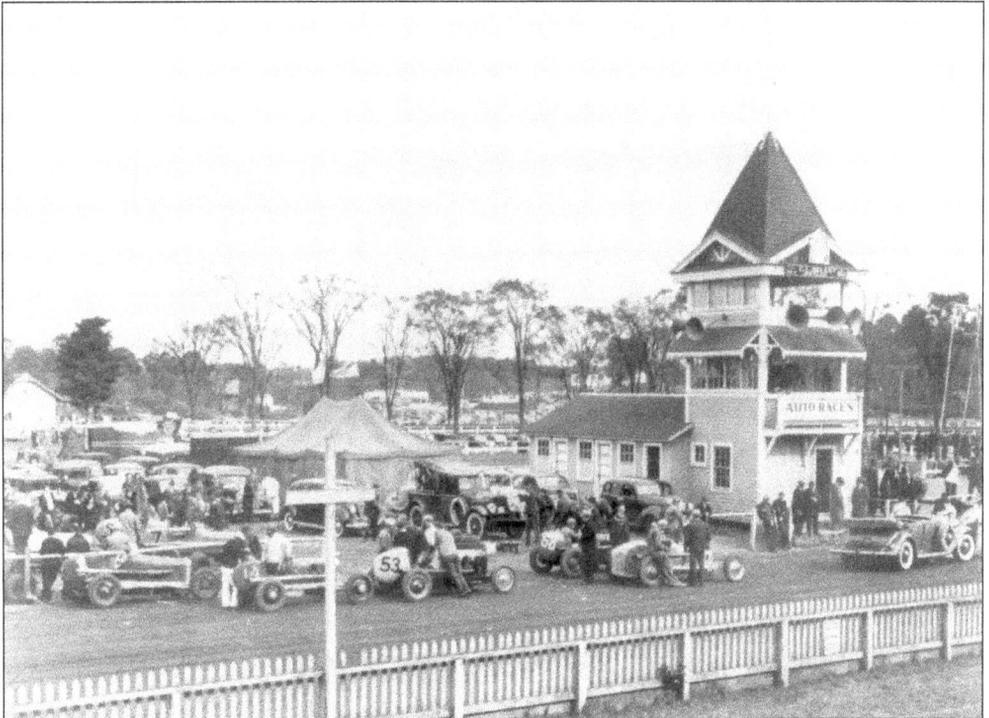

"GENTLEMEN, START YOUR ENGINES." Auto racing and the Danbury Fair go back as far as 1904. Half-mile car racing at the fairgrounds ended in 1938, and the midgets ran from 1940 to 1964. The Southern New York Racing Association made its debut during Fair Week in 1951 and, except for 1956 and 1957, the organization held stock car races every year until the fair closed in 1981.

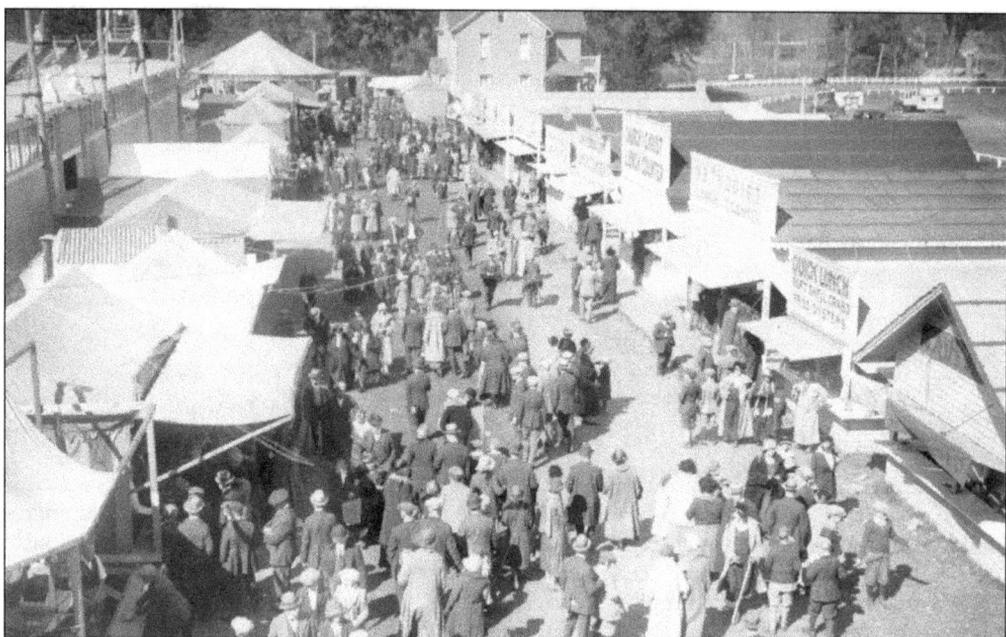

CHURCH LUNCH ROW. Nearly every church in town is represented at a food stand near the main tent, although some members of the clergy frowned upon their churches doing business on Sunday. Women wore bustles when the first Danbury Fair opened in 1869; however, by the time this picture was taken, hemlines had shortened, shortened some more, and then dropped again. Note how few bare heads can be seen in the crowd.

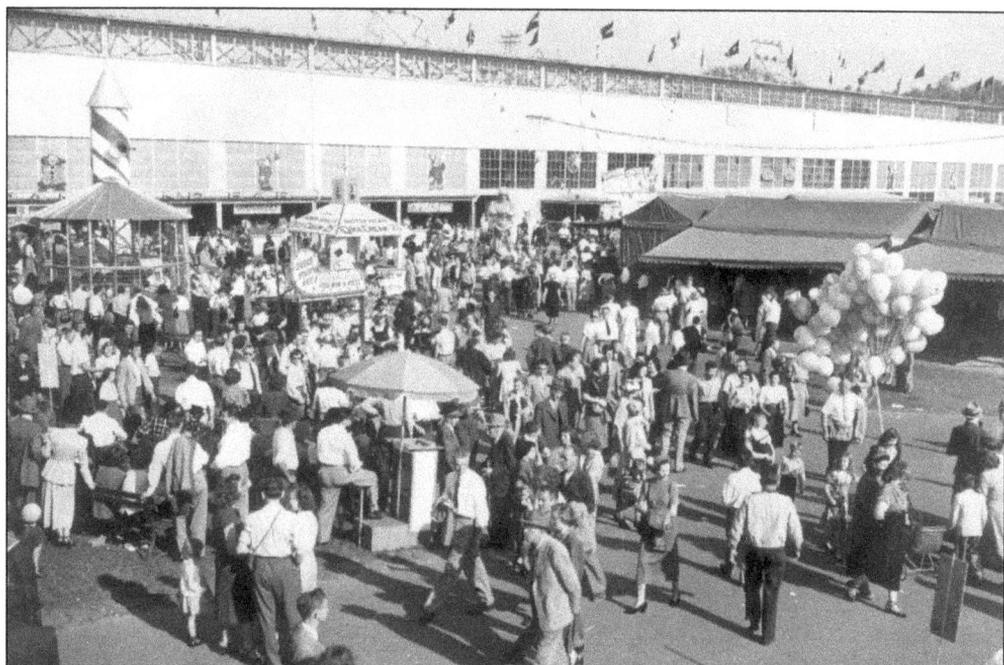

DANBURY FAIR, 1949 EDITION. Although many visitors to the fair on this date are in shirtsleeves, suits and skirts were the order of the day. The hatless trend was very much in evidence by this time, and Hat City denizens had to go along with the inevitable.

124

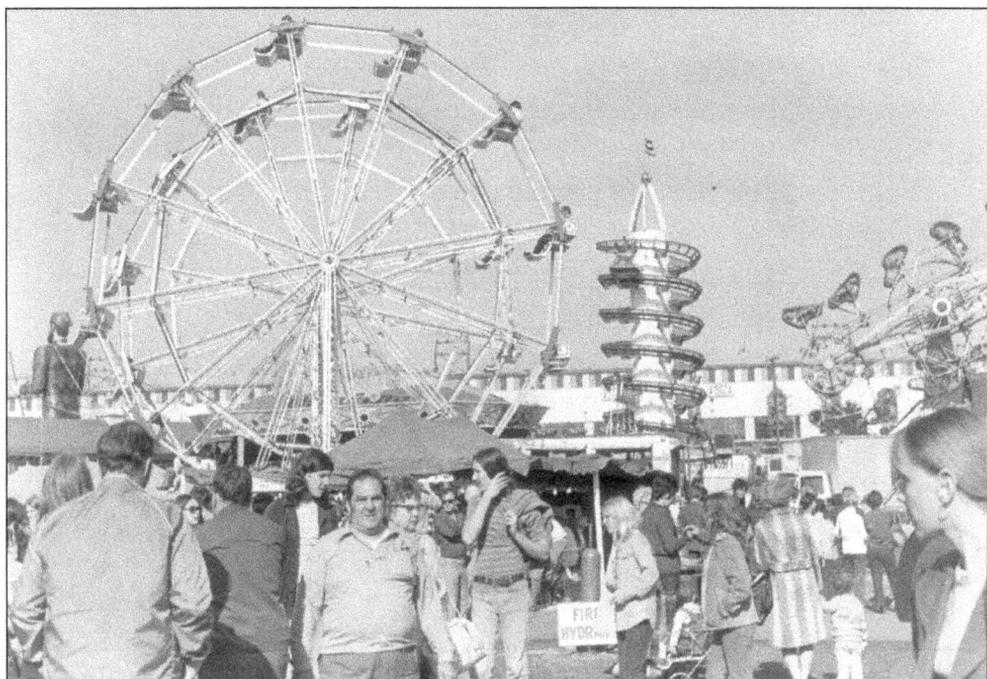

AND NOW FOR SOMETHING COMPLETELY DIFFERENT. Not a suit in sight in this c. 1970s Danbury Fair photograph. Jeans, windbreakers, and other casual dress are worn by males and females of all ages.

DAVID COOPER AND FURRY FRIENDS, 1969. David Cooper takes time out from a busy day at the Danbury Fair to enjoy one of the exhibits. General manager John Leahy made sure that the fair offered something for children of all ages.

A New England Village. These buildings were formerly on display at Grand Central Station in New York City. The village arrived at the Danbury Fair in 1948, and it included a barn, Colonial church, country furniture store, dress shop, drugstore, general store, mineral museum, theater, and wool-spinning center.

Virginia Wren and John Leahy. Radio personality Virginia Wren did a live broadcast from John Leahy's Fair for station WLAD in Danbury. In 1964, she opened a health food store on Ives Street.

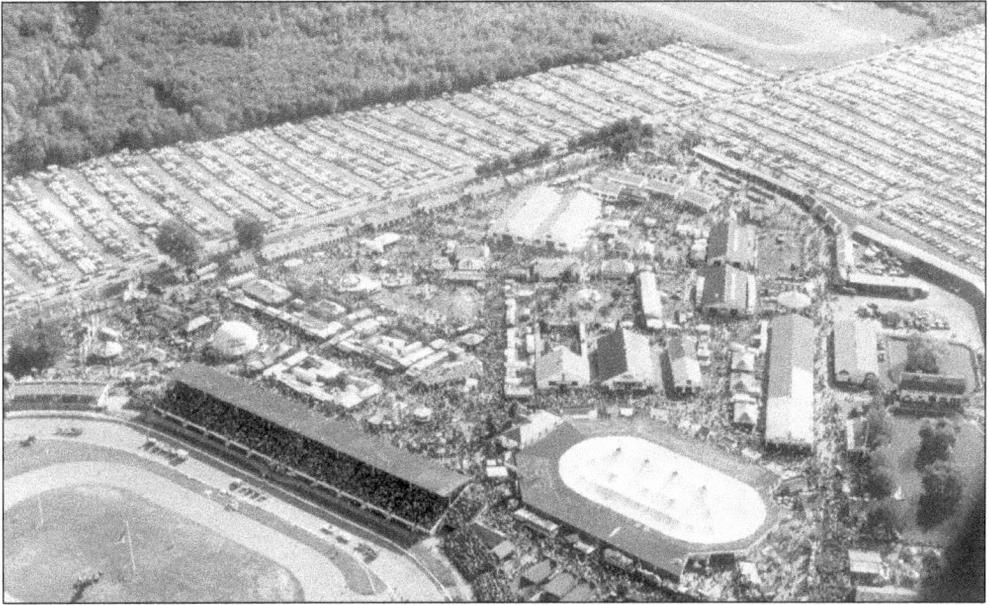

A Panorama of the Fairgrounds, 1966. John Leahy's boyhood dreams of owning his own circus came to fruition when he became owner of the Danbury Fair in the 1940s. His fuel oil empire provided funding for his ever-improving efforts on the fair that, according to him, never made a profit. The latter-day P.T. Barnum was considered a hero to children for not only the entertainment he contributed but also the school holiday he bestowed.

A Grandstand Show, c. 1970. Early entertainment for the grandstand crowd consisted of vaudeville acts that were inserted between harness races. A 40-foot howitzer would shoot the Great Wilno into the air, and acrobats and Wild West shows were other popular acts. John Leahy's post–World War II presentations had stiff competition from another entertainer: television.

THAT'S ALL, FOLKS. "We normally would say, 'See you next year' but this time we'll be saying good-bye," said Big Top supervisor Arlene Yaple in 1981. When John Leahy died in 1975, he left no provision in his will for the future of the Danbury Fair. After several offers were considered for the land, the trustees of the estate sold the property to the Wilmorite Corporation for $24 million to build one of the largest malls in New England. "The lowering of the curtain to a long and joyful event" came on Monday, October 12, 1981.

www.ingramcontent.com/pod-product-compliance
Lightning Source LLC
Chambersburg PA
CBHW080854100426
42812CB00007B/2029